chihuly

The George R. Stroemple Collection

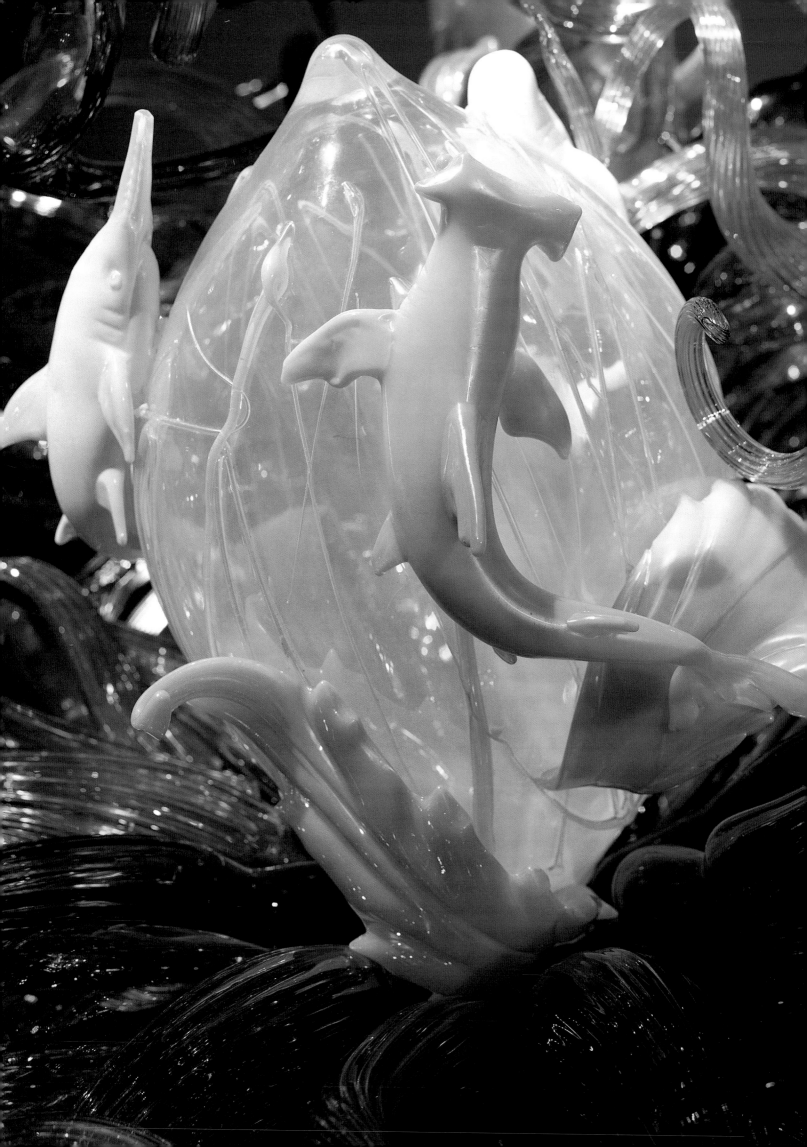

Loretta Moskaluk

chihuly

The George R. Stroemple Collection

Essays by Donald Kuspit and Kathryn Kanjo

Portland Art Museum

This publication was prepared in conjunction with the exhibition *Dale Chihuly: The George R. Stroemple Collection.* Curated by Kathryn Kanjo, Curator of Contemporary Art, this exhibition was presented at the Portland Art Museum from October 25, 1997, through January 18, 1998. This exhibition and publication are made possible through the support of the Stimson Lumber Company, Presenting Sponsor, and Andrew J. Davis, Patron of the Exhibition. Additional support was received from: IKON Office Solutions, U.S. Trust Company—Charles and Caroline Swindells, City Center Parking, ODS Health Plans, KINK fm 102, *The Business Journal,* and KPTV Oregon's 12.

Library of Congress Cataloging-in-Publication Data

Chihuly, Dale, 1941–

 Chihuly : the George R. Stroemple collection / essays by Donald Kuspit and Kathryn Kanjo.

 p. cm.

 Catalog of an exhibition held at the Portland Art Museum.

 Includes bibliographical references.

 ISBN 1–883124–06–9

 1. Chihuly, Dale, 1941– —Exhibitions. 2. Glass art—United States—History—20th century—Exhibitions. 3. Stroemple, George R.—Art collections—Exhibitions. 4. Glass art—Private collections—Oregon—Exhibitions. I. Kuspit, Donald B. (Donald Burton), 1935– . II. Kanjo, Kathryn. III. Portland Art Museum (Or.) IV. Title.

 NK5198.C43A4 1997

 730' .92—dc21 97–36096

Cover front and back (detail): *Gilded Mystic Blue Putti Venetian with Swan and Cherubs,* 1994, cat. no. 242
Frontispiece: *Laguna Murano Chandelier,* 1996–97, cat. no. 311

Printed in Hong Kong

John E. Buchanan, Jr.

It is with great pleasure that the Board of Trustees and I celebrate the publication of this catalogue to accompany the exhibition *Dale Chihuly: The George R. Stroemple Collection*. This exhibition of 350 works is drawn from a larger holding of pieces assembled by collector George R. Stroemple, a Portland businessman who has patronized Dale Chihuly for the past seven years. Over that time, Mr. Stroemple has amassed the largest collection of Dale Chihuly's art in either public or private hands. The Stroemple Collection reflects the close friendship between collector and artist through works that track the artistic growth and diversity of Dale Chihuly's oeuvre. The Portland Art Museum is privileged to be the first to introduce to the public the breadth and depth of this extraordinary collection.

There is no question that Dale Chihuly is a household name, not only in his native Pacific Northwest, but on the international scene as well. To say that Dale Chihuly has been a pioneer of the contemporary art glass movement is, of course, an understatement. As innovator, engineer, and consummate artist, Chihuly has achieved a level of artistic genius that strikes rarely in any era. Although several previous museum exhibitions have focused on the visual delights of Dale's installations or specific series, the George R. Stroemple Collection selectively surveys the past twenty-five years of Chihuly's artistic and technical development, delighting us with a few surprises not formerly seen in any public exhibition.

Dale Chihuly: The George R. Stroemple Collection would not be possible without the generous cooperation and support of the collector himself, and the Portland Art Museum extends its sincere gratitude to him. I also thank Dale Chihuly for his support of this project. His personal involvement has enabled us to mount an extraordinary exhibition and to view his work in new and unique ways. Tracy Savage also deserves our thanks for all that she has done to develop and strengthen our relationship with the artist. Her assistance has been invaluable. In addition, the Museum is grateful to its Development Director, Lucy M. Buchanan, for her leadership in bringing the project and its programs to fruition.

Kathryn Kanjo, Curator of Contemporary Art at the Portland Art Museum, has been instrumental in the development and execution of this catalogue and exhibition. Her critical curatorial eye and incisive essay further the existing scholarship on Chihuly. Likewise, Donald Kuspit's provocative essay brings new insight to the art of collecting. This catalogue, designed by Ed Marquand, artfully documents the beauty of these objects in the exhibition. Also, I acknowledge Curatorial Intern Alison Dozono who assisted with the catalogue coordination.

And, finally, no museum exhibition would be possible without the generosity of the donors who support the exhibition and allow the artist, collector, and curatorial staff to bring the concept for an exhibition to life. I thank Stimson Lumber Company and Andrew J. Davis for their leadership support, as well as IKON Office Solutions, U.S. Trust Company–Charles and Caroline Swindells, City Center Parking, ODS Health Plans, KINK fm 102, *The Business Journal*, and KPTV Oregon's 12 for their contributions to *Dale Chihuly: The George R. Stroemple Collection*.

It is my hope that those who see this exhibition or its catalogue will have a chance to encounter a more personal side of Dale Chihuly, one not usually on view in his typically more extravagant installations for museums, galleries, and other public spaces.

Most of the objects in this collection were selected from Chihuly's private archive and represent his most personal work, a kind rarely seen before by the general public. While the collection is now rather large, it spans two-and-a-half decades of Chihuly's artistic life. This collection is not an overview of an entire career, but is simply, in my opinion, Chihuly's most intimate and accomplished work, more reflective of the private man than the artist impresario most people know.

I first became familiar with Chihuly's work in the mid-1980s when I saw an exhibition of large Macchia and Sea Form sets. While I was immediately intrigued by the scale, shapes, and colors of the pieces, my collecting had been confined mostly to "traditional" art. At the time it was a difficult decision to begin a new collection in an area that was not then considered fine art. Today there is no question that what Chihuly creates belongs in that realm, but ten years ago contemporary glass was regarded solely as "craft" by the wider art world. Chihuly himself has changed that. Looking at the long history of glassmaking, one quickly realizes that what separates Chihuly from other famous names in glass, such as Tiffany, Daum, Gallé, and Lalique, is his intimate relationship with what he creates. While others have been, more or less, factory managers and designers, Chihuly is involved in the smallest details of each piece represented in this collection, including serving as gaffer for many of them. He is active in every stage of a work's creation, from envisioning and developing the original design, to creating the working drawing and determining scale, color, and configuration; to assembling the best team and gaffer suitable for the piece; and finally, to orchestrating the blow itself, making split-second decisions that literally determine the success or failure of any attempt. I am always impressed with Chihuly's mastery of all aspects of the creative process and with how successful he is in realizing his innermost vision for his work. Though he is undoubtedly a master craftsman, Chihuly is also, unquestionably, a great artist.

I want to thank Dale for his friendship and for entrusting in me the responsibility of caring for some of his most important life's creations. He has been a true friend over the last eight years and I look forward to strengthening that friendship in the years to come and to continuing to build the collection.

Finally, this collection could not have been formed without the trust, friendship, and assistance of Tracy Savage, curator of the collection. She has shown remarkable patience, fairness, and endurance in representing the interests of both Dale and me, and for that I thank her.

I also thank John and Lucy Buchanan, Kathryn Kanjo, and the entire staff of the Portland Art Museum for their interest in organizing this exhibition and in recognizing the importance of Dale Chihuly as a contemporary American glass master.

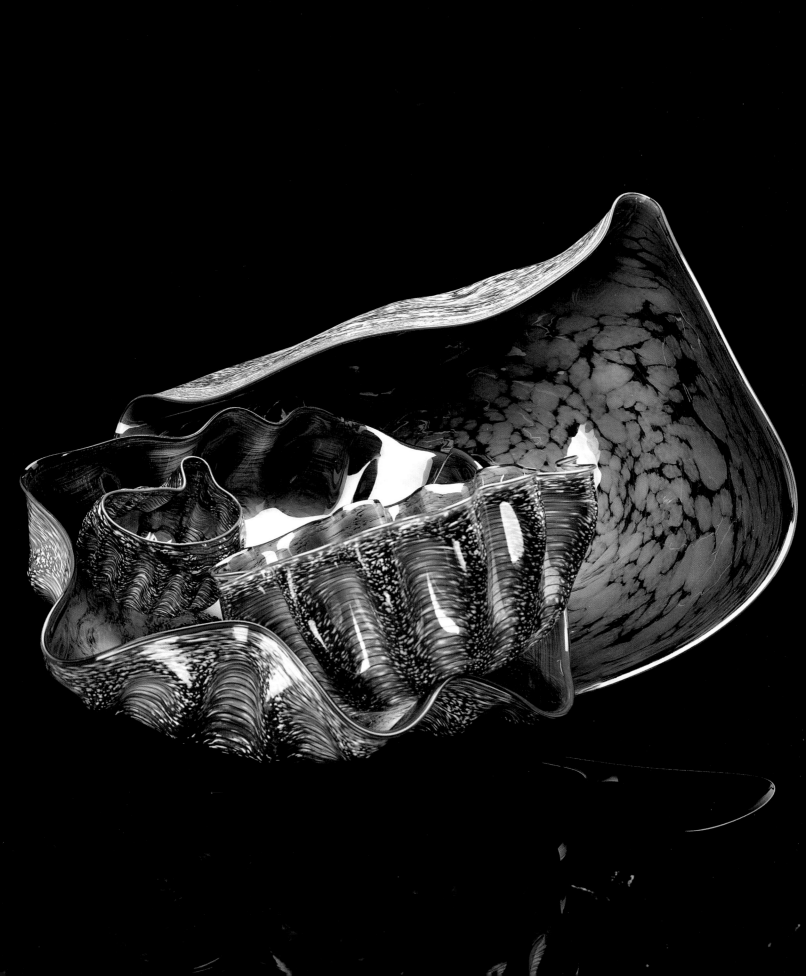

chihuly

An Appreciation

by Tracy Savage

More than ten years ago, the telephone rang in my office at SAFECO
Corporation in Seattle where, in 1986–87, I worked as curator of the corporate
collection. A voice said, "Hi, it's Chihuly. We're blowing glass at my studio. You want
to come over and watch?" I'll never forget its sound, like the voice of a great radio
announcer—powerful, warm, and completely engaging. I knew at that moment that
he contained a life force unlike anything I had ever experienced. I went to his studio
that day and, meeting Chihuly for the first time, I felt as though I had known him
all my life.

Just a year later I was running his studio and managing a career already headed
for the stratosphere. I didn't know what the stratosphere looked like, or what it
would be for Chihuly, but I knew it would be exciting and that his work would be
recognized throughout the world. Now, ten years later, I see what he has accom-
plished, confirming my instincts. Dale's vision of himself in the world contains no
obstacles or roadblocks. If an idea comes to him, he simply goes to work figuring out
how he can make it happen. Nothing stops him. We see this in the things he has
accomplished at Pilchuck, in Venice, and around the world.

Dale's sense of time is indicative of how his mind works. He is the only person
I have ever met who thinks almost exclusively about the future. The past occupies
him so little that he often cannot remember what he has done only a few hours
earlier. He is not the easiest person to keep up with. But some try, and if you can
manage to hold on, it is the wildest ride of your life. George R. Stroemple is one who
approached Dale's world head-on and in the process amassed the most significant
collection of the artist's work ever assembled.

My first encounter with George Stroemple also came in the form of a telephone
call. At the time, Dale had a strict policy of not having visitors to the studio. Pilchuck
board members and museum curators occasionally visited, but private collectors
were steered to galleries and encouraged to view the work in that context. But when
George called, he offered a very convincing argument about why he must make a
personal visit to Seattle. He said he was a lifelong collector, had been following

facing: *Pheasant Macchia Set with
Eucalyptus Lip Wrap,* 1984, w. 26 in.,
cat. no. 96

9

George R. Stroemple and Dale Chihuly

Chihuly for several years, and was ready to make a serious commitment to acquiring the work.

I was struck by the man's confidence, charm, and willfulness, not unlike the first time Chihuly called. George said that he would like to acquire several pieces for his collection. He asked a lot of questions (another Chihuly trait) and obviously wanted to soak up as much knowledge as he could about Dale Chihuly. I talked with him about his collection, and it was apparent that he had the "bug"—he was the real thing, a true collector. I think this appealed to Dale, a voracious collector himself.

George Stroemple's phone call came in the spring of 1990; Dale had been working on the Venetians with Lino Tagliapietra since the summer of 1988. The series was completely resolved—the most exquisite, demanding, and controversial works of Dale's career. Dale had just acquired the legendary Pocock Building on Lake Union, fulfilling his lifelong dream of having a studio on the water in Seattle. We were in the middle of renovation, which included building a state-of-the-art glass shop. George told me that he wanted to see the Venetians, and the first time he came we had a dozen or so for him to look at in the new studio, now called The Boathouse. The building was a mess, but the Venetians just glowed in that space, and the group of them together was stunning. I really didn't know how Stroemple would respond once he actually saw the work, but clearly, he was enthralled by the Venetians.

Dale liked the idea that George was so interested in collecting his work, especially the Venetians. George selected five pieces that day with the promise of purchasing seven more in the next twelve months. I think he ended up acquiring many more pieces that first year; we really lost count.

Stroemple's enthusiasm was unusual. The Venetians had not been accepted very well, particularly by collectors who had acquired Dale's previous work. To have someone immediately make such a strong commitment to this body of work made a huge impression on Dale and me. But the more I got to know George Stroemple, the more I understood why this work so interested him. Having collected all his life, primarily focusing on the work of nineteenth-century American artists, George could not resist the color, complexity, playfulness, history, and abundance of the Venetians.

The collector continued to impress us as he traveled between Portland and Seattle on a regular basis to see new Venetians being made. Most of the time he arrived at The Boathouse as work was beginning, around 6 A.M. This meant he was getting up in Portland around 3 A.M. to make the drive. Like Dale, George is an early riser; thus the two of them found something else in common.

Lino Tagliapietra was a frequent visitor in the new hot shop, and he and Dale came together every three months or so to create new work. George would find his way to the hot shop whenever Lino was in town. He was content to stand and watch for hours as the crew worked. In the beginning he didn't talk to Dale much. He respected the creative process and certainly didn't want to get in the way. Communication between them was conducted through me, and they both seemed perfectly happy with that arrangement.

George continued to collect at an astonishing pace, and as the relationship grew, Dale and I felt comfortable showing him older work and pieces that Dale had archived for his own collection. I think we all understood that we were building something extremely important, in the form of George's collection. Some particularly complex negotiations occurred for pieces Dale was hesitant to give up, but which George felt that he simply had to have. I think they both enjoyed this process

immensely, both loving the "art of the deal." I, on the other hand, as the go-between, sometimes felt a lot of stress. Dale was often in his kitchen, George in the front room, with me running back and forth. But this allowed them a certain freedom in the negotiating process, and I guess I was doing something right, because the Stroemple collection continued to grow. But even risking ulcers and gray hair was worth it, because I knew I was part of history in the making.

The three of us became close friends. We spent a lot of time together in Portland and Seattle, at George's ranch in eastern Oregon, and at museum and gallery openings, as Dale's desire to share his work with the world continued to grow. George and Dale came to discuss more than the work, with the artist often seeking the collector's advice as Dale's business began to grow beyond his wildest imagination. George revealed himself to be not only the greatest collector Dale had known but also a true gentleman and friend.

I believe the trust that grew between them had to do with a kind of need they had for each other: the collector required a seemingly endless bounty of art, and the artist needed the unwavering commitment and third eye of a discerning patron. I think it was important for Dale to know that George believed in him completely, and George needed to believe. The result, a magnificent collection, speaks for itself. Both artist and collector share in the "creation" of something that will forever be a symbol of their unique bond. The collection takes on its own life and bespeaks the interdependent and specific nature of their close friendship. For me it has been a rare opportunity, first working side by side with Dale, helping him fulfill his role in the world as one of this century's great artists, and then independently as a curator and adviser to George, who is the greatest collector one could imagine working with. They have both been tremendously supportive of me and my career over these past ten years.

I have been given a unique opportunity to play an instrumental role not only in helping to shape a collection but also in making a friendship between the two of them and among the three of us together. While working closely with George and Dale and, most importantly, with Kathryn Kanjo of the Portland Art Museum, in preparation for this exhibition, I realized the overwhelming sense of pride I have in this collection and the intense affection I have for it. I will forever feel fortunate and grateful that I was at the intersection of Dale Chihuly's and George Stroemple's lives as they created history. There are no two men whom I admire more, and it has been pure joy to know them and be with them on this thrilling ride.

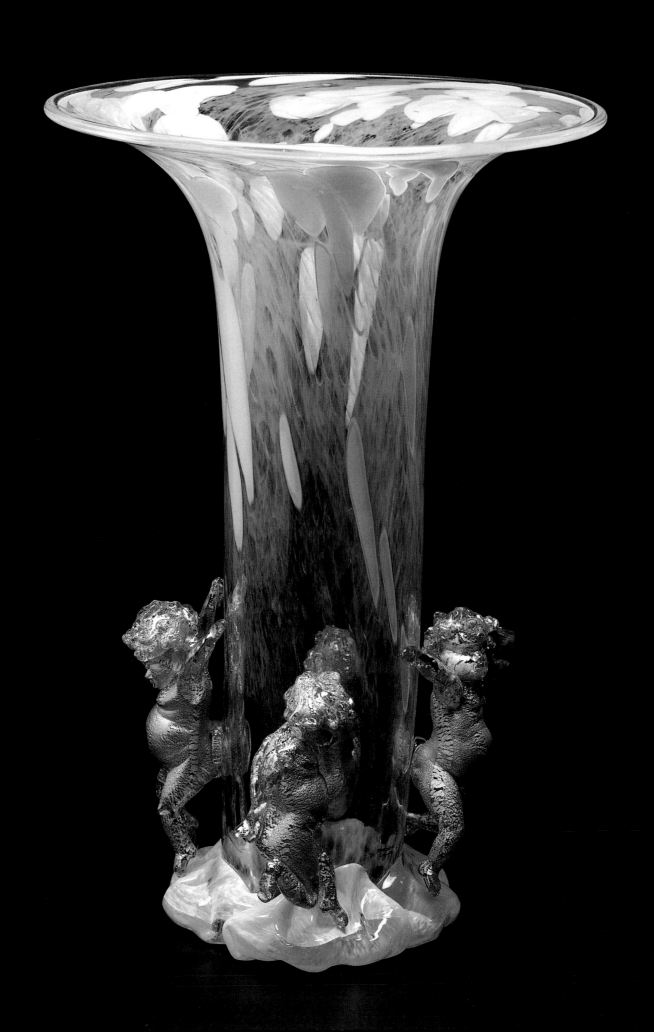

Chihuly and Stroemple: A Meeting of Imaginations

by Donald Kuspit

This exhibition is not only about Dale Chihuly's glass art, but also about George R. Stroemple's enthusiastic, if selective, collecting of it. The issue is why Stroemple chose to collect what he did, as much as why Chihuly made what he did. In other words, the exhibition embodies the meaning of the bond between them: it is about what each sees in the other, and why he sees it.

Conventionally, the collector is thought of as being dependent on the artist. But I want to suggest that the artist is equally dependent on the collector, not just for economic reasons but for emotional reasons. Collectors can inspire artists, in effect, functioning as patrons, as occurred when Stroemple suggested that Chihuly make a series of small Venetians. Chihuly, as Stroemple said, "with his usual enthusiasm, loved the idea, and the Piccolo Venetians were born." But Stroemple, a collector who has bought literally hundreds of Chihuly's works—who has bought in depth, and with his own sense of quality—offers something more than passing inspiration: he confirms the art's human value. An art may appeal to specialists and experts, who confirm its historical significance and credibility, but when it appeals to a broad public—represented by the individual collector, who owns the art for his own edification and pleasure—then it has realized its rock-bottom emotional purpose: to bridge the space of separation, as Joyce McDougall calls it, that invariably exists between people.[1] Every collector takes a risk, and in the end it is an emotional risk— a relational risk, as McDougall says.

Stroemple in effect walks across the bridge of art that Chihuly has created in his effort to affect other people deeply—proof that his art does not exist in the limbo of separation. Stroemple's enthusiasm for Chihuly's art—which has its own kind of enthusiastic form—indicates that it is solidly built and will hold the weight of Stroemple's attention and emotion, rather than drop him into the abyss of indifference and boredom. Thus Stroemple's commitment to Chihuly's art—the connection he feels to it and the trust he gives it—is as imaginative as the art itself, for it fulfills the work's innermost purpose: to connect with another, in the most intimate way possible. The artist's connection with a caring collector who has faith in his art gives him confidence, over and above the confidence he gains from expressing himself

facing: *Payne's Grey Venetian #24*, 1989, h. 22 in., cat. no. 103

through it. Art exists to overcome separation anxiety, McDougall argues; creative self-expression—self-assertion—is a means to that goal, not the goal itself. It is reached only when the collector takes the initiative of investing himself in the art, in effect identifying with the artist and thus supporting his identity, as well as his own. Thus, just as the collector needs the artist—especially an artist with a strong sense of self—to be fully himself, the artist needs the recognition of a collector who is courageous, critical, serious, independent, and determined to be fully himself. Their reciprocity counts as much as their individuality and independence.

As Marcel Duchamp said, "the creation of art" restlessly oscillates between "two poles: the artist on one hand, and on the other the spectator who later becomes the posterity."[2] What occurs between them is "comparable to a transference," he asserts, borrowing a basic psychoanalytic idea. The "subjective mechanism" of the collector's transference to the art makes it convincing. His willingness to invest his own substance in it helps give the art substance. Thus, the collector is the ideal spectator. His personal commitment to the art goes a long way: it is socially contagious, to the extent of legitimating the art. Presumably posterity will see in it what the devoted collector—especially its first owner—saw in it. At issue in this exhibition, then, is not only Dale Chihuly's complex, subtle art, but George R. Stroemple's passionate transference to it—his subjectivity. Stroemple's belief in and idealization of Chihuly's art confirms its beauty, but there remains the question of why Stroemple adheres to Chihuly's art with such fervor.

Originally he collected nineteenth-century American painters and Japanese ceramics and bronzes from the Meiji era, but when, in his words, "prices on the really great things reach[ed] . . . unreasonable levels," Stroemple began to collect Chihuly. And he continued to collect Chihuly, amassing a huge number of works, as the exhibition confirms, which suggests that his motivation was more than economic. Indeed, Stroemple's collecting was more driven than rational: he "remembers getting up many times at 3 A.M. [during the summer of 1990] to drive to Seattle in order to be there by 6 A.M.," the hour when Chihuly and Lino Tagliapietra, "perhaps the greatest glassblower living today," began work. It is as though Stroemple wanted to be part of the collaborative process of glassblowing, if only as a witness— a silent, supportive partner, a kind of participant-observer. Clearly, he was seduced and fascinated, even mesmerized by the process as well as by the extraordinary glass works that embodied it. For Stroemple, collecting Chihuly meant establishing a working relationship with him, spiritually if not literally.

Why does Stroemple have such an intense transference to Chihuly's art? I think the answer has to do with the paradoxical relationship between the very material process of glassblowing and the very refined products that are its result, at least for Chihuly—the spiritual art that he is able to wrest from it, an art truly unique for its time. Chihuly's importance is all the greater because of the current decadence of modernism, in which craft and concept have gone their separate ways (the latter is usually held to be superior to the former, which is dismissed as unessential, beside the point of "thoughtful" art) and in which irony and cynicism have become de rigueur, as though to defend against the fact that standards and values have become unclear and contradictory to the point of chaos. It is a situation of "regressive desublimation," as George Frankl argues.[3] Chihuly's sublime, ripe, precious art restores the balance between craft and concept, seamlessly integrating

them, subverting cynical irony with its beauty. It stands apart from modernist decadence and infantilism like a beacon in the black sky.

Nonetheless, it has modernist roots: glass is a grand gesture, which Chihuly whips into hallucinatory form. Glass may be the last place in which the paradox of modernist gesturalism can make a stand; the last place in which gestural fluidity can produce dreamlike images; the last place in which, out of a fluid matrix emblematic of unconscious turmoil, a haunting image can emerge. Chihuly respects the meta-morphic potential of molten glass. He is sensitive to every last expressive nuance of its fluidity, even as he seems to let it run hot and wild. His forms seem to derive directly from its lability: there is nothing forced about them. They seem as organic and uninhibited and contingent, however definite, as the liquid material from which they are made.

The point is that such paradoxical gesturalism and the paradoxical character of the glassmaking process converge: the molten, "gestural" glass, with its unpredict-able, potentially explosive movement, like lava spewing from a volcano, represents instinct, while the finished glass product, with its ultrarefined form and aura of inevitability, symbolizes the ego that has mastered it. I think the miracle or magic—and I use these words without any attempt to mystify—of Chihuly's glass sculptures is that they seem so finished and polished and poised, and as such, ego orgasms, to borrow D. W. Winnicott's term, while the molten glass from which they are made seems so volatile and uncontrollable, and as such, id orgasmic. One can lose control of the raw instinctive material at any moment, but Chihuly remains in firm control, nursing the material to flexible, refined form. Chihuly's products are serene and balanced and lucid, while the process used to produce them is dangerous and uncertain and primordial. Indeed, it suggests "the simultaneous operation of the libido (the life principle) and the destructive urges (the death principle)," to use W. R. D. Fairbairn's words, while its products seem to reconcile them.[4]

"The essential elements of beauty are order, symmetry and definiteness," as Aristotle said, which is why, as W. R. D. Fairbairn writes, a thing of beauty always seems "intact, whole, complete, or perfect." Chihuly is the Hephaestus of glass. He constructs beautiful objects out of a fiery material, a literally inflammatory situation that could turn destructive at any moment. Authentic beauty, with its balance and lucidity and wholeness, and the sense that a process has been brought to a perfect conclusion, all its components integrated into a clear, transcendent unity, is rare in the modern world, and Chihuly has created it. I think Stroemple collects Chihuly's glass because it embodies beauty in an emotionally and physically ugly world. No wonder Stroemple was eager to engage Chihuly: the excitement of discovering beauty makes one want to fathom the primordial, risky process that produced it, all the more so because that process is emblematic of the psychic process of self-integration. Stroemple, in collecting Chihuly, recapitulates his own, and everyone's, emotional development, at least when its result is healthy, that is, when it produces a sense of wholeness and integrity, the ingredients of inner beauty.

The first works Stroemple collected embody this emotional idealism, with its intriguing mix of liberated instinct and strong ego. In *Payne's Grey Venetian #24* (1989; cat. no. 103), the vase represents ego strength, the putti—all seem to have Chihuly's puckish face, wild hair, and build—represent instinct. It is a perfect symbol of the emergence of Apollonian transcendence from Dionysian frenzy—

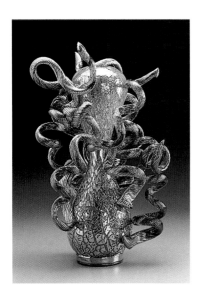

Olive Green Venetian with Blue Coils,
1989, h. 22 in., cat. no. 234

Attaching glass figure to *Gold Over Pale
Ruby Putti Venetian with Burgundy
Leaves,* 1994, cat. no. 243

a symbol of the creative process and its triumphant product. Like all of Chihuly's works, the sculpture seems imbued with light, seems to be made of light, sometimes displayed in the form of color, sometimes radiantly pure. Chihuly's glass holds light and fuses with it in a way that makes the glass seem immaterial and the light material.

The Venetians were inspired by "a group of rare Venetian art deco vases Chihuly first saw in 1987 at a palazzo in Venice and described as 'very odd, with garish colors.'"[5] Venetian Renaissance painting is characteristically a rich textural matrix of color glazes, unlike Florentine Renaissance painting with its almost astringent linear structure of schematic shapes. In Venetian painting, color is not filler but thoroughly saturates the surface, giving it body; it becomes a kind of voluptuous flesh, and brings with it a sense of inner light; such painting seems to emanate luminous color. In a sense, Chihuly's numerous Venetians, thoroughly saturated with color, are three-dimensional, modernist—late expressionist—Venetian paintings. But what is startling about them is the interplay of the vessel form, with its decisive shape and clear outline, and the colorful elements that flamboyantly curve around it. Two kinds of line are at stake, one belonging to the serene, soothing architecture of the self-contained vessel, the other the lush, ceaseless, uncontainable, almost manically elated line that curls or swirls around it. The relationship between them is implicitly sexual.

Thus, while hedonistic, richly textured, luxurious color is pervasive in all the Venetians, they are also imbued with erotic tension and excitement. The formal dialectic between the comparatively simple, stable rhythms of the implicitly domestic vessel form and the wild, intransigent tangle of the elements that dynamically and spontaneously emerge from it—sometimes like flowers bursting into exuberant bloom, as in *Cadmium Yellow Venetian with Red Lilies* and *Clear Venetian with Crimson Lake Birds* (both 1989; cat. nos. 231, 230), sometimes like festive ribbons, as in *Olive Green Venetian with Blue Coils* (1989; cat. no. 234), and sometimes like irrepressible vines, as in *Cadmium Yellow Light Venetian #340* and *Cadmium Orange Venetian #350* (both 1990; cat. nos. 97, 98)—is unresolved. Nonetheless, the forms are not incommensurate: they playfully engage, as though in foreplay to consummate intimacy. Thus Chihuly's Venetians are elegantly at odds with themselves—a dynamic of curves that tangentially touch, reflecting the "touchiness" of the pieces in general. This is exactly what makes them engaging and urgent. In a sense, Chihuly has caught the inspired, "organic," peculiarly bizarre "sexual" moment when form polymorphously emerges from the formless flow of molten glass, at the point when the emotional effort and physical energy of the glassblower has created an unexpected yet not unfamiliar shape, and has metaphorically embodied it in an "outburst" of nature. The glassblower is like God breathing life into inorganic matter; "inspiration," we may recall, archaically means "to breathe life into."

The elusive, erotic, creative moment of origin is crucial in the Venetians, and, I venture to say, in the Macchia and the expressionistic drawings as well. These seem more improvised and casual and informal than the Venetians, but that is deceptive: the moment of origin, half calculated, half impulsive, is evident in them also. Chihuly tries to capture and preserve this magical, liberating moment of coming-into-being in his restless, vibrant, luminous, color-charged biomorphic forms. This moment of creation—the moment when the pagan artist-god "stains" inanimate yet fluid matter with his breath, animating and bringing it to life (the Italian word *macchia* means

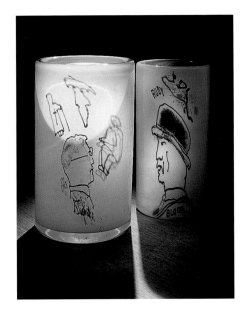
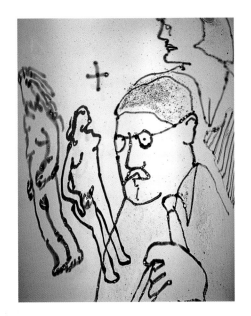
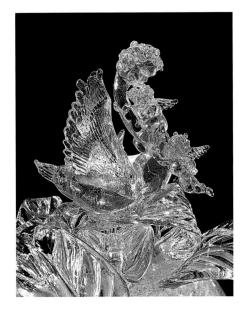
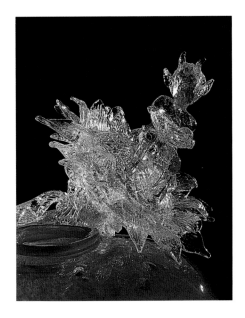

top left: Irish Cylinders (cat. nos. 13, 35)
top right: detail, *Irish Cylinder #44*, 1975, h. 10½ in., cat. no. 44
bottom left: detail, *Gilded Mystic Blue Putti Venetian with Swan and Cherubs,* 1994, h. 19 in., cat. no. 242
bottom right: detail, *Spotted Raspberry Putti Venetian with Devil On Sunflower,* 1994, h. 19 in., cat. no. 245

"stain," and the stain of color is the sign of life)—seems to obsess Stroemple, however unconsciously. It is the rationale for his collection and explains his choices: it is dominated by works that decisively suggest creative origination—works which for this alone are Chihuly's most original ones. (As mentioned earlier, Stroemple eagerly drove from Portland to Seattle in 1990 to witness such moments of origination, or raw creativity.) The flowery Venetians, large and small, are filled with the original breath of life, which the "puffy," impish, impulsive putti also represent, and the Macchia, bizarre vases that open like seashells, are in effect primordial creatures fresh from the ocean depths, and thus also close to the origin of life. Their eccentric concavity and convexity seem to embody the primitive in-and-out rhythm of breathing basic to all living things, including Chihuly's living art. Chihuly's forms may be idiosyncratic in appearance, but they have a clear and constant rhythm.

But Stroemple's collection also contains the Irish Cylinders, of 1975, which deal with all-too-human figures—a motley crew of characters and street scenes from James Joyce's *Ulysses.* The urban scenes and unhappy figures on the Irish Cylinders are a long way from the flamboyant, mythological, self-symbolizing, and self-dramatizing putti (at once demonic and angelic) of the happy Venetians. The

mythological cast of Chihuly's more recent works, such as *Spotted Raspberry Putti with Devil on Sunflower* and *Fountain Green Putti with Gilt Leaves and Centaur* (both 1994; cat. nos. 245, 247) as well as the vivid grandeur of the *Laguna Murano Chandelier* (1996–97; cat. no. 311), which are, in effect, toasts to life, make a particularly telling contrast with the starker, even barren, and smaller images on the Irish Cylinders. (There are of course a few ribald scenes among the Irish Cylinders, as one might expect from the life-affirming, pleasure-seeking Chihuly. They are clearly derived from those in *Ulysses*, but much less grim and morbid.) The relative plainness, modesty, economy, and colorlessness of the Irish Cylinders seem far removed from the brilliant colors and baroque abundance of the complicated Venetians' excesses. The words of the Irish Cylinders have been replaced by the body language of the Venetians, which seem to have a richer vocabulary and more subtle syntax. The distance from flat schematic figures to surging, expansive flowers seems unbridgeable: it is hard to imagine that the same artist made such different groups of works. In their un-adorned, relatively naked state, visual uneventfulness, and lack of sensuous color and texture, as well as their use of a simple vessel, whose identity is not threatened as it is in the Macchia, the Irish Cylinders certainly seem far removed from the "total freedom in the use of color and experimentation"—the sheer creativity that went into their making, and the brilliant, jewellike color—that attracted Stroemple to the Venetians and Macchia.

And yet the Irish Cylinders remind us of, and are in a sense the remainder of, Chihuly's early conceptual, experimental phase. Their integration of text and object was innovative—a radical gesture at the time, and an important step in Chihuly's development of avant-garde glass. They also remind us that glass vessels are made for human use; they have an instrumental value. The Irish Cylinders can hold flowers—the flowers that are represented and integrated into the vessel, sometimes springing from it irrepressibly, in the Venetians—and some of the smaller ones seem to be drinking mugs (one wonders what their volume is). More to the point, perhaps, is that the Irish Cylinders are, in Stroemple's words, "a very special body of work that had never really been seen outside of Dale's staff." They were quite private, fraught with personal meaning. Chihuly made them with Seaver Leslie and Flora Mace at the Rhode Island School of Design over the 1975 Thanksgiving holiday. A year later Chihuly and Leslie tried to find a venue for them in England or Ireland. During this trip, they were involved in an automobile accident; Chihuly lost the sight in his left eye and required 250 stitches in his face. No wonder they were so meaningful for Chihuly, and no wonder Stroemple had to posses them—when he saw them all together for the first time, after they had been in storage for a decade and a half, he recollects that his "heart was just pounding and [he] was mesmerized by them for a good thirty minutes," and so it is no wonder there was "a very emotional negotia-tion" with Chihuly for them. They were an important—and repressed—piece of Chihuly's personal and professional history, which is why, although they were "not as visually stunning" as the Venetians, Sea Form, and Basket sets they were displayed next to, "there was something magical" about them.

To possess them was in some way to possess the essence of Chihuly—to merge completely with him, to become part of his history by appropriating an important part of his personal history. It would make Stroemple's relationship with Chihuly even more intimate than it already was: he could now own early as well as late Chihuly —the Chihuly he knew and the Chihuly he didn't know. Stroemple had come full

circle, from the Chihuly of today to the Chihuly of the past. It was the collector's dream come true: he knew Chihuly from the inside, not just through his works. Chihuly had once been as human and desperate and hurt as the figures on the Irish Cylinders, not just the brilliant, successful artist of today. In claiming the Irish Cylinders for himself, Stroemple stripped Chihuly of his defenses and forced him to face his past and history, especially the traumatic memory of almost dying—I think this is why the "negotiation" between them was particularly "emotional"—but he also liberated Chihuly from the painful past. Stroemple was finally entrusted with the works—a measure of Chihuly's belief in him, reciprocating his belief in Chihuly, and a confirmation of the strength of their friendship—but in acquiring them, he also purged Chihuly of his past, which always looks unoriginal in retrospect, and thus permitted him to be all the more creative and original, that is, to stay fresh, which is ultimately what his works are about. Thus collecting benefits the artist, for it relieves him of his past, leaving him open to the future. It also gives the collector a future, for his name, associated with that of the artist, will be part of his posterity. Above all, it will stand for a courageous perception of human and aesthetic value, and their inextricability. It will stand for a critical commitment rather than blind adulation, which is, after all, what every artist wants.

notes

1. Joyce McDougall, *Plea for a Measure of Abnormality* (New York: Brunner/Mazel, 1992), p. 481.

2. Marcel Duchamp, "The Creative Act," in *The New Art,* ed. Gregory Battock (New York: Dutton, 1973), p. 47.

3. George Frankl, *Civilisation: Utopia and Tragedy* (London: Open Gate, 1992), p. 173.

4. W. R. D. Fairbairn, "The Ultimate Basis of Aesthetic Experience," *International Journal of Psycho-Analysis* 28 (1938): 179.

5. Patterson Sims, *Dale Chihuly: Installations 1964–1992* (Seattle: Seattle Art Museum, 1992), p. 13.

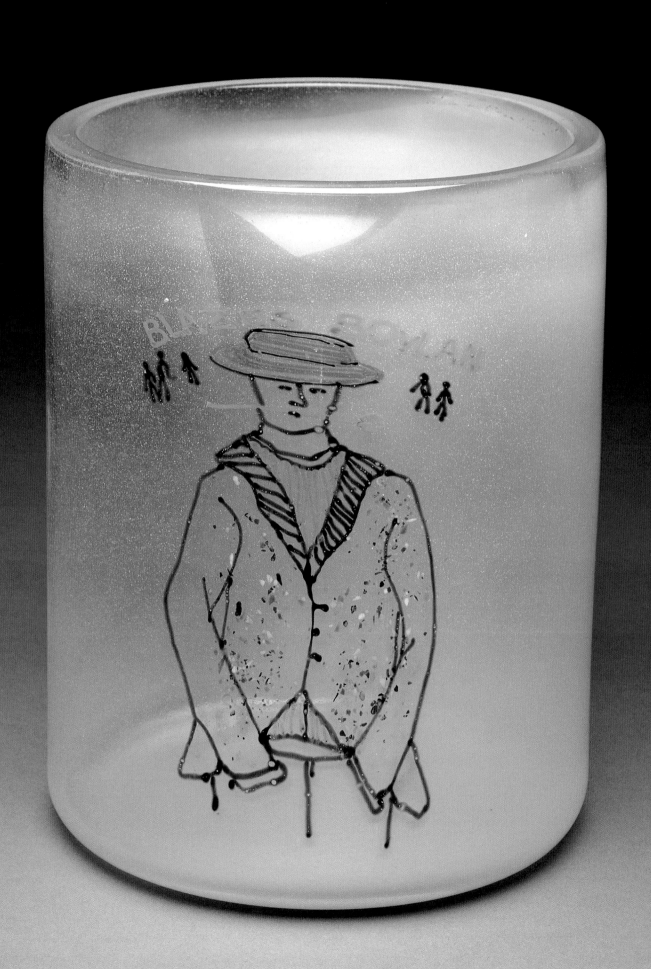

Glass Without Limits

by Kathryn Kanjo

Since he first wove strips of glass and thread into an unlikely wall
hanging, Dale Chihuly has revolutionized the world of glass. Confounding the art
establishment in his creative oscillation from installation to object and back to
installation, Chihuly has made an oeuvre that seems to defy categories. He works
in series that are not strictly sequential, but which frequently recur. What remains
consistent is his concern with process, collaboration, control, and its partner, lack
of control. Chihuly thrives on the edgy balance of calculation and chance that is
inherent to glassblowing.

Chihuly's earliest, ill-informed experience with glass involved melting down
old bottles in his Tacoma, Washington, basement in 1961. Five years later he entered
the newly formed glass program at the University of Wisconsin under Harvey
Littleton, an innovator of American glass. After receiving his degree from Madison,
Chihuly continued his glass studies at the Rhode Island School of Design (RISD).
Upon graduation he wrote numerous letters to Italian glass factories, asking permis-
sion to apprentice. Yet if Littleton set out to spread the word of glass, Italy, the home
of glass, made every effort to contain it. After sending more than a hundred letters,
Chihuly received only one reply, an invitation from Ludovico de Santillana, of the
prestigious Venini Factory. On a Fulbright Fellowship, Chihuly traveled to Italy in
1968. There he learned the studio concept of glassblowing, in which a team of
master craftspeople work together on a single piece. This collaborative approach
became the foundation of the Pilchuck Glass School, which Chihuly cofounded in
1971 with John Hauberg and Anne Gould Hauberg. Pilchuck, now twenty-five years
old, continues to be the pulse-point of contemporary glass production.

Chihuly pursued the study of glass after first studying architecture and interior
design. RISD encouraged a cross-disciplinary approach, and Chihuly remains a bit of
a hybrid, working a craft medium to fine-art effects. Many of his works suggest, but
ultimately subvert, function. Attending art school in the late 1960s, Chihuly came of
age under the spell of "process art," or "postminimalism." With this movement,
artists pursued the expressive potential of a range of media, including lead, plastic,
vinyl, and fabric. Organic composition and the mark of the hand distinguished these

facing: *Irish Cylinder #38*, 1975, h. 10 in.,
cat. no. 38

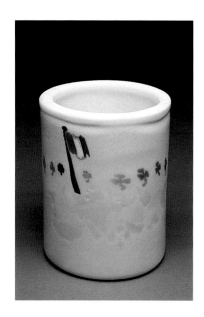

Irish Cylinder #4, 1975, h. 8½ in., cat. no. 4

works from the industrial order of minimalism. For Chihuly the material was glass—glass without limits. Chihuly's earliest experiments with blown glass resulted in biomorphic forms, attenuated bubbles—thin and tenuously lit with coursing, garish neon. While his often-cited accurate photo documentation acknowledges that glass comes to life when properly lit, it also reflects the artistic spirit of "process," that art can be transient, an event that occurs and disappears. Of his earliest glass environments, he had "no possessive instinct." He was interested in their production and presentation, not preservation.[1] By pursuing and developing glassblowing, Chihuly has carried these then-radical art views through to his current working practices. The hot shop is itself an event, tightly choreographed but vulnerable to chance. From this collaboration of gaffer and assistants, the glass lingers seductively, evidence of the action: proof.

George Stroemple began collecting proof of Chihuly's talent in 1990. The Stroemple Collection now numbers over five hundred objects, the largest holding of Chihuly's work. It is both massive and specific. Spanning over twenty-five years, the collection concentrates on select bodies of Chihuly's work. Collecting with rigor and thoroughness, Stroemple has focused on the Irish Cylinders, the Macchia, the Venetians, and the drawings. Chihuly often notes the imperative to be prolific in glass production—an experimental quality lingers in glass, and only through production can progress be made. Just as Chihuly creates, so does Stroemple collect. Through abundance and variation, the Stroemple Collection celebrates Dale Chihuly's vision: it celebrates his art.

The earliest works in the Stroemple Collection, the Irish Cylinders, were acquired much later in the collector's relationship with Chihuly. Created in 1975, all forty-four works carry the name Irish Cylinders, although the works are frequently referred to by three subcategories: Saint Patrick's Day Cylinders, Irish Cylinders, and Ulysses Cylinders. They were blown in the United States prior to Chihuly's 1976 trip to the British Isles. In England, en route to Ireland, Chihuly was involved in a devastating auto accident that left him blind in one eye. Chihuly briefly exhibited the Cylinders at the Benson Gallery, Bridgehampton, New York, in the summer of 1976,[2]

below left: Seaver Leslie preparing *Irish Cylinder #2* (cat. no. 2)
below middle: Prepared drawing for *Irish Cylinder #2* (cat. no. 2)
below right: Flora Mace preparing *Irish Cylinder #15* (cat. no. 15)

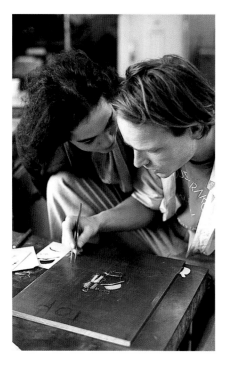
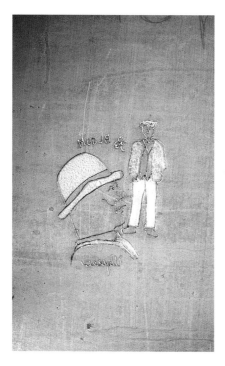
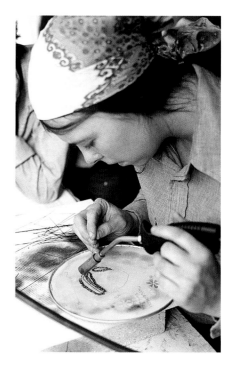

but then placed the series in storage. Only some twenty years later did he revisit the works and ultimately agree to sell them as a group to Stroemple.

For Chihuly the cylinder was a neutral foil for rudimentary yet expressive line drawings. Averaging 10 inches high and ranging in diameter from 4 to 9 inches, the forms illustrate Irish motifs and folk tales as well as passages from James Joyce's *Ulysses*. Minty and milky, the Cylinders vary in opacity. Some are more glassy, more like a glass—a historical beaker or *Humpen*; others are less transparent, more surface—a canvas for the glass-drawn scene. Blown entirely by Chihuly, the Cylinders were begun with Kate Elliot and Flora Mace on Saint Patrick's Day in 1975. These earliest Irish Cylinders featured shamrocks and flags amid glassy white clouds (*Irish Cylinder #4, #6, #7, #8, #33*; cat. nos. 4, 6, 7, 8, 33). Chihuly completed the series over the Thanksgiving holiday at RISD with Seaver Leslie and Mace. Chihuly concentrated on the folk tales, often mapping diagrams of rock formations, while Leslie focused on the Joycean portraits and street scenes.

Made with the glass-drawing pick-up techniques developed at Pilchuck, the Irish and Ulysses Cylinders are closely related to the more abstract Blanket Cylinders of 1974. Formed of glass threads, the detailed drawings were composed in reverse on smooth hot plates primarily by Mace. After the final gather for each form, the glass cylinder, while still molten, was rolled over the composed drawing. When successful, the process fused the image into the surface of the cylinder, which was then finished. When the process was not successful, the contact shattered the glass threads, destroying the effort.

While the Irish Cylinders capture a sense of the country's terrain, the Ulysses Cylinders keep time with the action from the epic and the facts surrounding Joyce's book. Published in 1922, the more than seven hundred pages of *Ulysses* recount the occurrences of a single day in the city of Dublin's ordinary life. Beginning at 8:00 A.M. on Thursday, June 16, 1904, the novel documents *Odyssey*-like wanderings in then-contemporary Ireland and concludes eighteen hours later. The simple portal on *Irish Cylinder #40* (cat. no. 40), inscribed with the date "Thursday, JUNE 16,

1904," and the depiction of the martello tower and Sandymount on *Irish Cylinder #11* (cat. no. 11) set the stage for the novel's action. Leopold Bloom, the story's protagonist, is shown on *Irish Cylinder #2* (cat. no. 2); his wife's suitor, Blazes Boylan, is jauntily rendered—an orange flower in his mouth—on *Irish Cylinder #38* (cat. no. 38). Stephen Dedalus, the author's alter-ego and Bloom's "son," is simply rendered in profile on *Irish Cylinder #13* (cat. no. 13).

Chihuly depicts Joyce himself on many of the cylinders. On *Irish Cylinder #30*, and *Irish Cylinder #31* (cat. nos. 30, 31), schematic contour drawings resemble Joyce and his familiar bespectacled portrait by Constantin Brancusi. Ironically, failing vision plagued Joyce throughout his life, and on *Irish Cylinder #31*, inscribed "ULYSSES," a series of floating eyes covers the vessel. Another portrait commemorates Sylvia Beach (*Irish Cylinder #14*, cat. no. 14); through her Paris bookstore, Shakespeare and Company (*Irish Cylinder #37*, cat. no. 37), Beach published the controversial novel on February 2, 1922—Joyce's fortieth birthday. Previously serialized in two different literary magazines, the novel had been declared unintelligible and obscene. Chihuly cheerfully renders one such controversial scene: the evening meeting of Leopold Bloom and Gerty MacDowell on the Sandymount strand, a Dublin resort (*Irish Cylinder #26*, cat. no. 26). Inscribed "8:00 P.M.," the composition corresponds to the hour in the novel when, during a fireworks show, MacDowell reveals her "nainsook knickers" to an observant Bloom.[3]

In the late 1970s and early 1980s, Chihuly's interest increasingly moved from surface illustration toward a more complete integration of surface and form. In the Stroemple Collection, the literary spirit of the Irish and Ulysses Cylinders is followed by the formal explorations of the Macchia. Begun at RISD in 1981, with William Morris as gaffer, the series appears after the gravity-pulled Baskets—inspired by the appearance of an array of Native American baskets—and the diaphanous Sea Forms. A startling contrast to the translucent purity of the Sea Forms, the Macchia emerged as exuberant amalgams of color and surface. With the Macchia, Chihuly set out to explore all possible combinations from the hot shop's three hundred–plus palette of glass rods. If systematic in his drive to explore all combinations, the results were spontaneous and unpredictable. Chihuly recalls a similar exercise with a set of watercolors on a cross-country train trip. The sixty-hour ride resulted in thousands of combinations; as Chihuly confesses, "I'm obsessed with color—never saw one I didn't like."[4]

Initially quite small, the Macchia grew in size and, like earlier works, were amassed into groupings or "families." Stroemple's Macchia occur early in the series that Chihuly would elaborate into increasingly large-scale objects. Averaging 10 inches in diameter, the early Macchia retain the intimacy of things held in the hand. Like geological nuggets, the Macchia are jewellike in form and color. Their puffed shapes ripple and clearly show the process of their creation, the process of glassblowing. Swollen vessels, they seem to hold a single breath. Their ruffled edges pay an off-kilter homage to the 1950s' handkerchief vase, or *vaso fazzoletto*, of the Venini Factory, and abutted color cells recall the early mosaic or dappled vessels from Rome of the first century A.D. While Chihuly works with awareness of art and design history, "the series inspired itself."[5]

The word *macchia* has many art historical connotations, from the Renaissance term for an improvisational drawing to the nineteenth-century meaning for the idea that becomes an artist's sketch.[6] Chihuly hit upon the title after asking his friend the

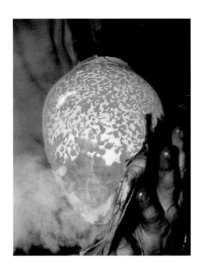
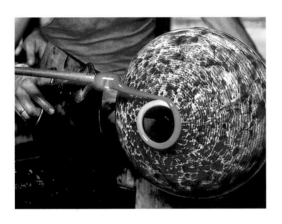
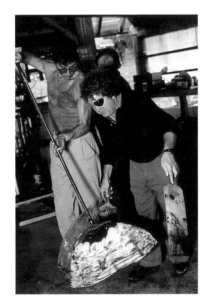
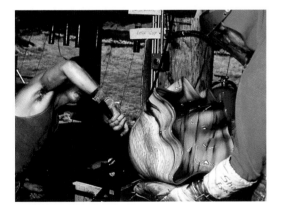

top left: rolling the bubble of hot glass through a bed of white glass chunks
top middle: applying the "jimmies," pulverized colored glass
top right: forming the molten glass
middle left: applying the "lip wrap"
middle right: William Morris and Chihuly finishing the form
bottom left: putting the piece into the annealing oven, a controlled temperature environment

artist Italo Scanga for the Italian word for spotted or stained. The Macchia's spotted and layered colors do not seamlessly integrate into a smooth uniform surface, but rather show their chemical differences. They hold together, but with slightly uneven ridges, like an applied paint surface. Technically confounding, the Macchia seem to disregard the differences between color—how each color attracts and holds heat differently, fires differently. Chihuly's combinations shouldn't work, but they do. His trial-and-error innovation results in unlikely color combinations. Chihuly's mother initially referred to the group as the "uglies," unimpressed by their technical bravura and not yet seduced by their daring compositions. Yet for Chihuly, the Sea Forms had "reached a point of elegance" that could not be taken any further; with the Macchia he introduced "more complexity and a grotesque quality. The contrast will make you look for beauty."[7]

In his earliest works at RISD, Chihuly created an interplay of color, light, and transparency by incorporating the pulsing current of neon into blown glass forms. With the Macchia, Chihuly achieves a similar effect through traditional lighting. Light animates the multilayered and multicolored Macchia to a dichotic effect. With a complex exchange of color, opacity, and transparency, the Macchia simultaneously emphasize interiors and exteriors.

Starting with a molten bubble of clear glass, Chihuly rolls the Macchia form over white glass chunks or "clouds." The form is next rolled over pulverized colored glass, or "jimmies," which, when returned to the furnace, fuse with the form. A colored "lip wrap" may be applied before the form is finished. The final shaping occurs thorough breath, gravity, and centrifugal force, hallmarks of much of Chihuly's work. By adding the layer of white to the molten glass, Chihuly separates the interior from the exterior. He recalls viewing a stained glass window that was partially blocked by a white building. It struck him how the exposed sky dulled the intensity of the pigmented glass.[8] In the Macchia, the "clouds" form a veil isolating the vessel's vibrant colors.

By 1988, Chihuly had turned his attention more directly to the Italian glass legacy, as he embarked on the Venetian series. Inspired by a collection of Italian art deco glass from the 1920s, Chihuly invited master glassblower Lino Tagliapietra to serve as gaffer for a new body of work. Although Tagliapietra had visited Pilchuck before, he and Chihuly had never worked collaboratively. For the Venetians, Tagliapietra followed Chihuly's designs, which paid tribute to the art deco forms. In one respect, the influence of Venice—the center of glass production since the Renaissance—lingers in all of Chihuly's work. Venetian glass practice was historically veiled in secrecy. A Grand Council decree in 1292 confined all glass houses to the nearby island of Murano, ostensibly to protect the city from the threat of fire. This decree kept the industry sealed and, in turn, controlled the commerce.

During his 1968 residency at the Venini Factory, Chihuly came to fully understand the Italian studio concept of glassblowing. But he left another trait of Venetian glass—its symmetry—in Italy. Throughout the 1980s, Chihuly had thoroughly established his style with swelling, irregular forms, from the Baskets and Sea Forms to the Macchia and Persians. Whether spinning outward or collapsing inward, the work admitted the pull of gravity on the process of glassmaking. While the Venetians struggled to conceal the process under refined order, Chihuly instead embraced the raucous energy of the molten glass.

Chihuly alters this sensibility in his Venetians. The period between World Wars I and II, which served as Chihuly's inspiration, was a fertile moment in Italy's glass history. Following a spate of revival and tourist-driven styles, many of the quality glass houses, including Venini Factory and Artisti Barovier, embarked on new designs. These objects paid tribute to the glass forms illustrated in Renaissance paintings, yet were infused with a modernist sensibility. Function and design join in these mannered, modern objects. These art deco examples are historically sensitive yet entirely individual. Here was an earlier version of Chihuly's own working method. These works can be readily identified by their creators: Ercole Barovier, Tommaso Buzzi, Napoleone Martinuzzi. Likewise Chihuly's tribute to these designers remains his own. For a Chihuly series, whether devoted to Joyce, baskets, or art deco glass, always yields an abstraction of the actual thing—a nod to, not a replication of.

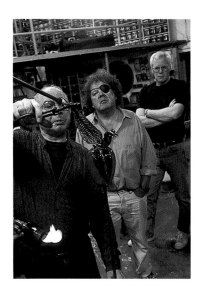

Lino Tagliapietra, Chihuly, and Stroemple with *Sandalwood Piccolo Venetian with Spotted Green Leaves* (cat. no. 216)

Like their art deco prototypes, a sense of function endures in Chihuly's Venetians. The core forms—cones, cylinders, amphorae, bowls, ginger jars—suggest familiar vessels. Yet if vessels imply reason, Chihuly's applied ornamentation overwhelms in an organic flourish. The symmetrical core becomes a stoical base from which feather, leaves, and ribbons burst forth. Handles spiral into disorder; lilies entwine exterior surfaces; glass prunts transform into scalloped flames. Iridescent, foiled, layered, and mottled, both the vessel and the ornament boast active "Chihuly" surfaces.

Dramatic scale-play further distinguishes Chihuly's tributes from their sources. Averaging 24 inches in height, the Venetians achieve a startling presence. In *Black Venetian with Golden Ochre Leaf* (1990; cat. no. 238), which stands over 3 feet tall, a shimmering stem coils an attenuated vase with coy asymmetry. Such scale not only magnifies the difficulty of the object's execution, but increases its sculptural identity. Yet the Venetians also hold a powerful sense of design, which carries regardless of their size. In the Piccolo Venetians, Chihuly literally scales back. Ranging in size from 5 to 12 inches, the Piccolos afford a greater freedom in production. In this collection of immediately identifiable "Chihuly Venetians," the artist freely experiments with his recurring interest: abundance and variation.

On several historic occasions, Chihuly brought together two of the most respected contemporary Italian glass masters for joint blowing sessions: Lino Tagliapietra, celebrated for his blown forms, and Pino Signoretto, a master of sculpted glass form. The first object they created, *Payne's Grey Venetian #24* (1989; cat. no. 103), reveals both artists' talents. A fluid vessel rises up and is held aloft by a ring of putti on a sculpted glass cloud. Tonal and attenuated, *Payne's Grey Venetian #24* is notably more contained than the riotous works that followed. At a glance, the subsequent works, rendered in bright pastels and sheer gold, are elegant objects of refinement. A closer look, however, reveals the shimmering shapes as arcing stages for cavorting putti, birds, dragons, and devils. In one mischievous narrative, a yellow-beaked swan perches on the belly of a leaf-cradled putto (1991; cat. no. 236); in another, athletic putti scale the neck of a cherub-headed swan (1994; cat. no. 242). These odd tableaux grow in size in Stroemple's three Stopper pieces (all 1994–97; cat. nos. 308, 309, 310). In these oversized works, Signoretto-shaped glass—putti, flowers, a dragon, and a single hand—sit atop pneumatic vessels. Like ornate perfume bottles taken to a monumental extreme, these thick-and-thin sculptures achieve a surreal balance of delicacy and abandon.

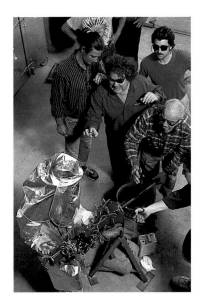

Lino Tagliapietra, Chihuly, and crew with *Cobalt Blue Venetian #410* (cat. no. 106)

bottom left: Chihuly, Pino Signoretto, Lino Tagliapietra, and crew with *Gold Over Fountain Green Putti Venetian with Leaves and Dragon* (cat. no. 244)
bottom right: Chihuly, Pino Signoretto, and crew with *Stopper (Putti and the Dragon)* (cat. no. 309)

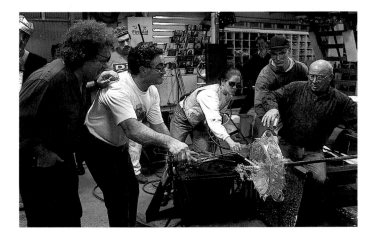

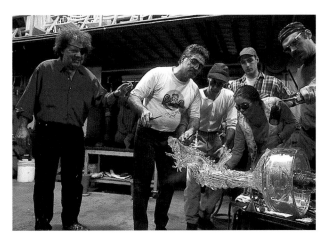

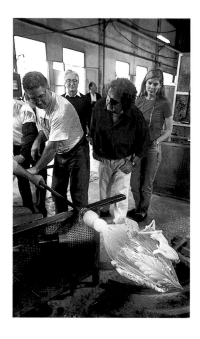

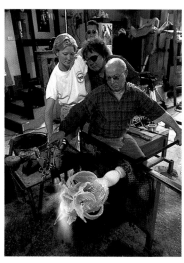

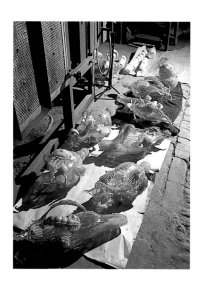

In *Blue Seascape Venetian with Four Putti* (1991; cat. no. 237), golden cherubs riding marine creatures float atop cresting waves of glass. This curious scene becomes a precursor to the seafaring forms blown by Signoretto and Tagliapietra during their most recent collaboration on the island of Murano, in September 1996. This blow occurred at the conclusion of Chihuly Over Venice, a multiyear, multicountry glass-blowing exchange. Chihuly conceived of the project as an international collaboration between his United States–based glass team and four countries with strong glass-blowing traditions: Finland, Ireland, Mexico, and Italy. Beginning in 1995, Chihuly traveled to the four countries and collaborated with the artists there, creating a series of Chandeliers. Composed of hundreds of individual elements, the Chandeliers were ultimately hung in fifteen sites throughout Italy. Signoretto and Tagliapietra blew ornamental elements for the final Chandelier at Vetreria Signoretto, Murano, in September 1996. The work, *Laguna Murano Chandelier* (1996–97; cat. no. 311), was not exhibited in Italy and, in fact, was only completed later in Seattle at The Boat-house, Chihuly's studio.

Chihuly initially began his Chandelier series after seeing a traditional Venetian chandelier hanging low over a dining room table. Brought to eye level, the chandelier suggested new sculptural possibilities to Chihuly. He then embarked upon a series of composite sculptures to be suspended overhead. In their latest incarnations, the Chandeliers are not confined to a single point of suspension or any set formation. Indeed, the *Laguna Murano Chandelier,* now in the Stroemple Collection, both hangs from the ceiling and sits on the floor. Greenish clusters of curling glass reach up from the ground, and similar bundles hover overhead. Nested within the spiky reeds are flesh-hued pods. Adorned with sharks, scallops, and other sea creatures, the objects hark back to *Blue Seascape Venetian with Four Putti.* Again, Chihuly pumps up the scale: what was once a small tableau is now a room-sized environment. In the Venetians, transparency leads the eye through the object's composition; here an actual passage invites physical interaction. A complex assemblage, *Laguna Murano Chandelier* presents an accumulation of examples, a collection in a single installation.

Linda Norden connects Chihuly's renaissance of drawings to a "new objectiv-ity" necessitated by his accident. Always a collaborator, Chihuly's role as a director became more pronounced following the accident. While these "gestural maps for working moves"[9] can often be directly linked to finished works, they are composi-tions in their own right. Like his glass, Chihuly's drawings seem to capture a state between fluid and fixed. In the early Macchia drawings, Chihuly spins handfuls of graphite and colored pencils, like the gaffer's rod, to create a field of floating forms. The pencils' many colors, like the hot shop's palette of hues, join into speckled clouds that are given shape by more definitive contouring strokes. The frenetic punch of the pencil points is countered by the fluid washes of color. Using the hot shop's blowtorch, Chihuly simultaneously dries, singes, and stains wet passages, as in *Basket Drawing,* 1983 (cat. no. 338).

With the Venetian drawings, Chihuly covers entire surfaces with streams of acrylic paints. Mixed wet on wet, the drawings hold on to the fluid process of their creation, just as glass, a supercooled liquid, seems to retain a sense of its molten past. While the Macchia drawings often capture groups of forms in motion, like airborne creatures dripping through space, the Venetian drawings fill the page, centered and iconic. Just as the Venetians are themselves more frontal and in some way fixed, so too are the drawings. The Danish Ebeltoft series of drawings (1991)

facing, top: Pino Signoretto and Chihuly in Vetreria Signoretto, Murano, Italy, September 1996
facing, middle: Lino Tagliapietra, Chihuly, and crew
facing, bottom: Completed forms for *Laguna Murano Chandelier* (cat. no. 311)
left: Chihuly working on a Macchia drawing

shows Chihuly working in dimensions up to 50 by 70 inches. Primarily green, peach, and purple, the drawings suggest blooming botanical studies. In *Seoul Venetian Drawing* (1990; cat. no. 346), an oversized composition on traditional mulberry paper, Chihuly incised lines into a thick field of silvery paint. The channeled mark serves double duty, as both a flattened and a raised line. Sumptuously pigmented and often iridescent, the Venetian drawings reflect the baroque spirit of their glass namesakes.

On paper or in glass, Chihuly captures process and motion. Indeed, Chihuly himself is in continual motion. In turn his work reflects thematic and stylistic shifts that range from the literary to the abstract, from the historical to the uncharted. Throughout these changes, Chihuly maintains a keen interest in mining the territory of the expressive power of glass. Through production and experimentation, Dale Chihuly has arguably produced the most influential body of contemporary glass art. And through commitment and discernment, George Stroemple has collected it. Spanning twenty-five years of Chihuly's career, yet concentrating on select series of objects, the Stroemple Collection is at once retrospective and idiosyncratic. It offers a unique opportunity to survey the artist's restless investigation of the structural and thematic limits of glass.

notes

1. Patterson Sims, *Dale Chihuly: Installations 1964–1992* (Seattle: Seattle Art Museum, 1992), p. 26.
2. Jean Libman Block, "Exhibitions," *Craft Horizons* 36, no. 5 (Oct. 1976) p. 56.
3. James Joyce, *Ulysses* (New York: Vintage International, 1990), p. 366.
4. Robert Hobbs, *Chihuly alla Macchia* (Beaumont, Tex.: Art Museum of Southeast Texas, 1993), n.p.
5. Ibid.
6. Ibid.
7. Linda Norden, *Chihuly: Glass* (Pawtaxat Cove, R.I.: Dale Chihuly, 1982), p. 17.
8. Hobbs, *Chihuly alla Macchia,* n.p.
9. Norden, *Chihuly: Glass,* p. 15.

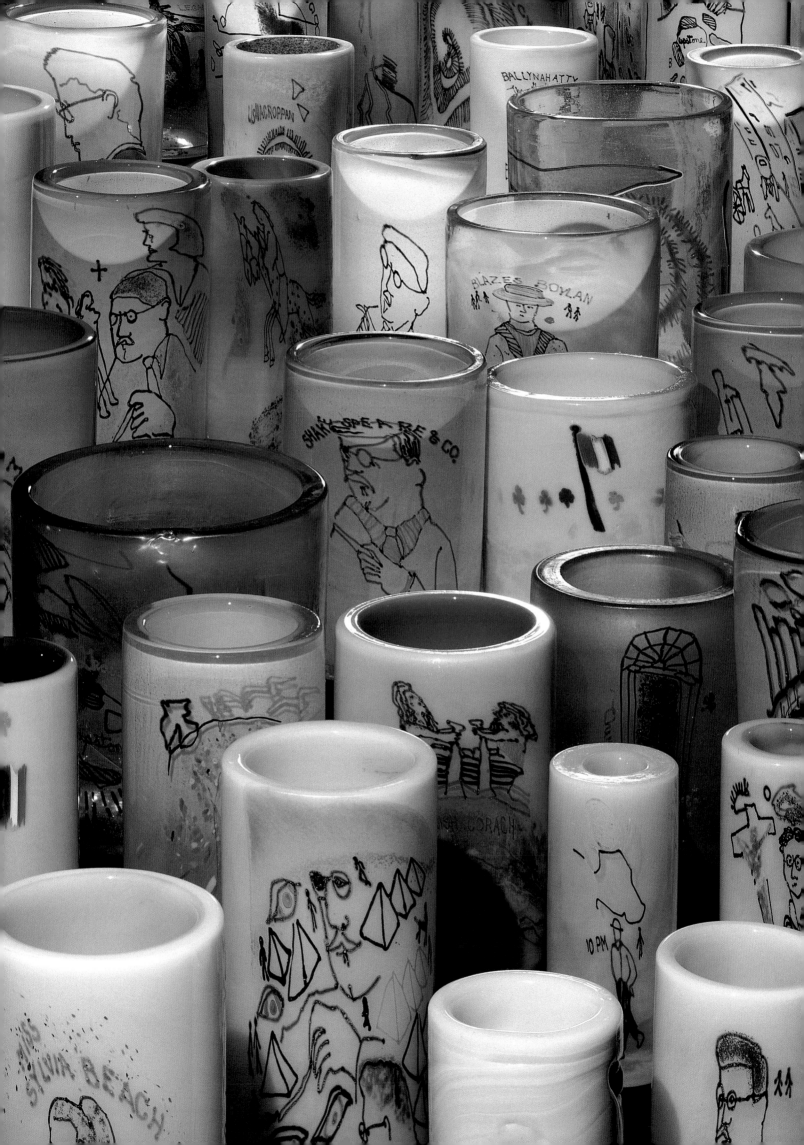

facing: Irish Cylinders
top left: *Irish Cylinder #6*, 1975, h. 6½ in., cat. no. 6
top right: *Irish Cylinder #7*, 1975, h. 8½ in., cat. no. 7
bottom left: *Irish Cylinder #8*, 1975, h. 7½ in., cat. no. 8.
bottom right: *Irish Cylinder #33*, 1975, h. 11 in., cat. no. 33

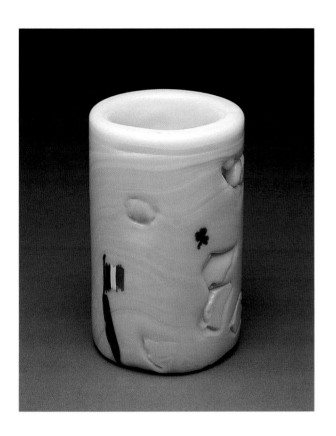

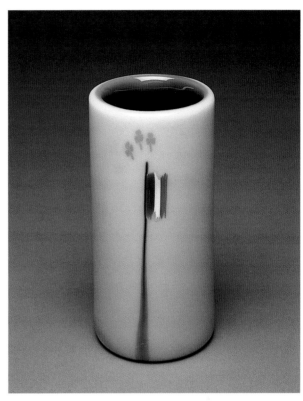

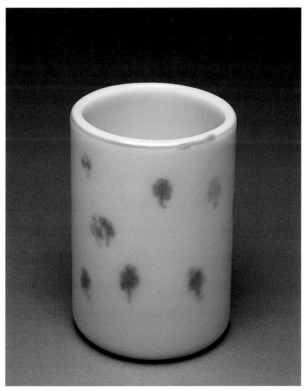

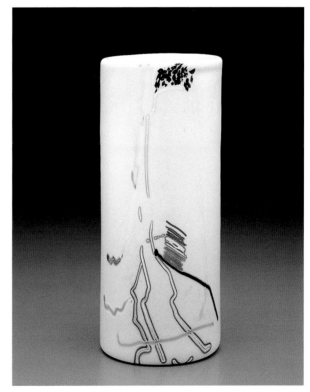

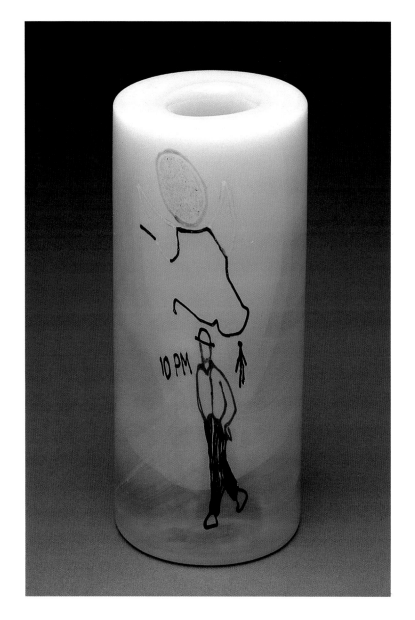

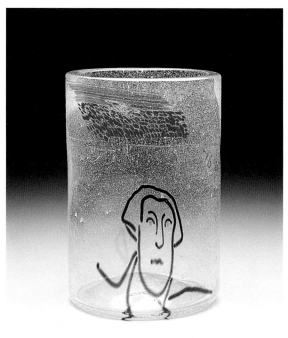

top left: *Irish Cylinder #17*, 1975, h. 7 in., cat. no. 17
top right: *Irish Cylinder #42*, 1975, h. 9½ in., cat. no. 42
bottom left: *Irish Cylinder #11*, 1975, h. 9½ in., cat. no. 11
bottom right: *Irish Cylinder #26*, 1975, h. 9 in., cat. no. 26
facing: Irish Cylinders (cat. nos. 30, 31, 13, 35, 29)

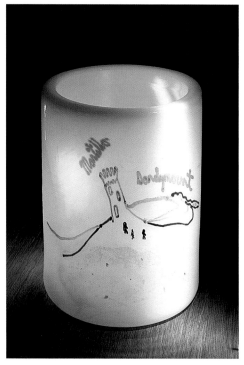

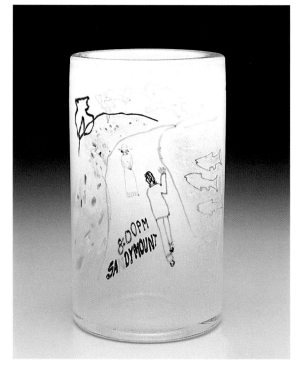

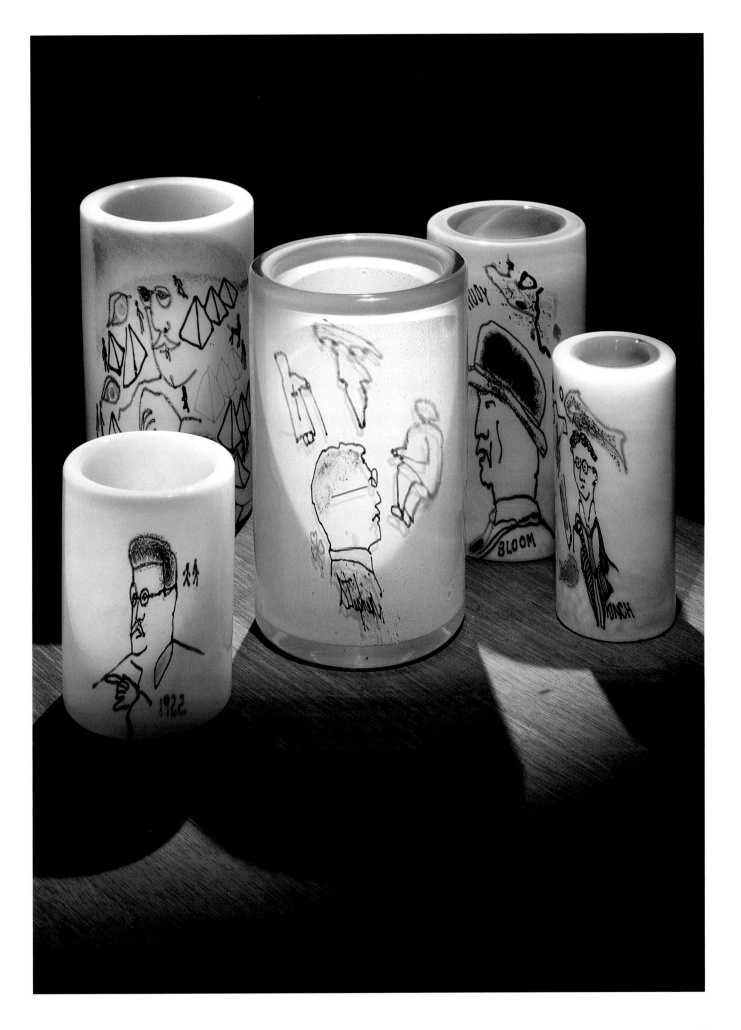

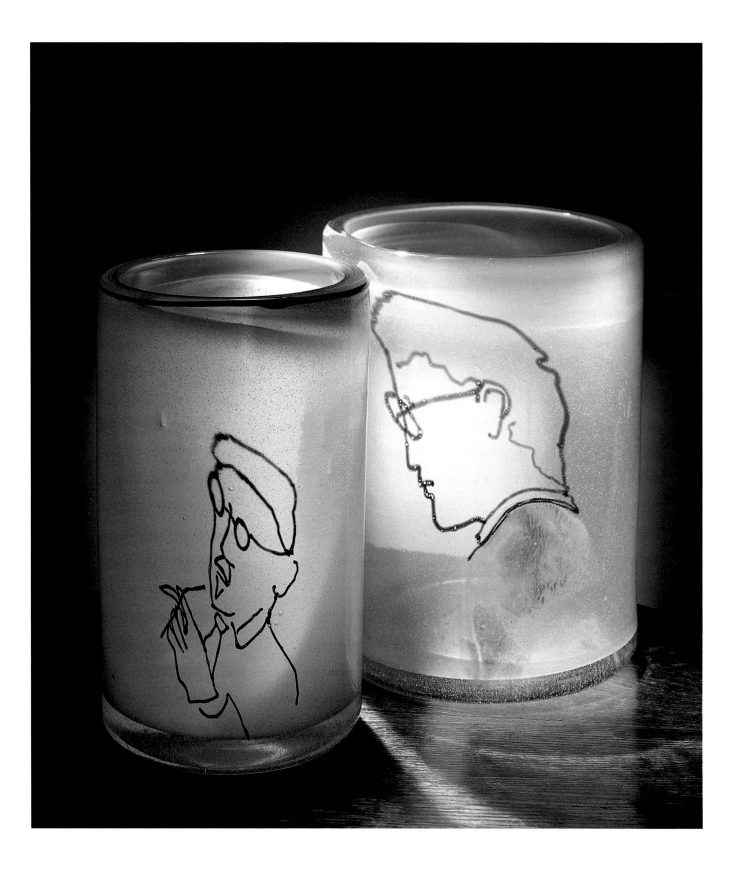

above: Irish Cylinders (cat. nos. 43, 41)

facing, top: Irish Cylinders (cat. nos. 16, 18)

facing, bottom: Irish Cylinders (cat. nos. 19, 12)

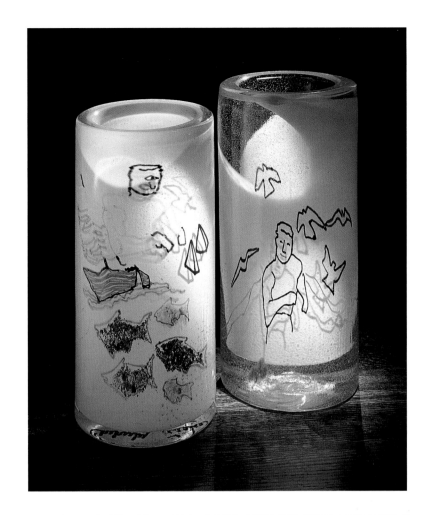

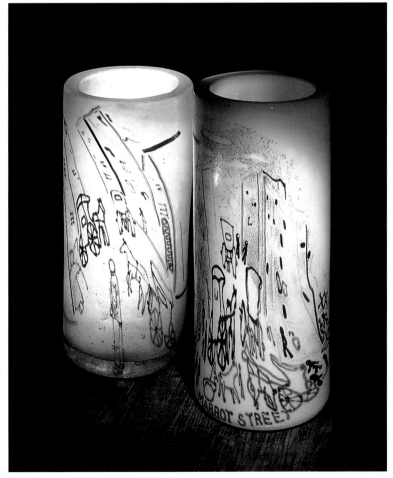

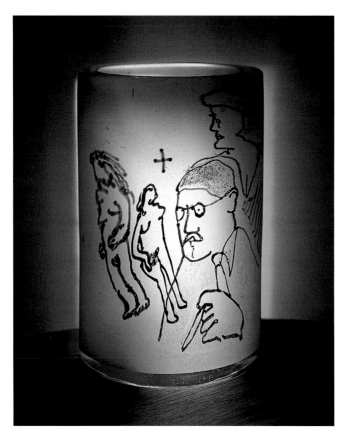

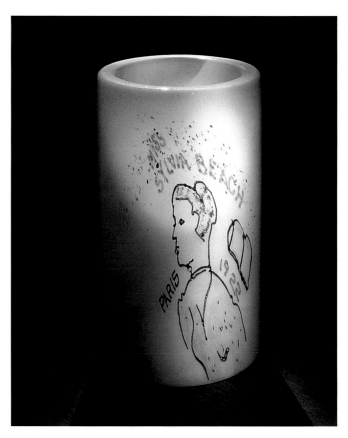

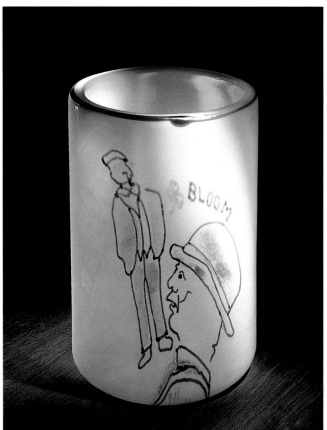

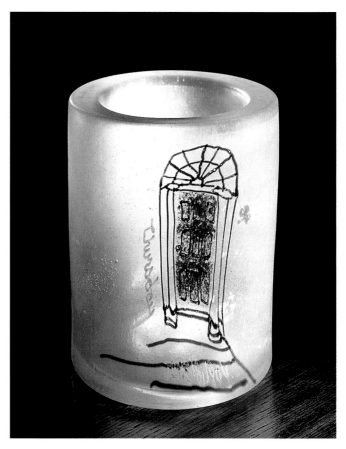

top left: *Irish Cylinder #44*, 1975, h. 10½ in., cat. no. 44

top right: *Irish Cylinder #14*, 1975, h. 9 in., cat. no. 14

bottom left: *Irish Cylinder #2*, 1975, h. 10 in., cat. no. 2

bottom right: *Irish Cylinder #40*, 1975, h. 8 in., cat. no. 40

facing: Irish Cylinders (cat. nos. 31, 37, 30)

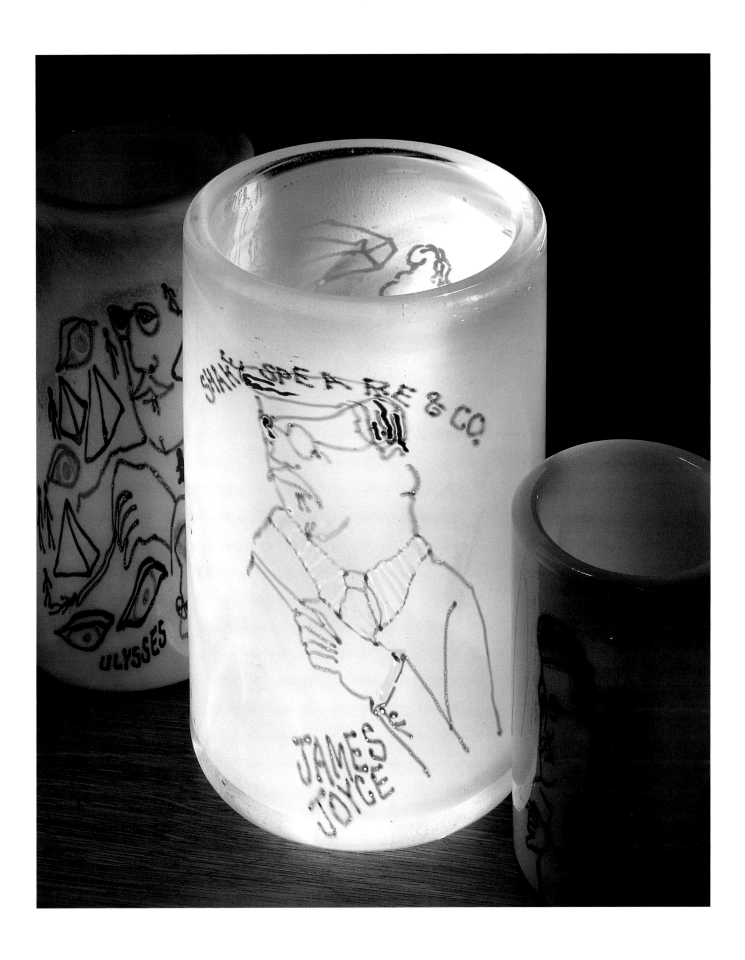

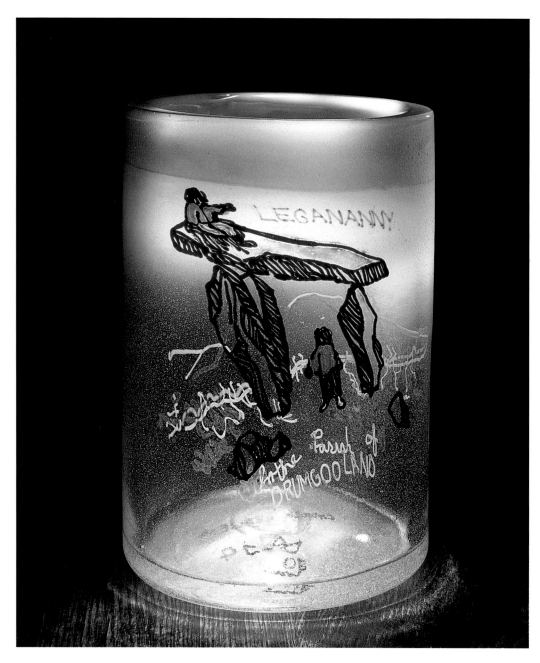

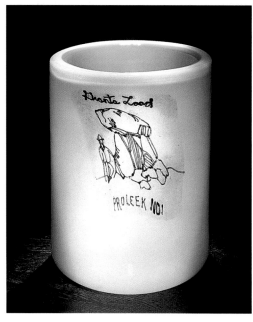

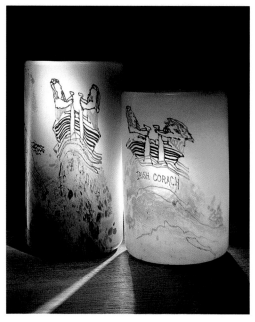

facing, top: *Irish Cylinder #27*, 1975, h. 9½ in.,
cat. no. 27
facing, bottom left: *Irish Cylinder #1*, 1975,
h. 9½ in., cat. no. 1
facing, bottom right: Irish Cylinders
(cat. nos. 34, 10)

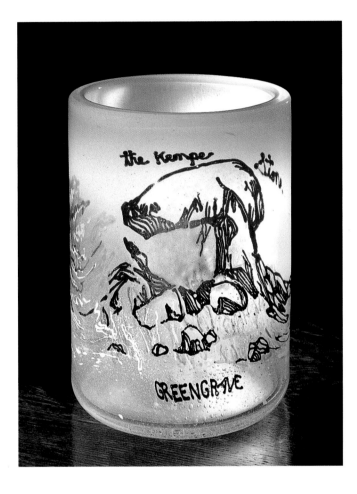

left: *Irish Cylinder #25*, 1975,
h. 10 in., cat. no. 25
below, left: *Irish Cylinder #39*, 1975,
h. 9 in., cat. no. 39
below, second left: *Irish Cylinder
#20*, 1975, h. 12½ in., cat. no. 20
below, second right: *Irish Cylinder
#36*, 1975, h. 10 in., cat. no. 36
below, right: *Irish Cylinder #3*, 1975,
h. 9 in., cat. no. 3

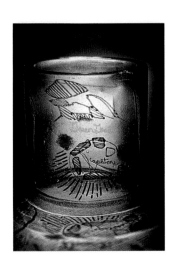
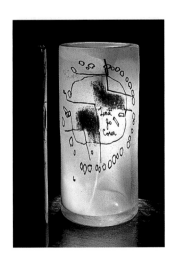
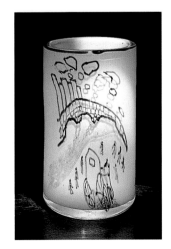
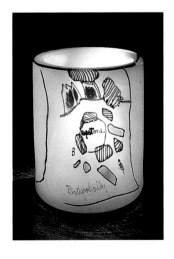

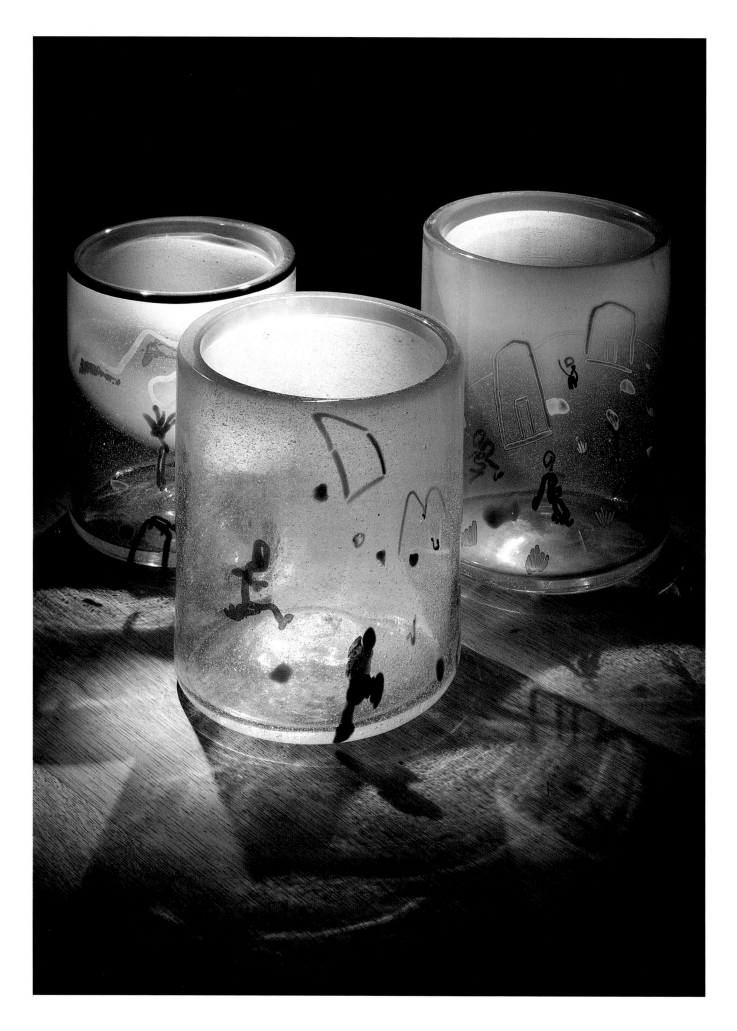

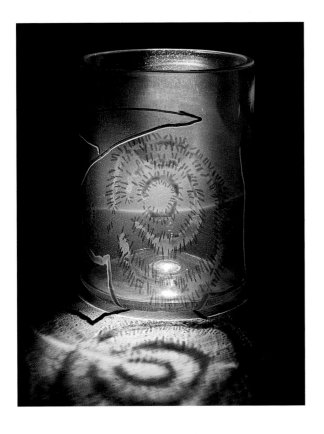

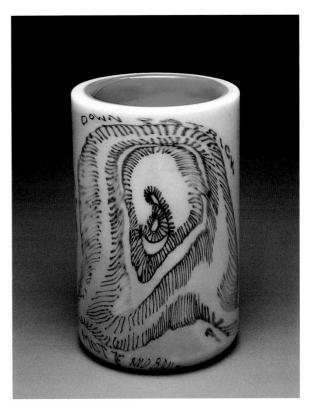

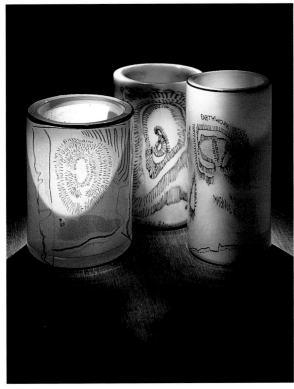

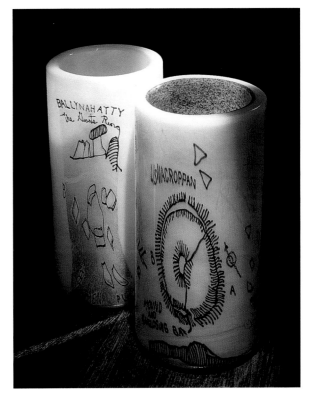

facing: Irish Cylinders (cat. nos. 23, 22, 24)

top left: *Irish Cylinder #28*, 1975, h. 11½ in., cat. no. 28

top right: *Irish Cylinder #5*, 1975, h. 11½ in., cat. no. 5

bottom left: Irish Cylinders (cat. nos. 21, 5, 15)

bottom right: Irish Cylinders (cat. nos. 32, 9)

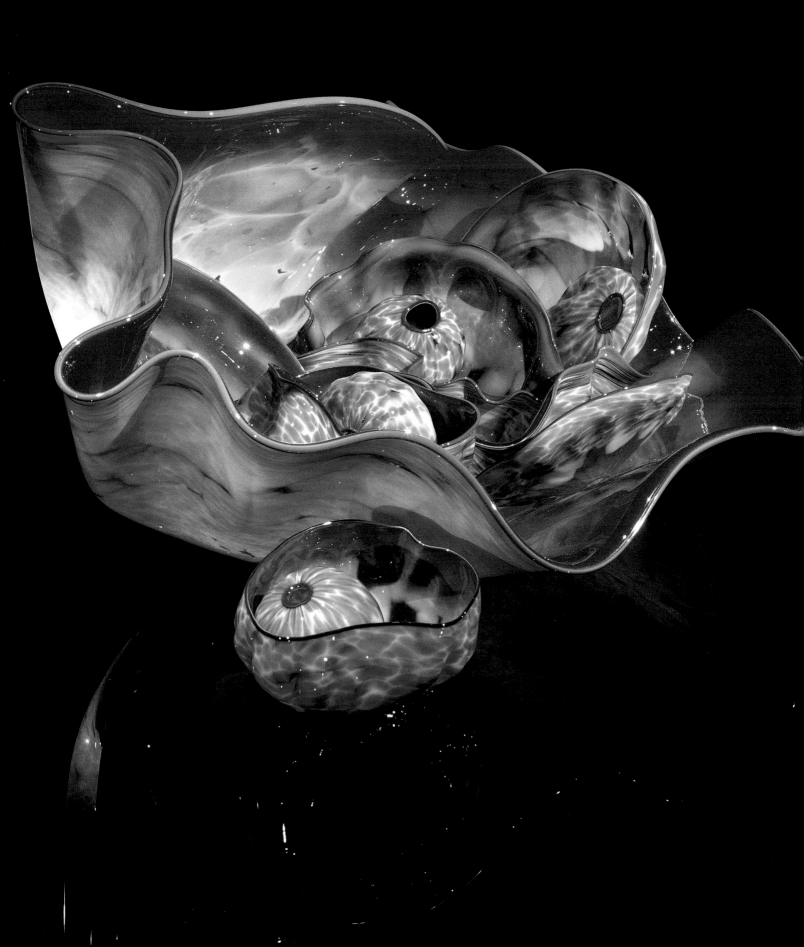

macchia

facing: *Marigold Macchia Set with Kashmir Green Lip Wrap,* 1982, w. 27 in., cat. no. 63

below: *Aureolin Yellow Macchia with Armenian Blue Lip Wrap,* 1981, w. 7 in., cat. no. 66

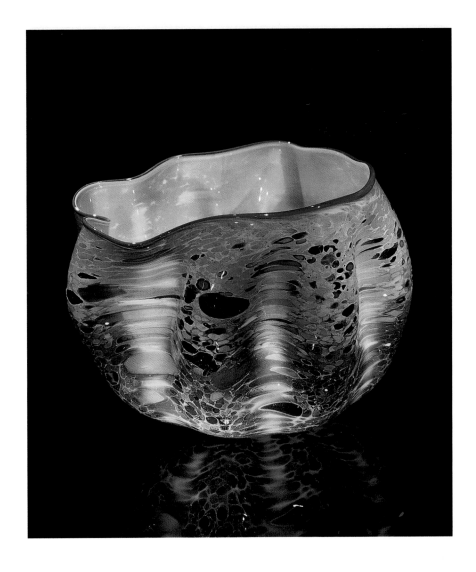

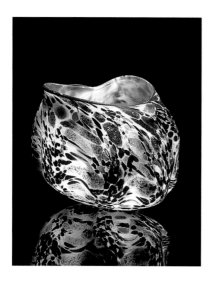

left: *Lumière Green Macchia with Lapis Blue Lip Wrap*, 1981, w. 5 in., cat. no. 51

below: *Coral Macchia with Orion Blue Lip Wrap*, 1982, w. 15 in., cat. no. 85

facing: *Cobalt Turquoise Macchia with Terra Rosa Lip Wraps*, 1983, w. 20 in., cat. no. 62

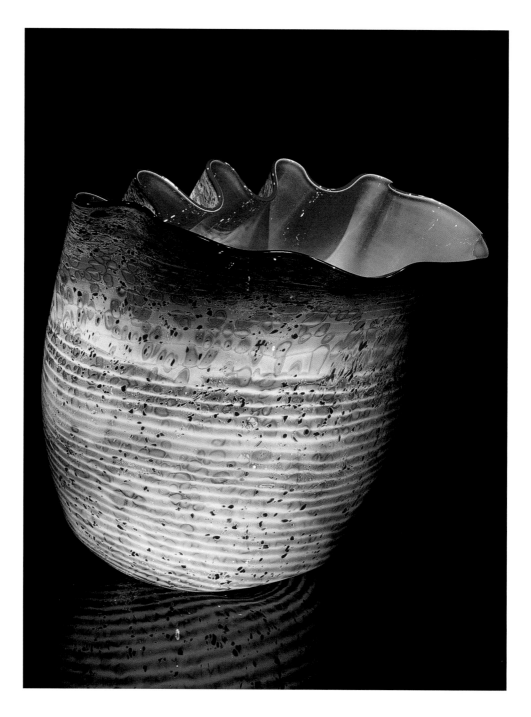

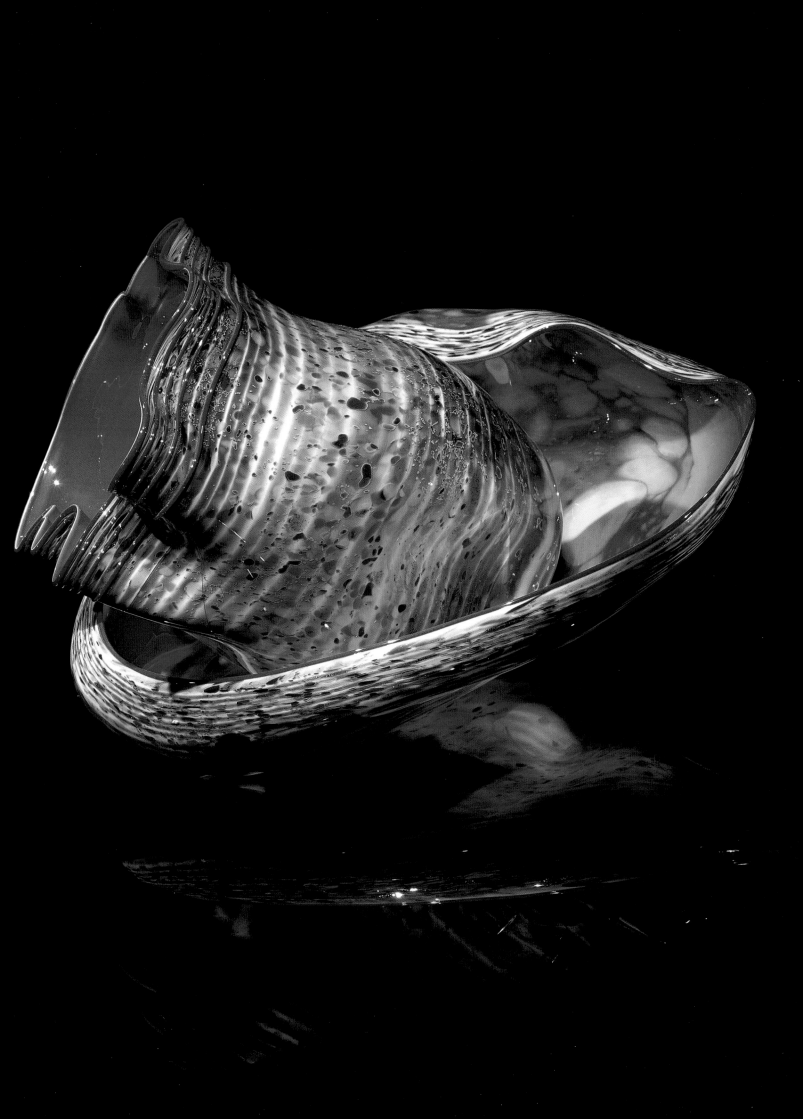

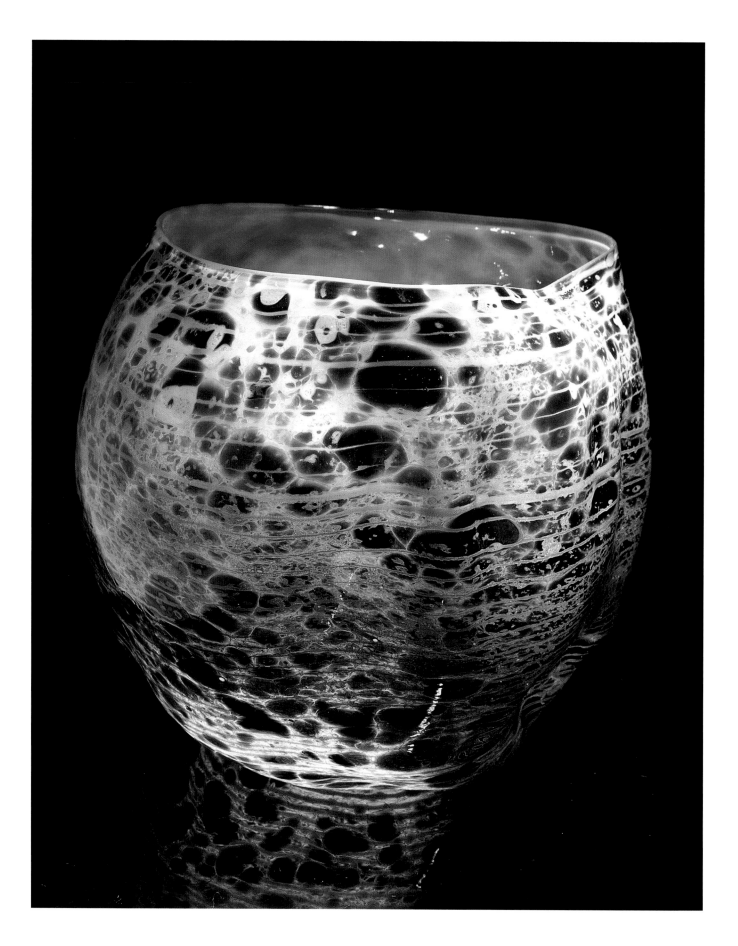

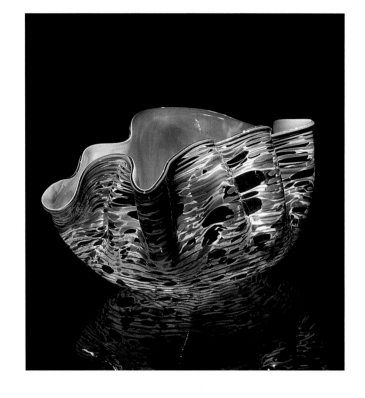

facing: *Veronese Green Macchia with Blue Etain Jimmies*, 1981,
w. 9 in., cat. no. 45

above: *Wisteria Violet Macchia with Plumbago Lip Wrap*, 1982,
w. 12 in., cat. no. 46

below left: *Fire Coral Macchia with Corsair Lip Wrap*, 1982,
w. 18 in., cat. no. 76

below right: *Commelian Blue Macchia with Ochre Jimmies*, 1982,
w. 10 in., cat. no. 79

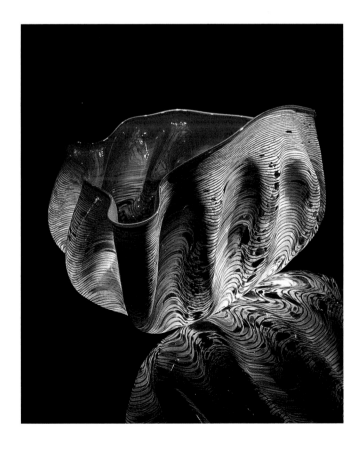

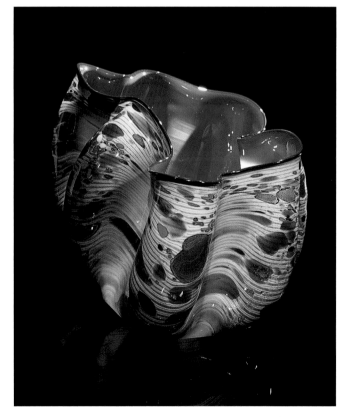

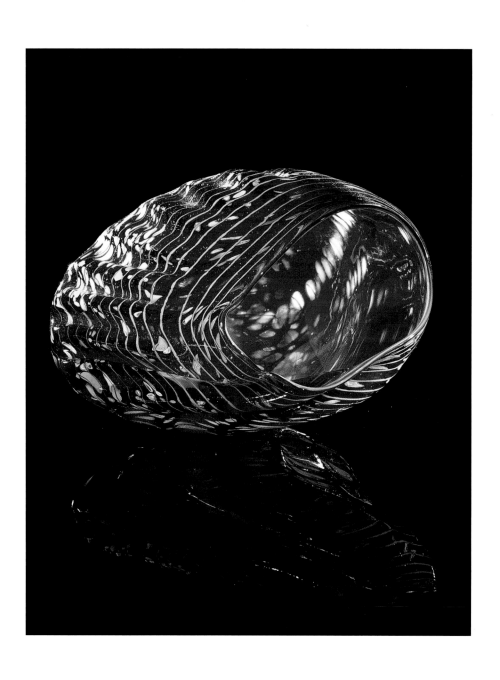

above: *Araby Red Macchia with Ultramarine Lip Wrap*, 1983, w. 9 in., cat. no. 57

facing: *Birch Macchia with Raw Umber Lip Wrap*, 1981, w. 9 in., cat. no. 58

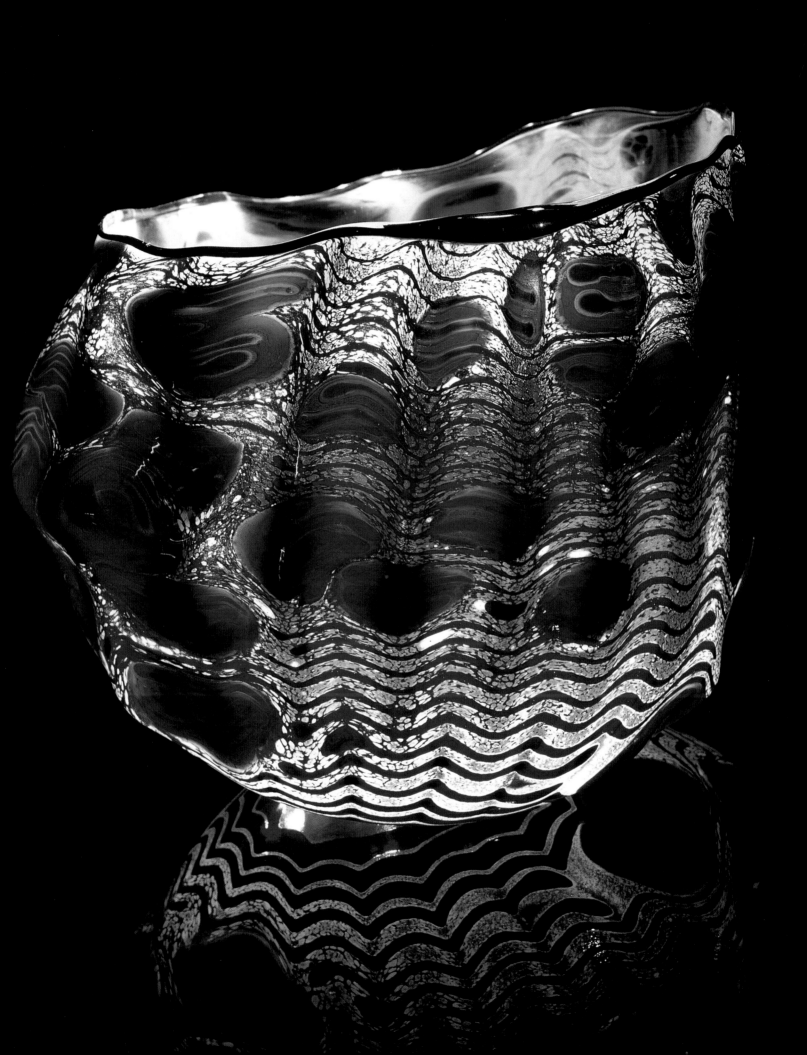

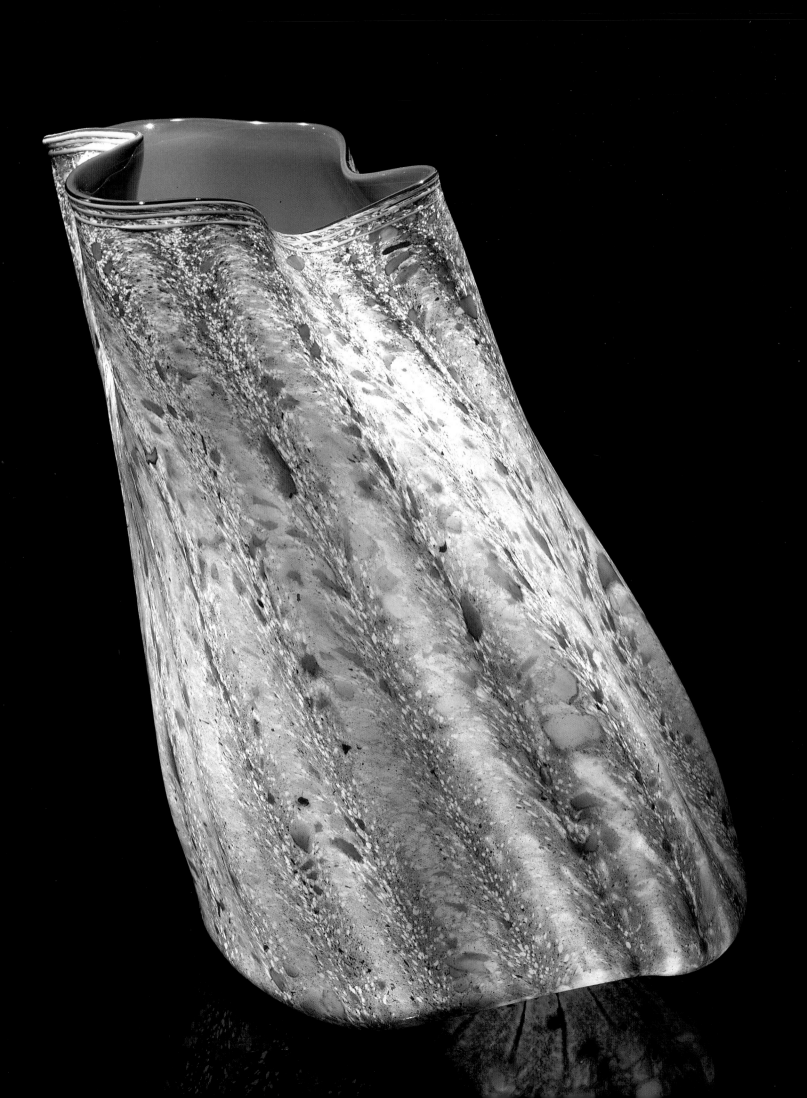

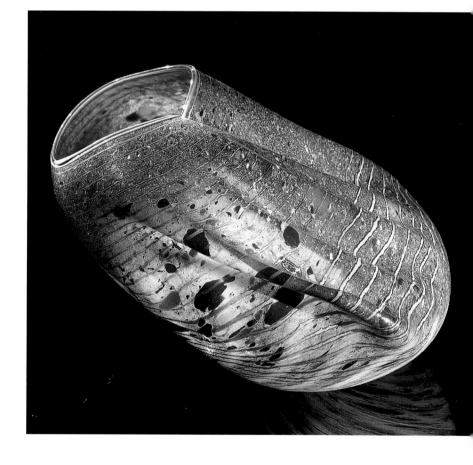

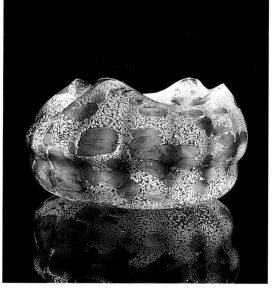

facing: *Olive Macchia with Chrome Yellow Lip Wraps,* 1982,
h. 12 in., cat. no. 91
above: *Larkspur Blue Macchia with Persimmon Lip Wrap,*
1981, w. 12 in., cat. no. 54
left: *Abalone and Oxblood Macchia,* 1982, w. 9 in., cat. no. 74

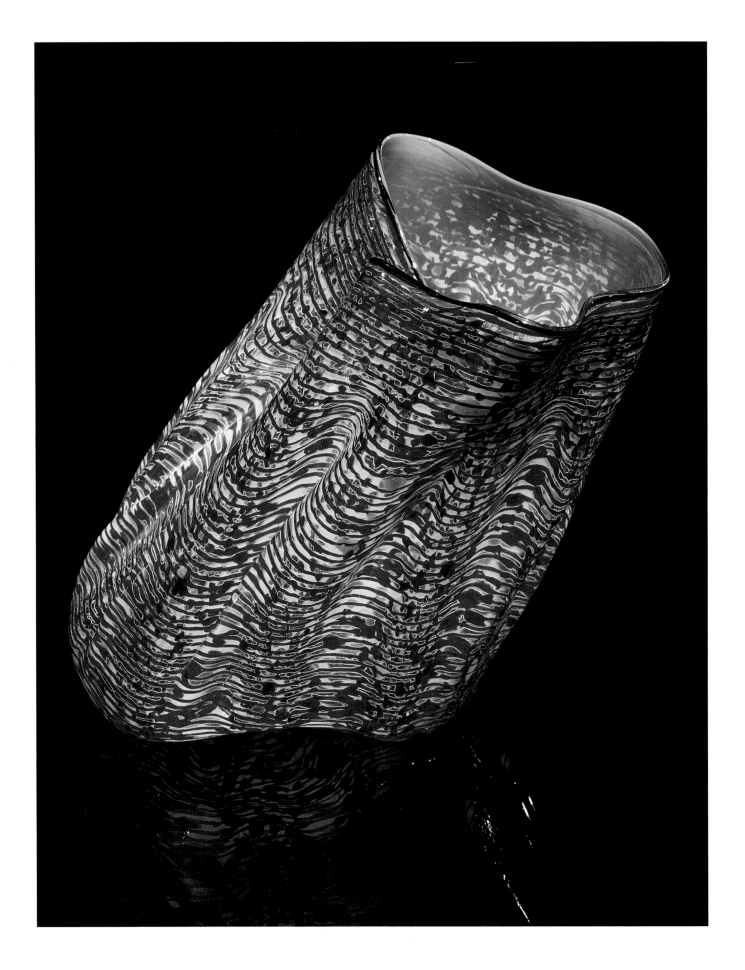

above: *Delta Yellow Macchia with Cassel Lip Wrap*, 1981, h. 10 in., cat. no. 47

facing: *May Green Macchia with Peach Lip Wrap*, 1982, w. 6 in., cat. no. 86

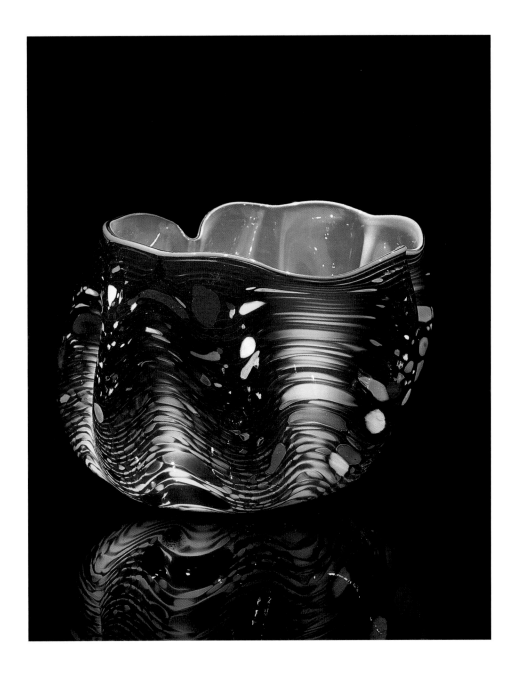

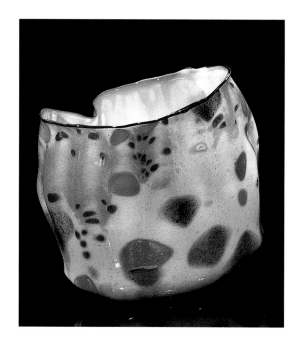

left: *Birch White Macchia with Ebony Lip Wrap*, 1982, d. 8 in., cat. no. 73

below: *Cobalt Violet and Poplar White Macchia*, 1982, w. 14 in., cat. no. 56

facing: *Chrysanthemum Yellow Macchia with Windsor Violet Lip Wrap*, 1982, d. 17 in., cat. no. 61

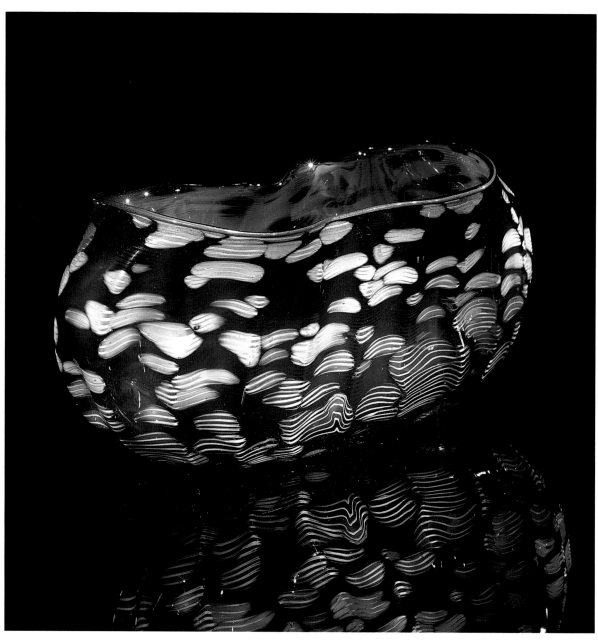

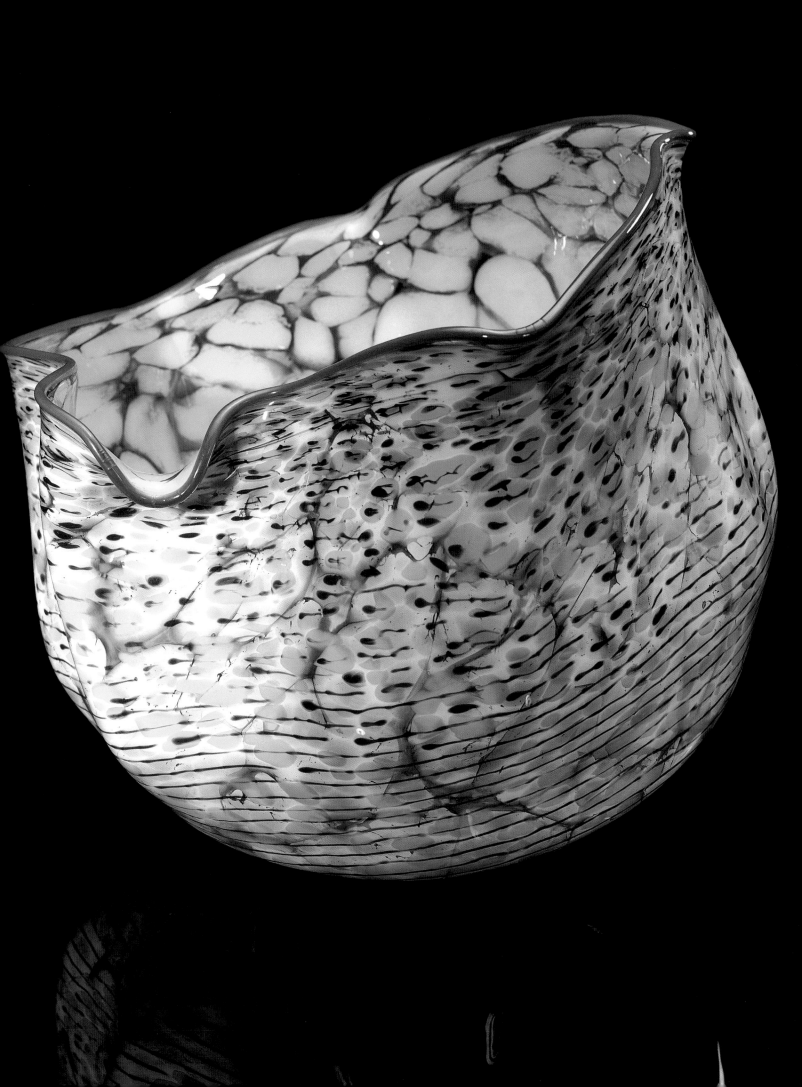

piccolo venetians

top left: *Gold Over Purple Piccolo Venetian with Clear Spotted Leaves,* 1994, h. 10 in., cat. no. 166

top right: *Gold Over Swiss Rose Piccolo Venetian with Green Leaves,* 1994, h. 12 in., cat. no. 175

bottom left: *Nymph Pink Piccolo Venetian with Pink and Green Ribbons,* 1994, h. 11 in., cat. no. 146

bottom right: *Sandalwood Piccolo Venetian with Spotted Green Leaves,* 1995, h. 11 in., cat. no. 216

facing: *Chartreuse Piccolo Venetian with Red Flowers,* 1993, h. 11 in., cat. no. 118

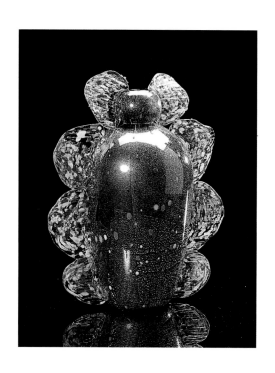

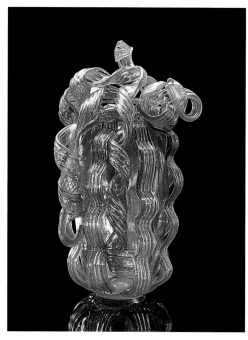

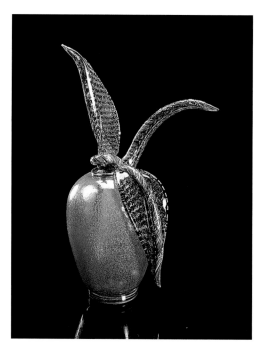

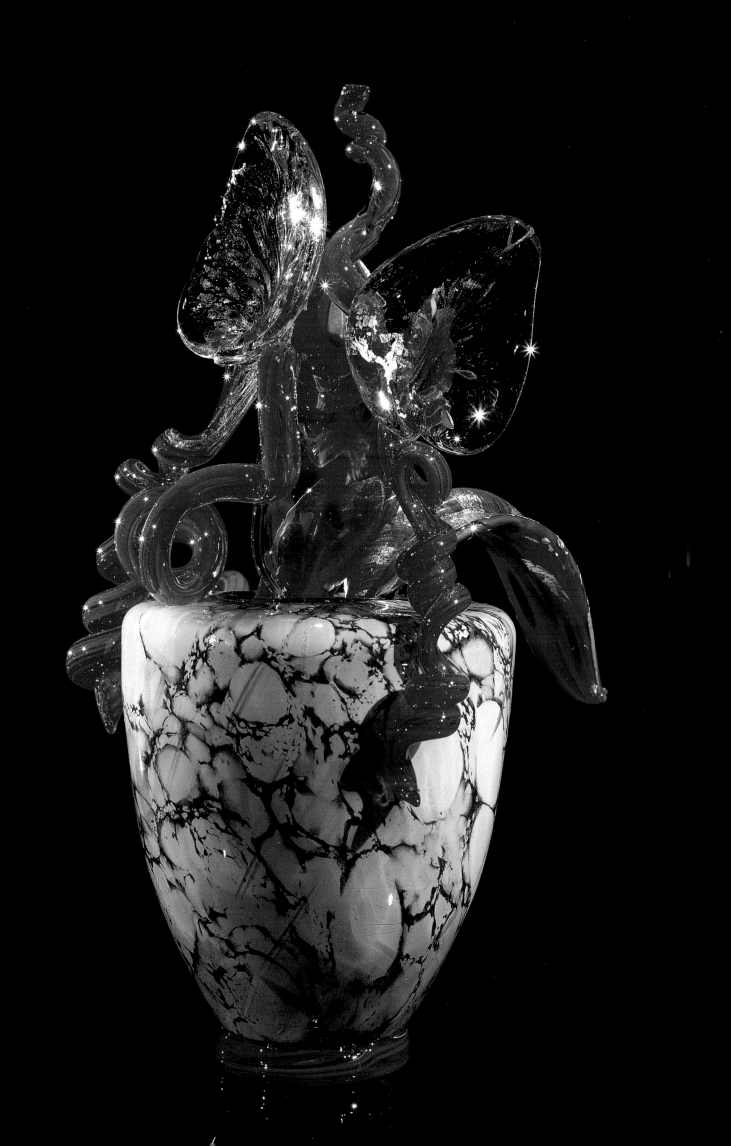

top left: *Orange with Green Speckles Piccolo Venetian with Blue Leaves,* 1994, h. 10 in., cat. no. 138

top right: *Gold Over Porcelain Blue Piccolo Venetian with Handles,* 1994, w. 10 in., cat. no. 160

bottom left: *Clear Red Piccolo Venetian with Opal Blue Leaves and Handles,* 1995, h. 9 in., cat. no. 199

bottom right: *Red and Green Piccolo Venetian with Red Handles,* 1994, h. 9 in., cat. no. 139

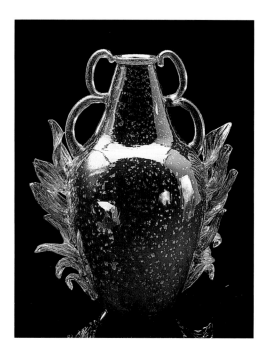

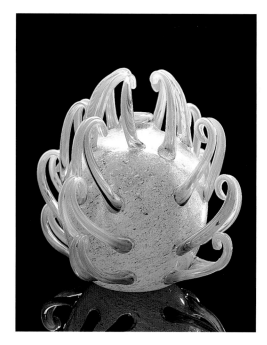

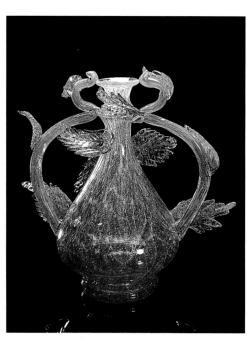

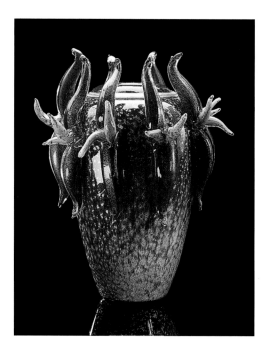

top left: *Cerulean Blue Piccolo Venetian with Red Prunts*, 1994, h. 11 in., cat. no. 147

top right: *Moss Green Piccolo Venetian with Red Handles*, 1994, h. 8 in., cat. no. 143

bottom left: *Crackled Mauve Piccolo Venetian with Mauve Handles*, 1994, h. 9 in., cat. no. 156

bottom right: *Silver Over Pastel Blue Piccolo Venetian with Clear Prunts*, 1994, h. 10 in., cat. no. 185

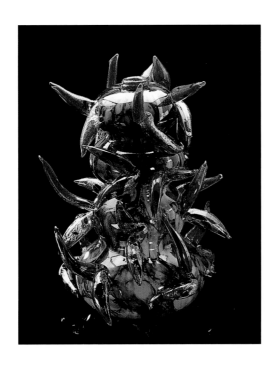 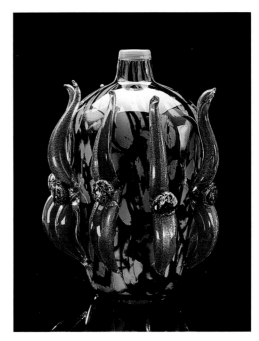

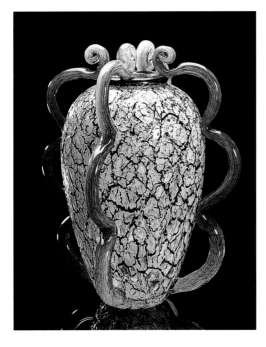 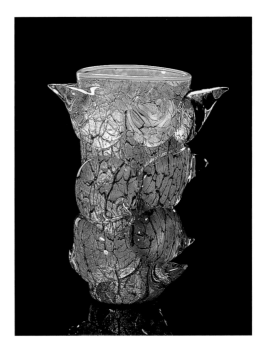

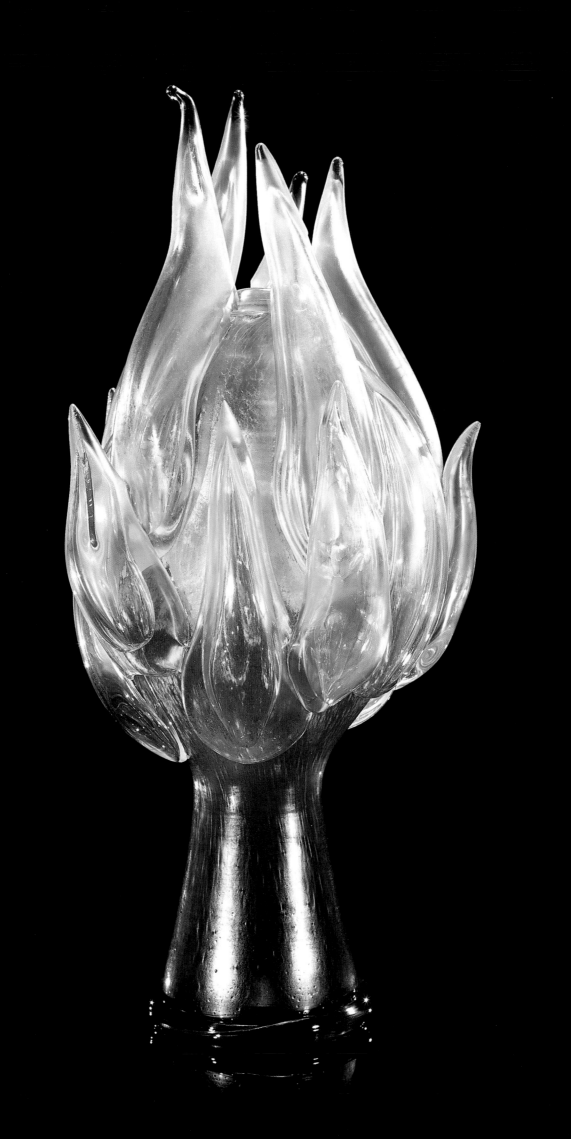

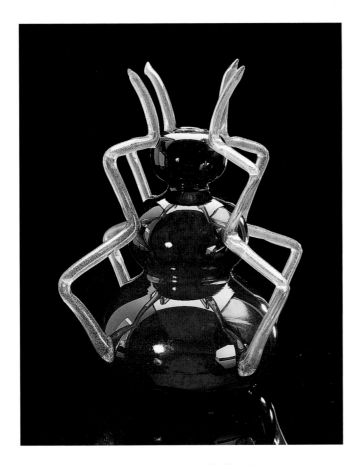

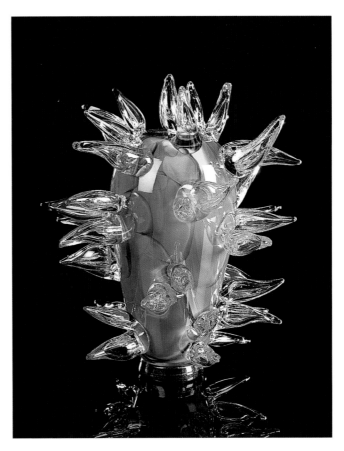

facing: *Damascan Violet Piccolo Venetian with Clear Fronds*, 1997, h. 13 in., cat. no. 259

above left: *Sultan Red Piccolo Venetian with Green Handles*, 1994, h. 9 in., cat. no. 137

above right: *Marble Green Venetian with Green Lip Wrap*, 1997, h. 10 in., cat. no. 211

below left: *Fluorite Violet Piccolo Venetian with Gilt Mint Green Leaves*, 1994, h. 12 in., cat. no. 173

below right: *Imperial Jade Piccolo Venetian with Kelly Green*, 1997, h. 10 in., cat. no. 296

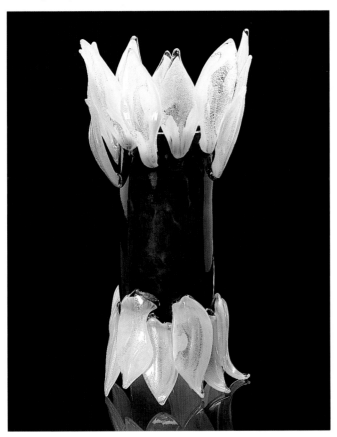

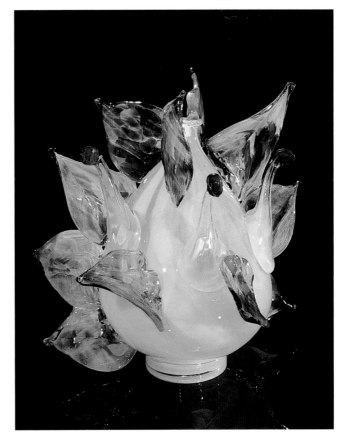

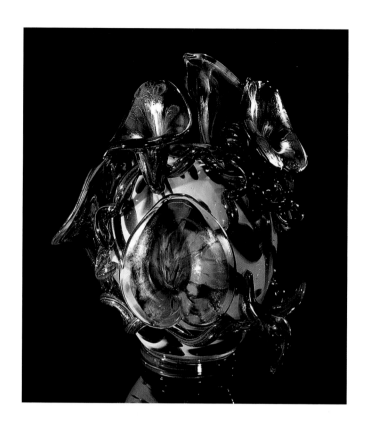

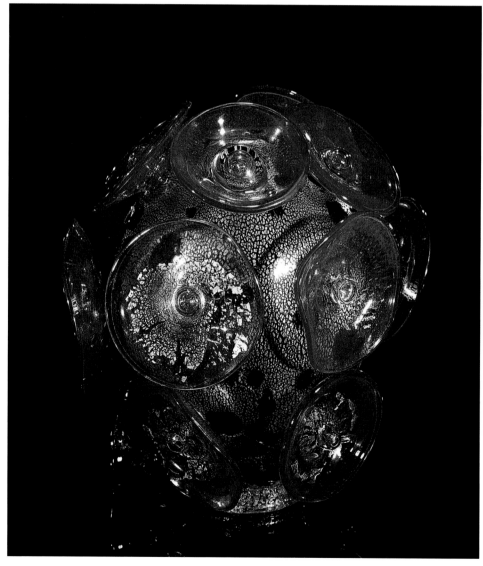

facing, top: *Aquamarine Piccolo Venetian with Iris Blooms*, 1997, h. 9 in., cat. no. 307
facing, bottom: *Canal Green Piccolo Venetian with Gold Leaf and Rose Prunts*, 1997, h. 7 in., cat. no. 302
below: *Moss Green Spotted Piccolo Venetian with Clear Spheres*, 1997, d. 9 in., cat. no. 306

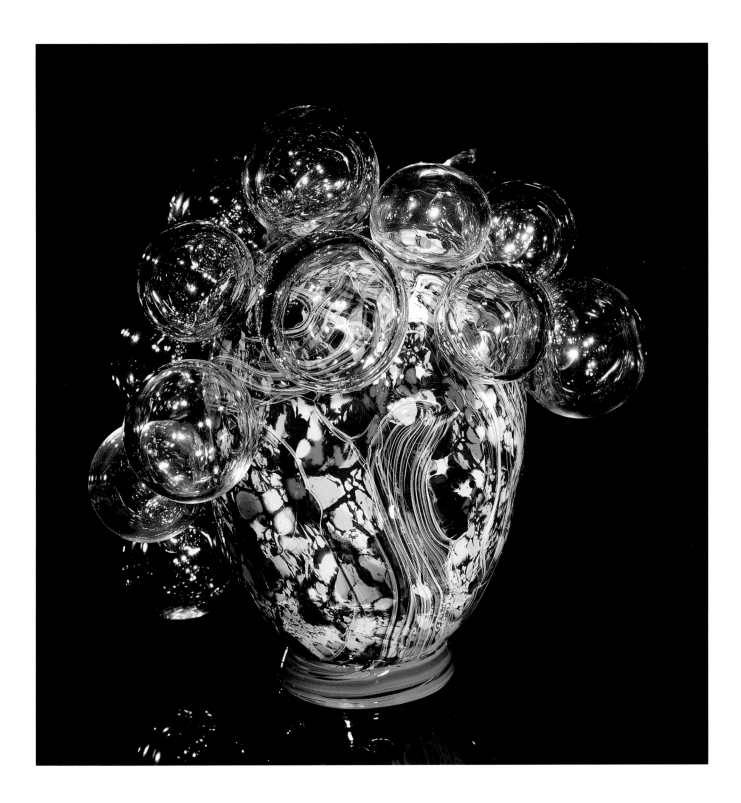

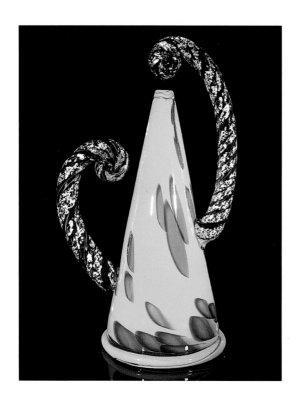 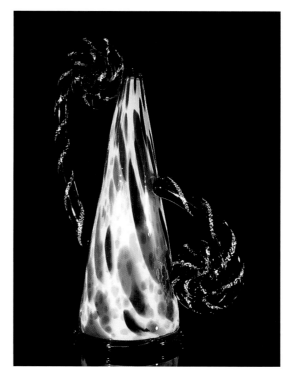

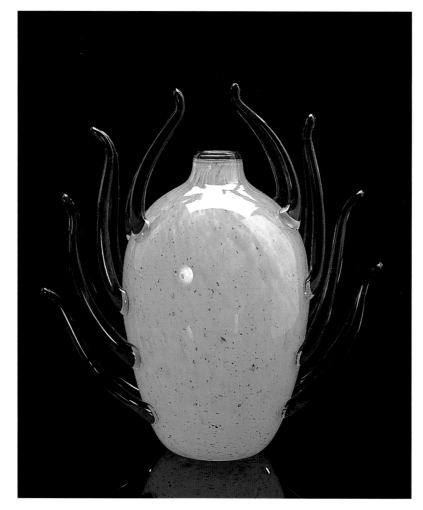

top left: *Iris Gold Piccolo Venetian with Teal Spires*, 1997, h. 11 in., cat. no. 304

top right: *Spotted White Piccolo Venetian with Burnt Umber Handles*, 1997, h. 12 in., cat. no. 303

bottom: *Marbled Sky Blue Piccolo Venetian with Cobalt Blue Handles*, 1994, h. 10 in., cat. no. 161

facing: *Creme and Coralbell Piccolo Venetian with Tiers*, 1997, h. 11 in., cat. no. 305

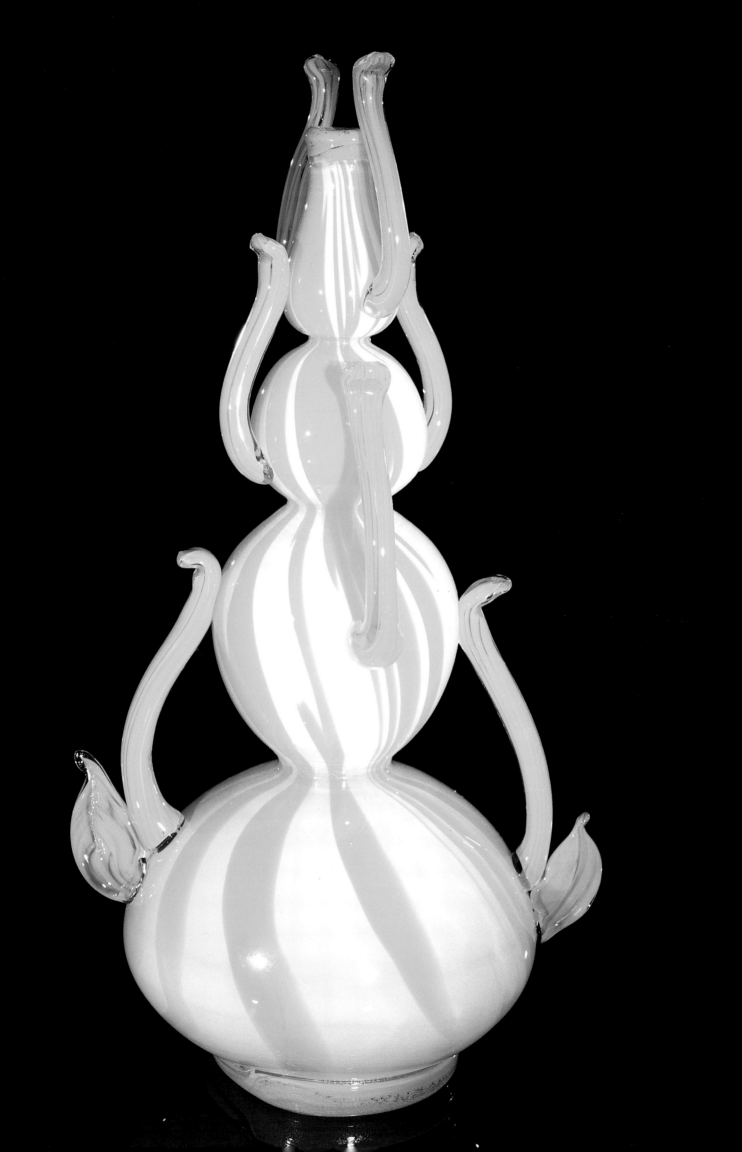

right: *Sistine Blue Piccolo Venetian with Golden Seals*, 1997, h. 9 in., cat. no. 297

below left: *Arctic White Piccolo Venetian with Ice Leaves*, 1997, h. 8½ in., cat. no. 298

below right: *Coral Blush Pink Piccolo Venetian with Handles and Leaves*, 1995, h. 10 in., cat. no. 204

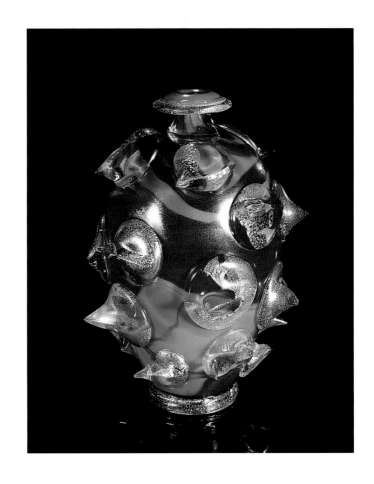

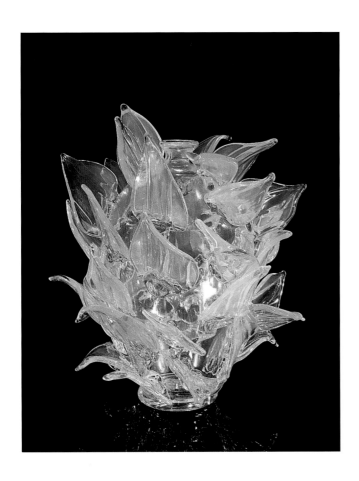

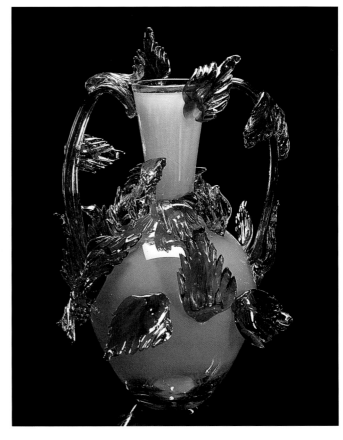

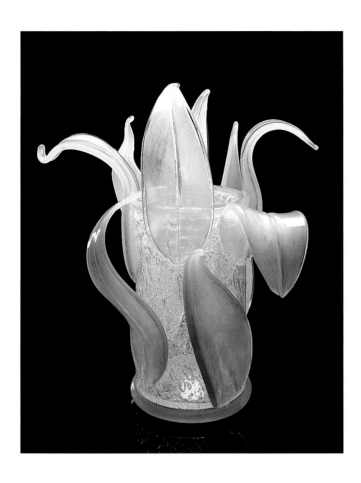

left: *Clear Pallid Violet Piccolo Venetian with Abundant Leaves,* 1995, h. 10 in., cat. no. 210

below left: *Clear Pale Green and Rose Piccolo Venetian with Ribbons and Leaves,* 1995, h. 10 in., cat. no. 206

below right: *Bronze Olive Piccolo Venetian with Clear Spines,* 1997, h. 11 in., cat. no. 299

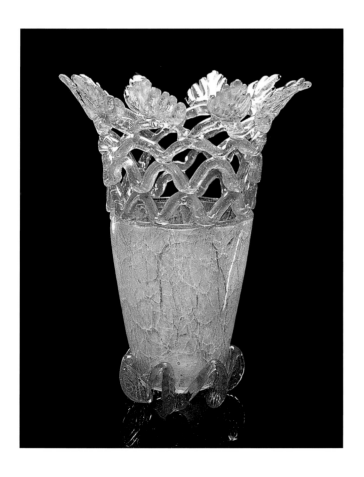

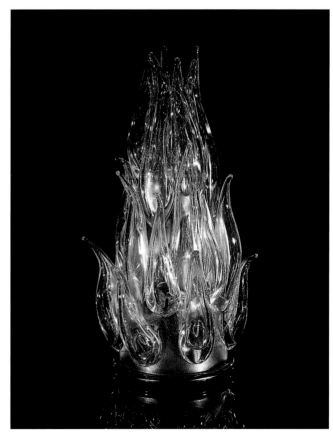

below: *Clear with Copper Piccolo Venetian with Amber Coils*, 1997, h. 12 in., cat. no. 301

facing: *Lavender Piccolo Venetian with Cerulean Lilies*, 1993, h. 8 in., cat. no. 119

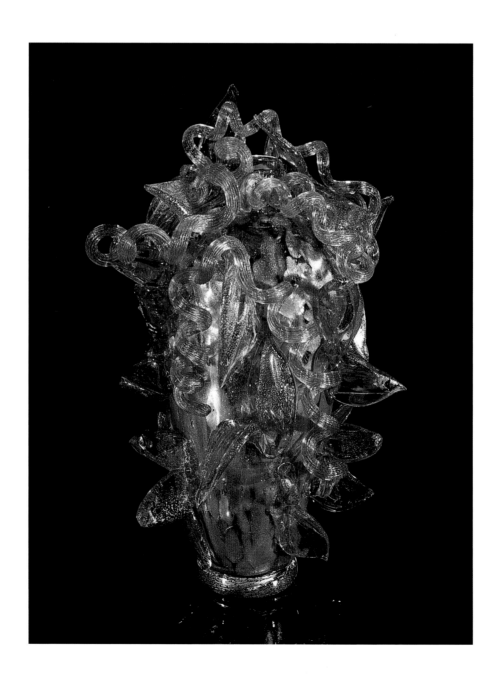

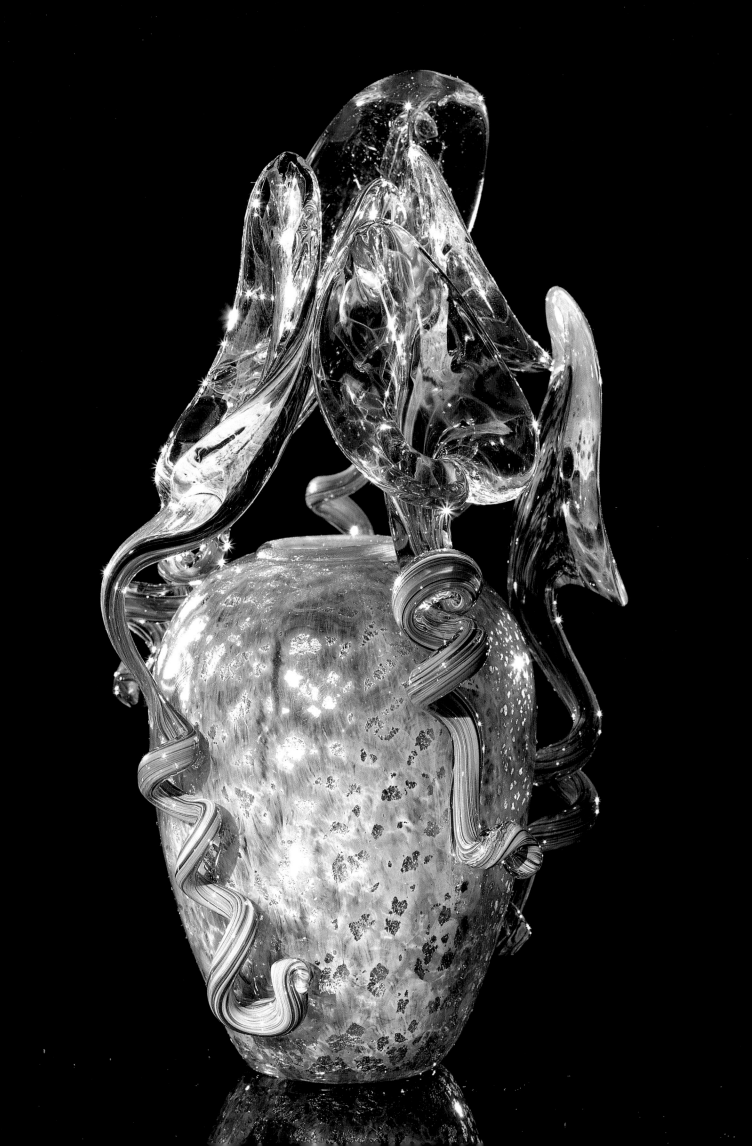

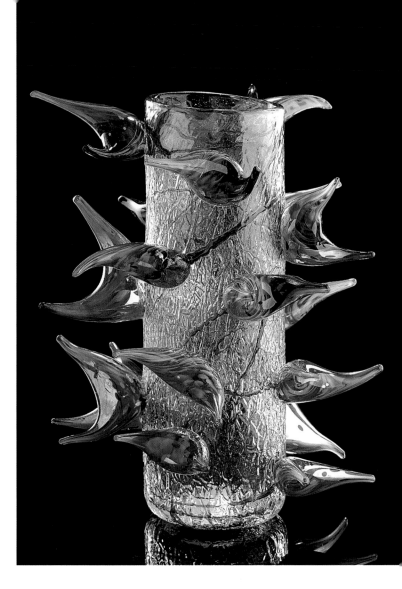

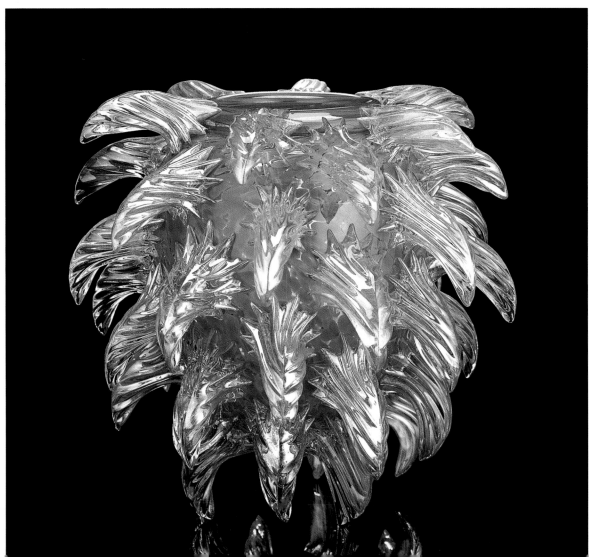

facing, top: *Clear Venetian with Crimson Lake Birds*, 1989, h. 17 in., cat. no. 230

facing, bottom: *Rose Pink Venetian #400*, 1990, w. 16 in., cat. no. 101

below: *Phthalo Green Venetian #127*, 1989, w. 16 in., cat. no. 108

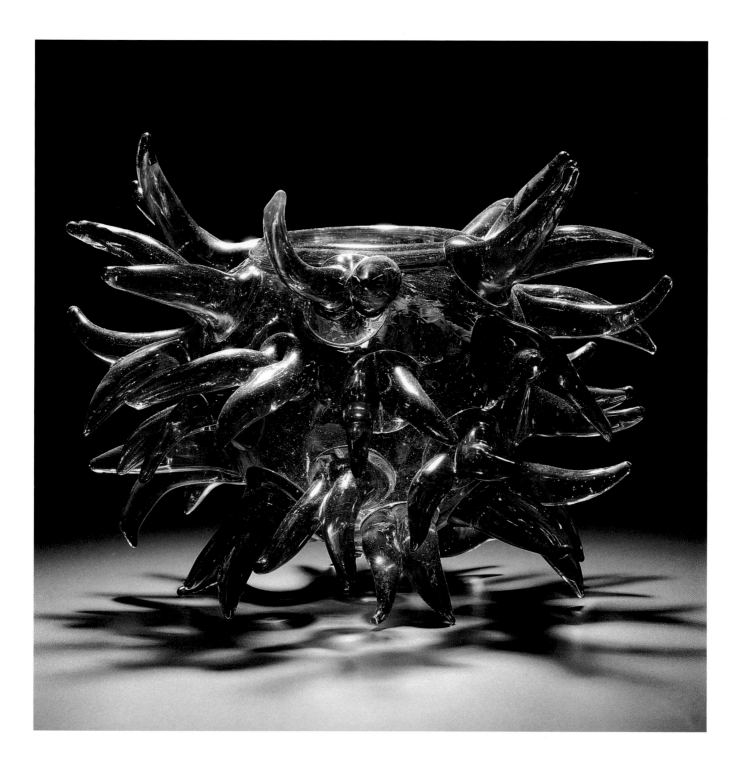

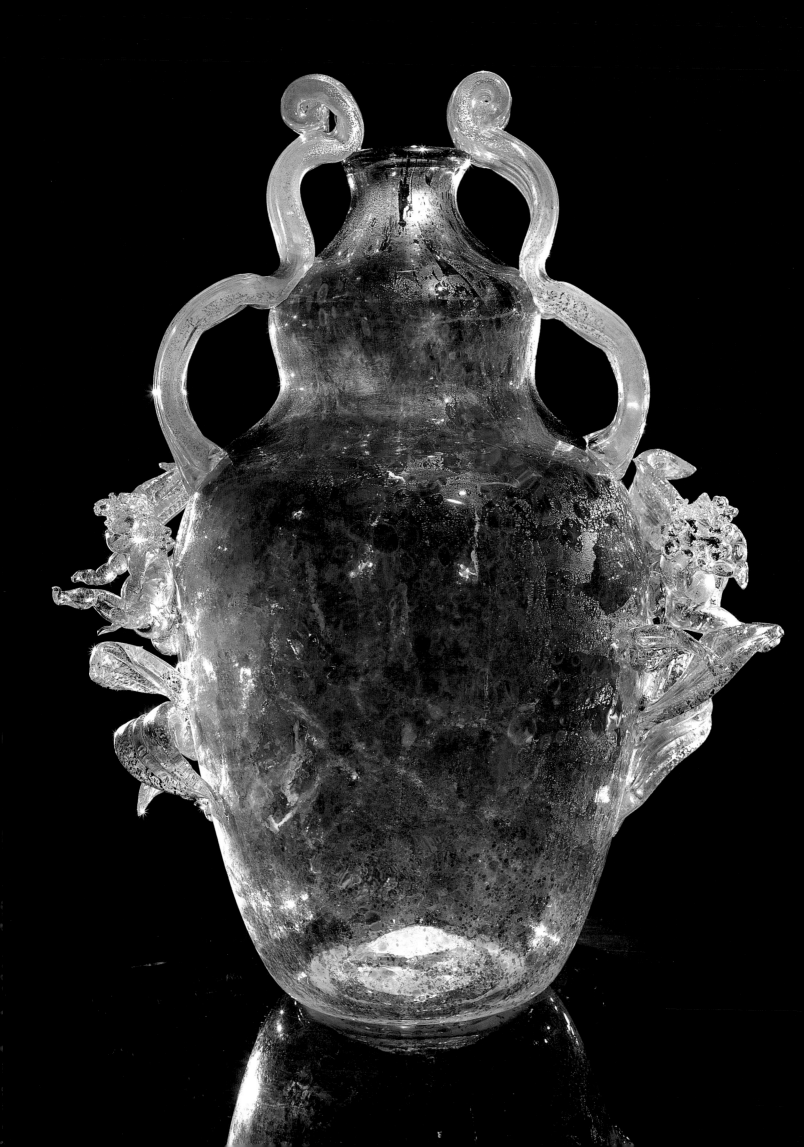

facing: *Translucent Cerulean Putti Venetian with Green Coils,* 1993, h. 24 in., cat. no. 111

below: *Cadmium Yellow Putti Venetian,* 1993, h. 27 in., cat. no. 100

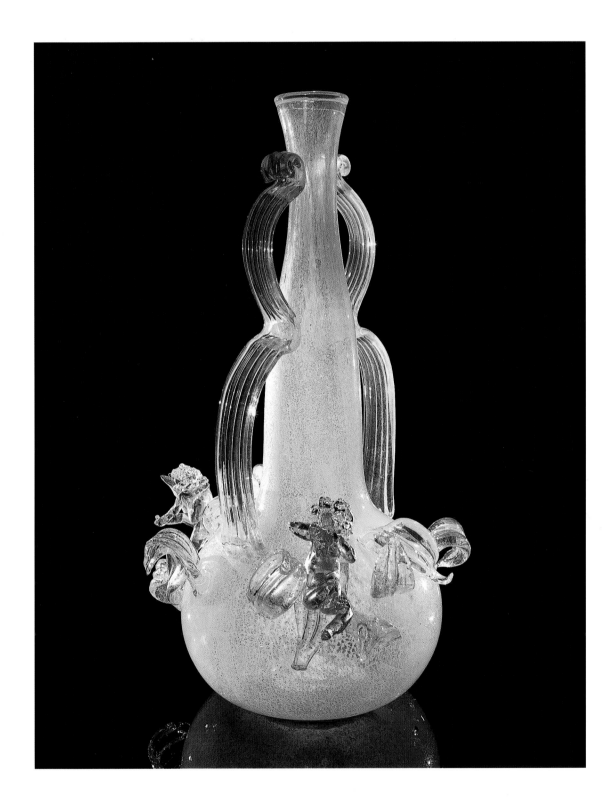

below: *Rose and Cadmium Yellow Venetian with Black Swirls,* 1989, h. 24 in., cat. no. 232
facing: *Gold Over Cobalt Venetian #49,* 1989, h. 24 in., cat. no. 233

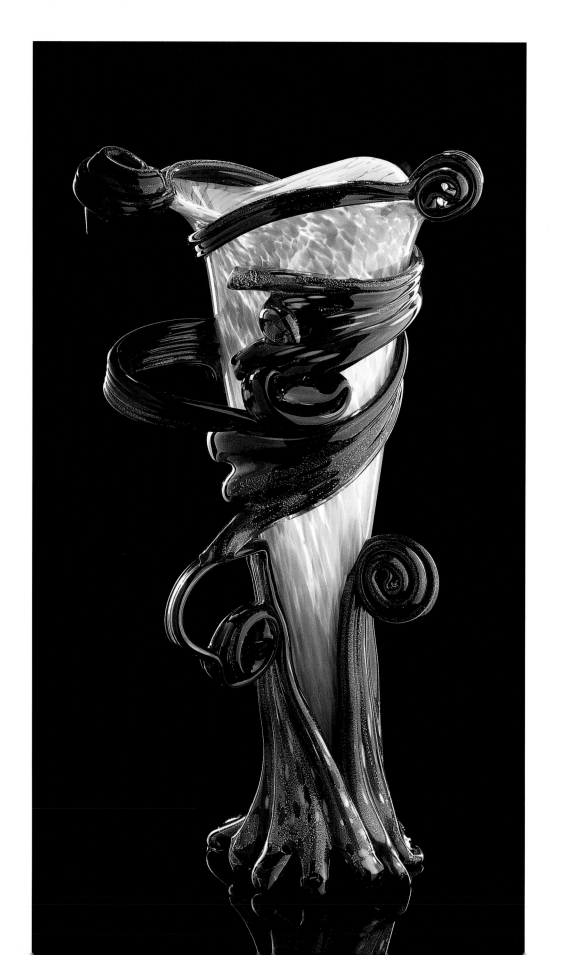

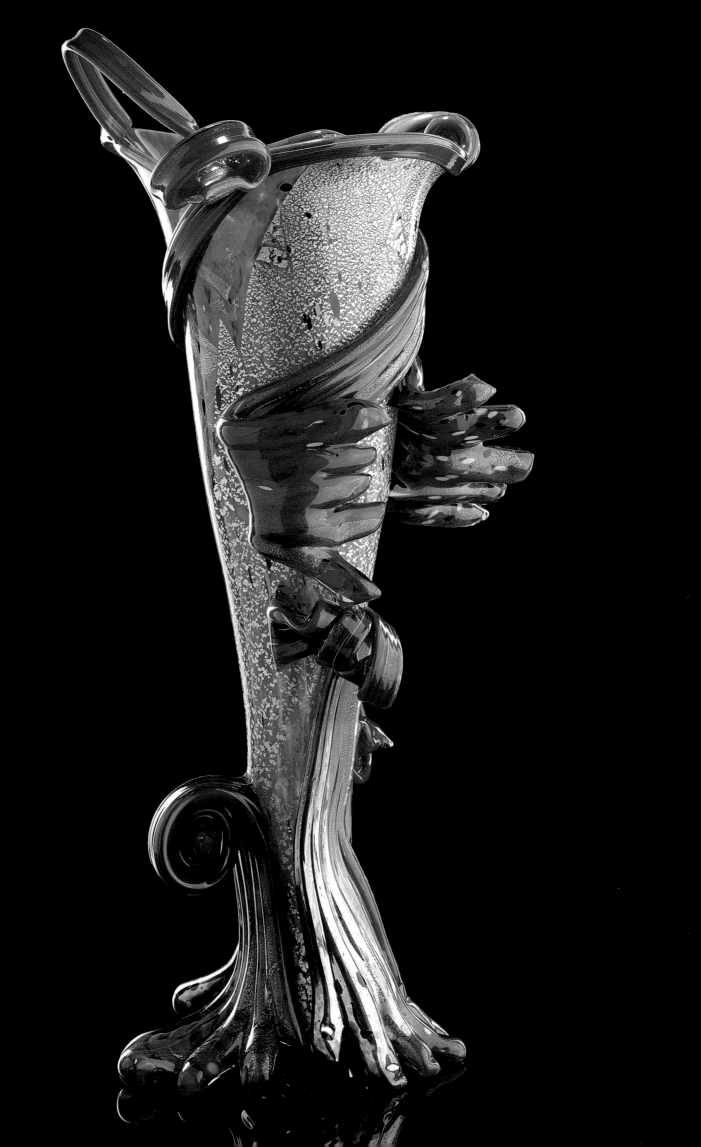

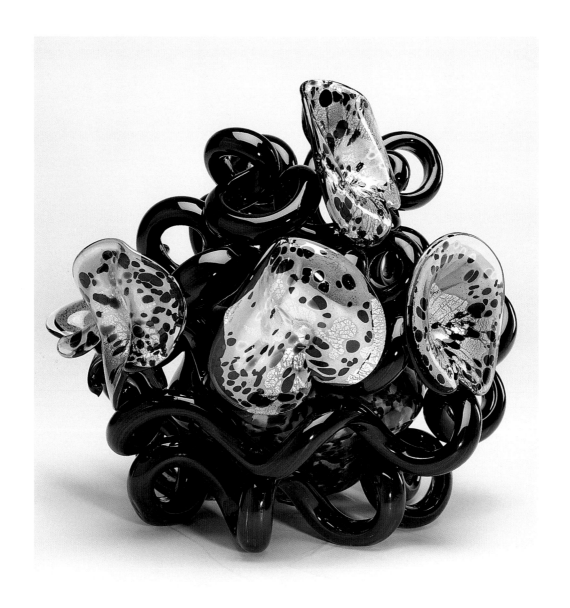

above: *Black Coiled Venetian with Lilies,* 1991, w. 21 in., cat. no. 112

facing: *Cadmium Orange Coiled Venetian with Lilies,* 1991, w. 19 in., cat. no. 113

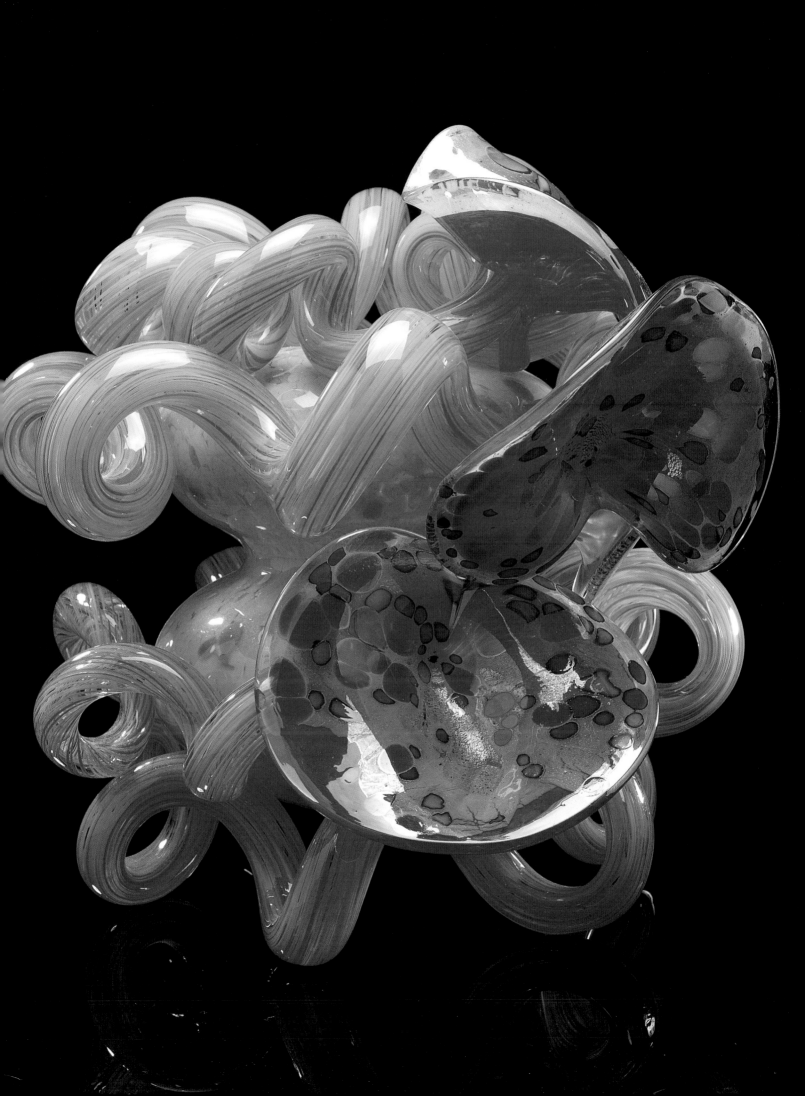

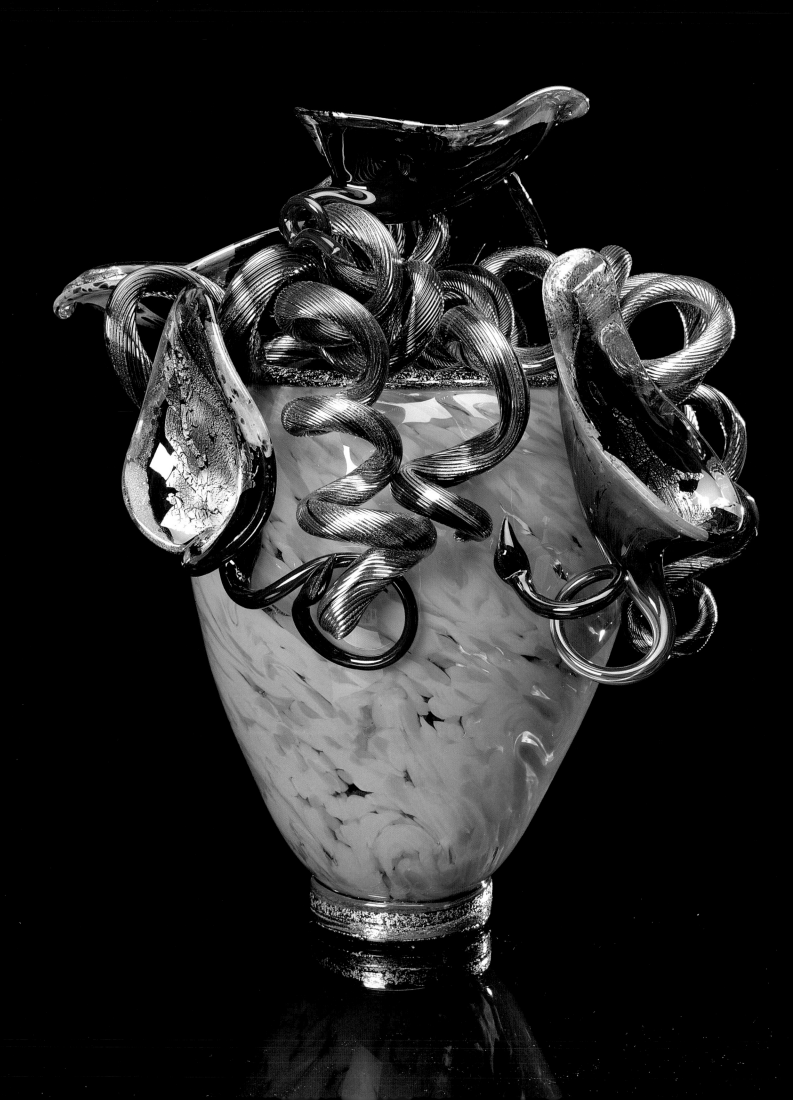

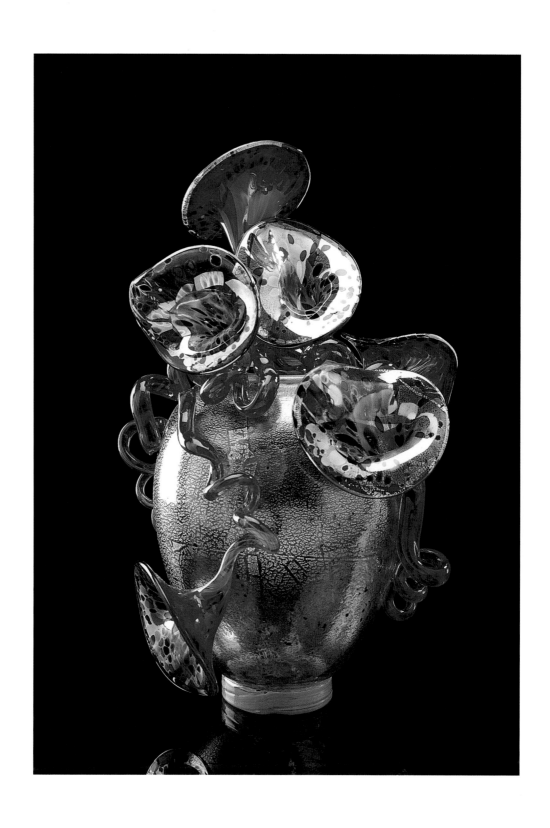

facing: *Turquoise Green Venetian #352,* 1990, h. 21 in., cat. no. 99
above: *Green and Gold Venetian #433,* 1990, h. 23 in., cat. no. 105

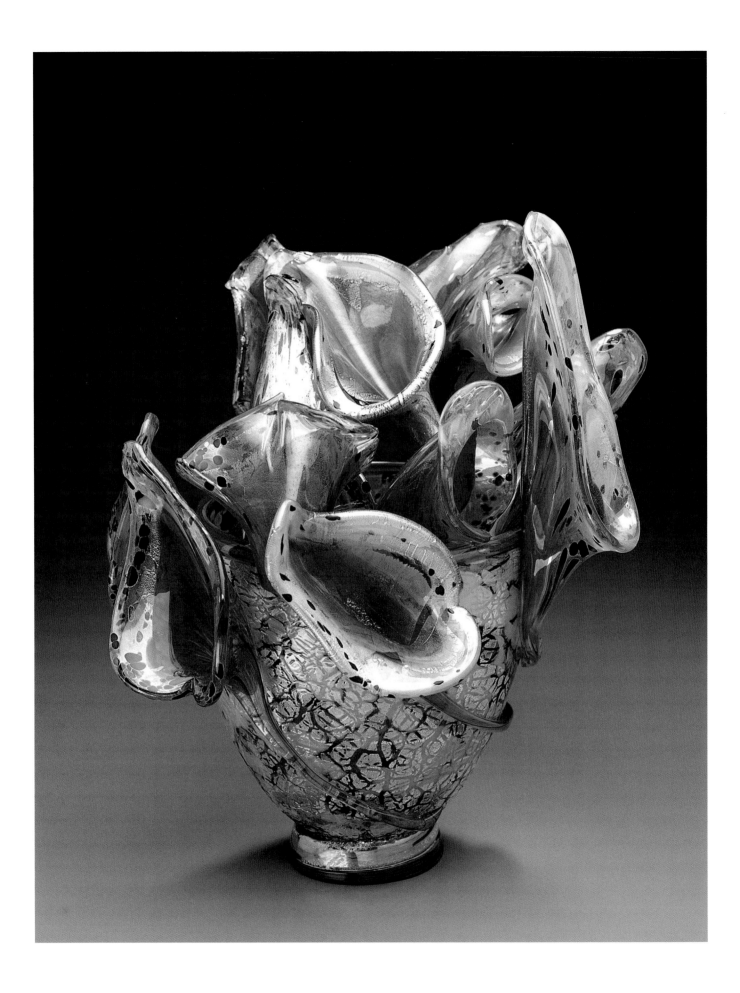

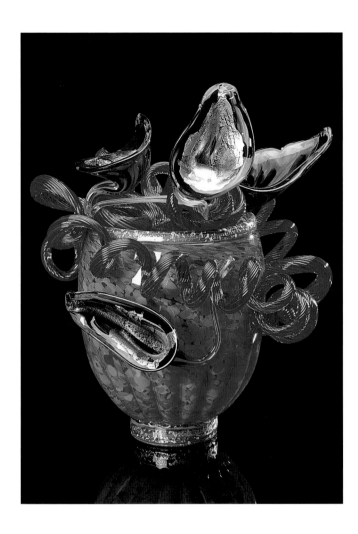

facing: *Cadmium Yellow Venetian with Red Lilies,* 1989, h. 19 in., cat. no. 231

left: *Cadmium Orange Venetian #350,* 1990, h. 19 in., cat. no. 98

below: *Iridescent Orange Venetian,* 1990, h. 24 in., cat. no. 102

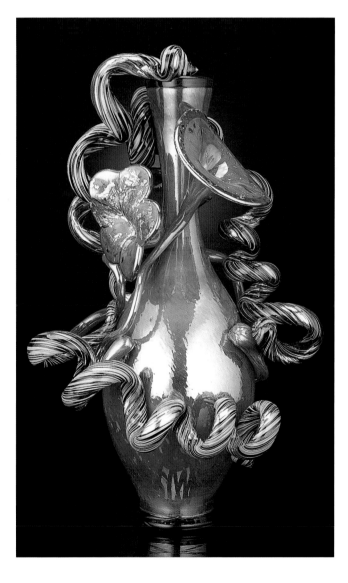

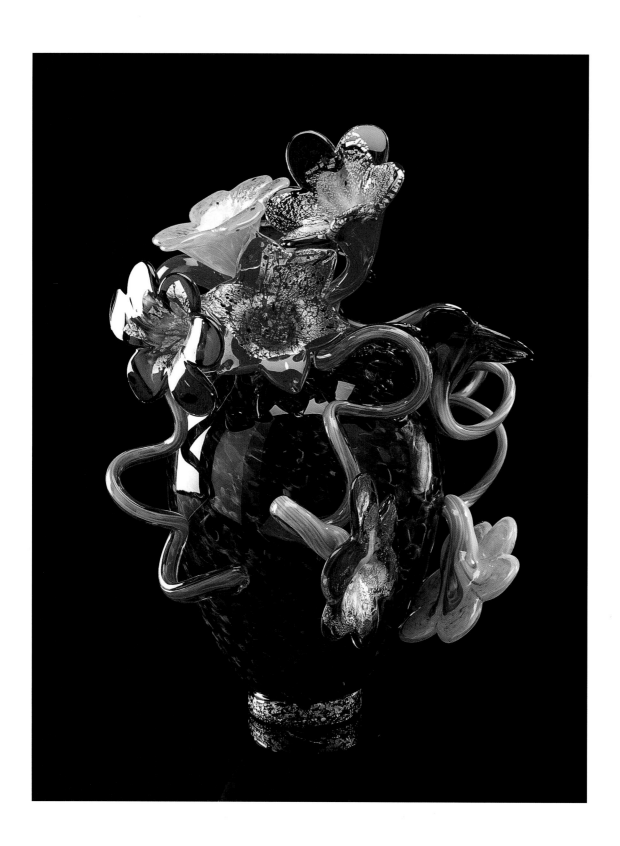

above: *Multicolored Venetian #450*, 1990, h. 24 in., cat. no. 104

facing: *Cobalt Blue Venetian #410*, 1990, h. 33 in., cat. no. 106

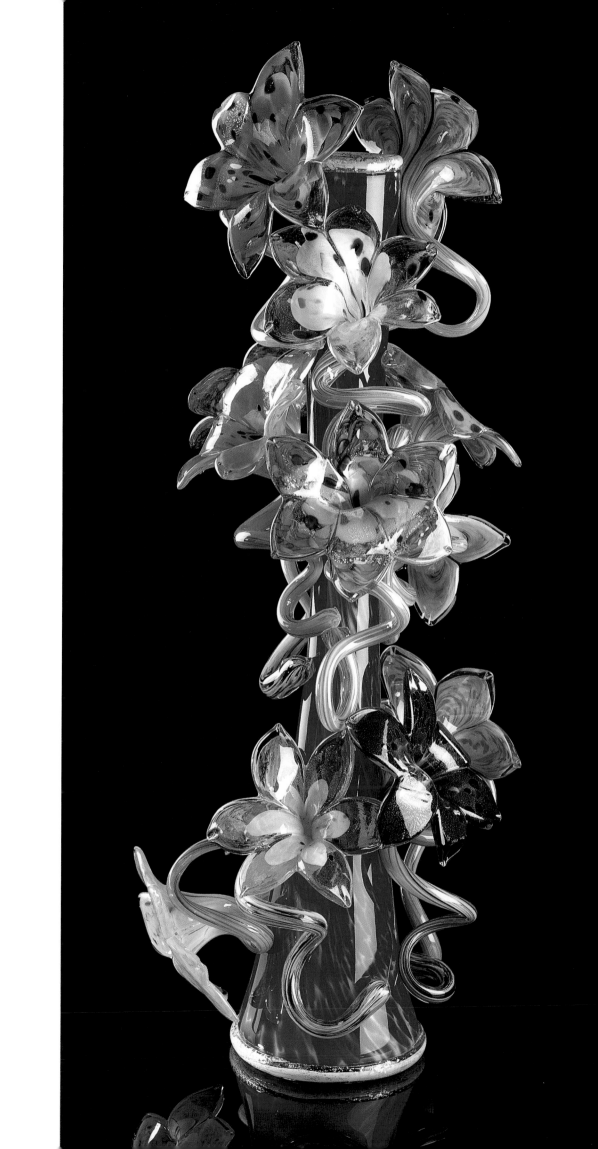

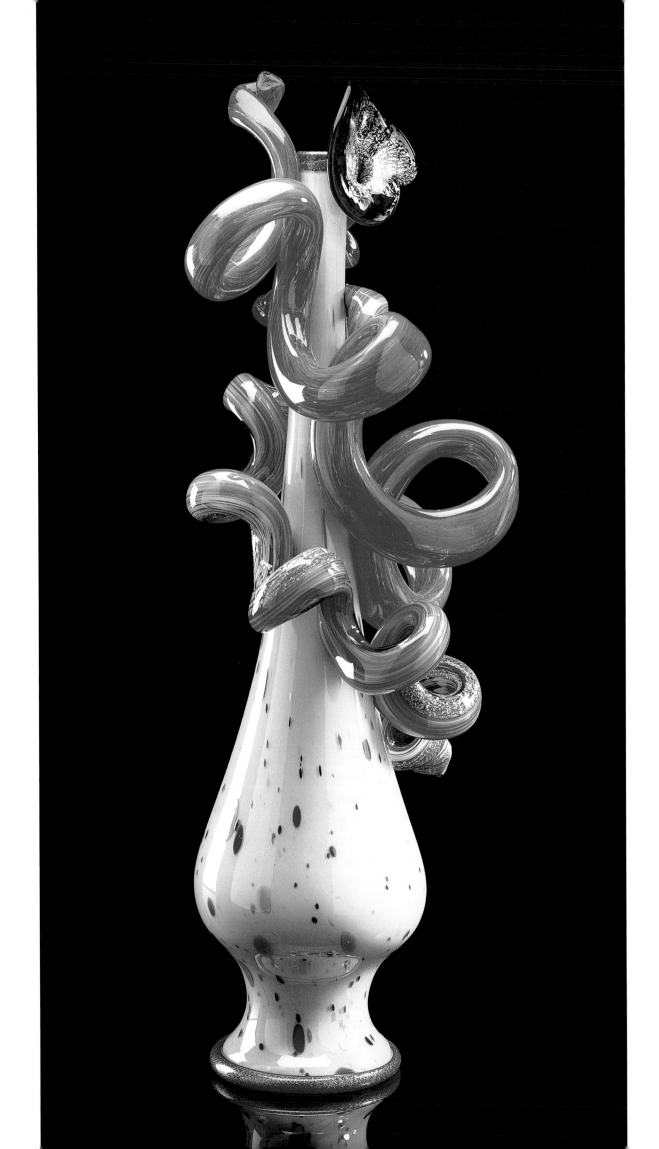

facing: *Chartreuse Venetian #488*, 1990, h. 35 in., cat. no. 110

right: *Cadmium Yellow Light Venetian #340*, 1990, d. 18 in., cat. no. 97

below: *Gold Over Green Venetian with Yellow Flowers*, 1990, h. 24 in., cat. no. 241

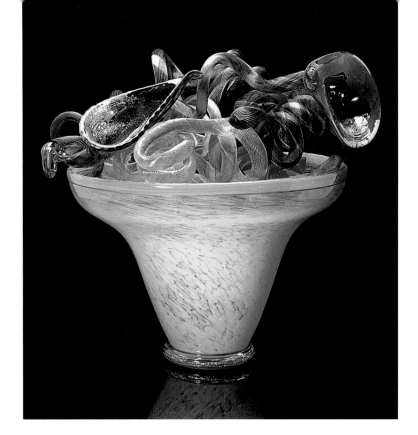

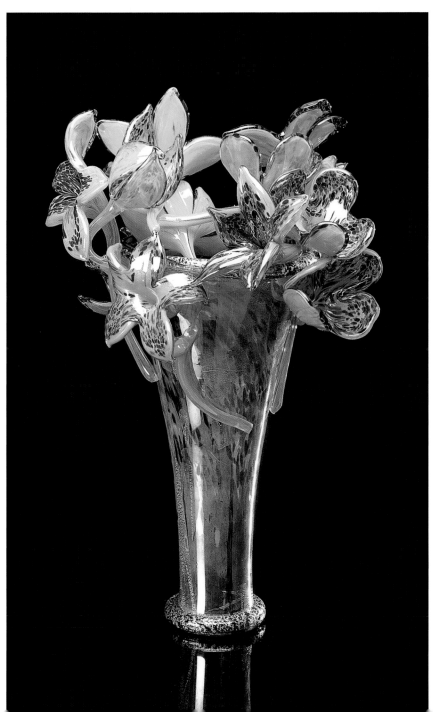

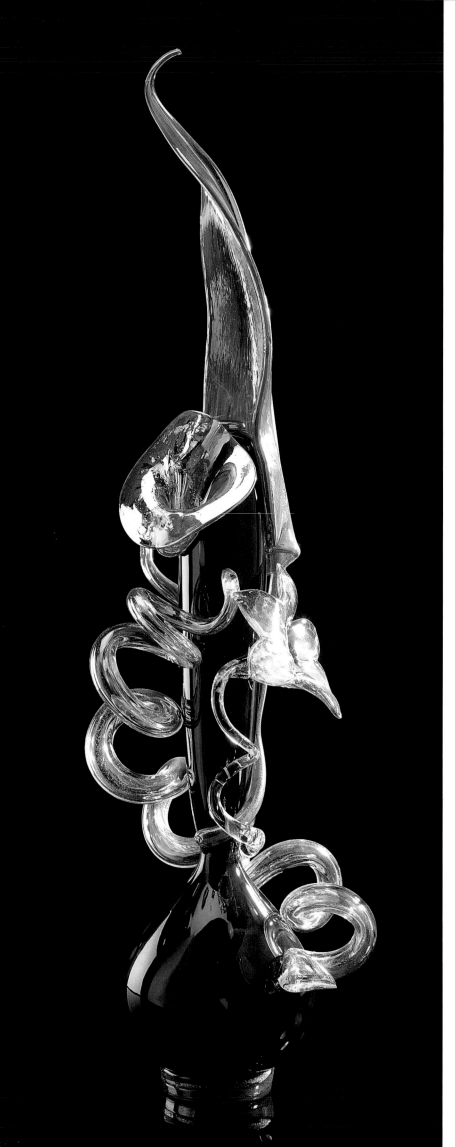

left: *Black Venetian with Golden Ochre Leaf*, 1990, h. 43 in.,
cat. no. 238
below: *Gilded Venetian with May Green Flowers*, 1990,
h. 32 in., cat. no. 107
facing: *May Green Spotted Venetian with Two Putti*, 1991,
h. 27 in., cat. no. 109

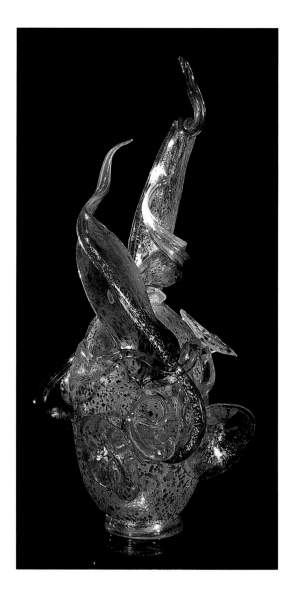

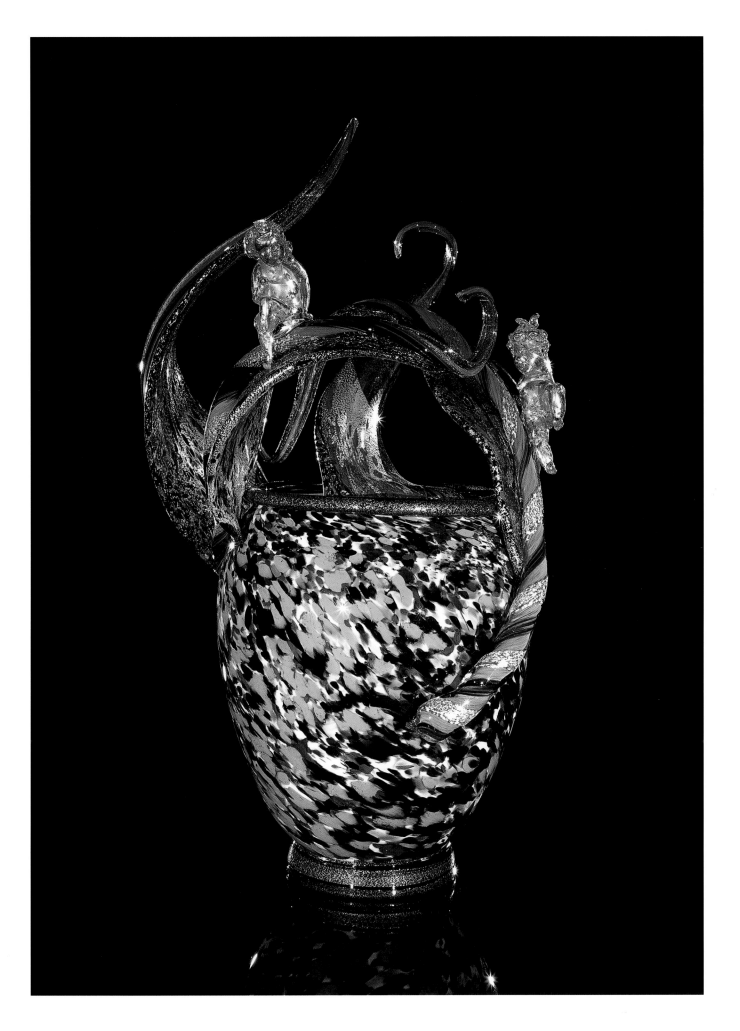

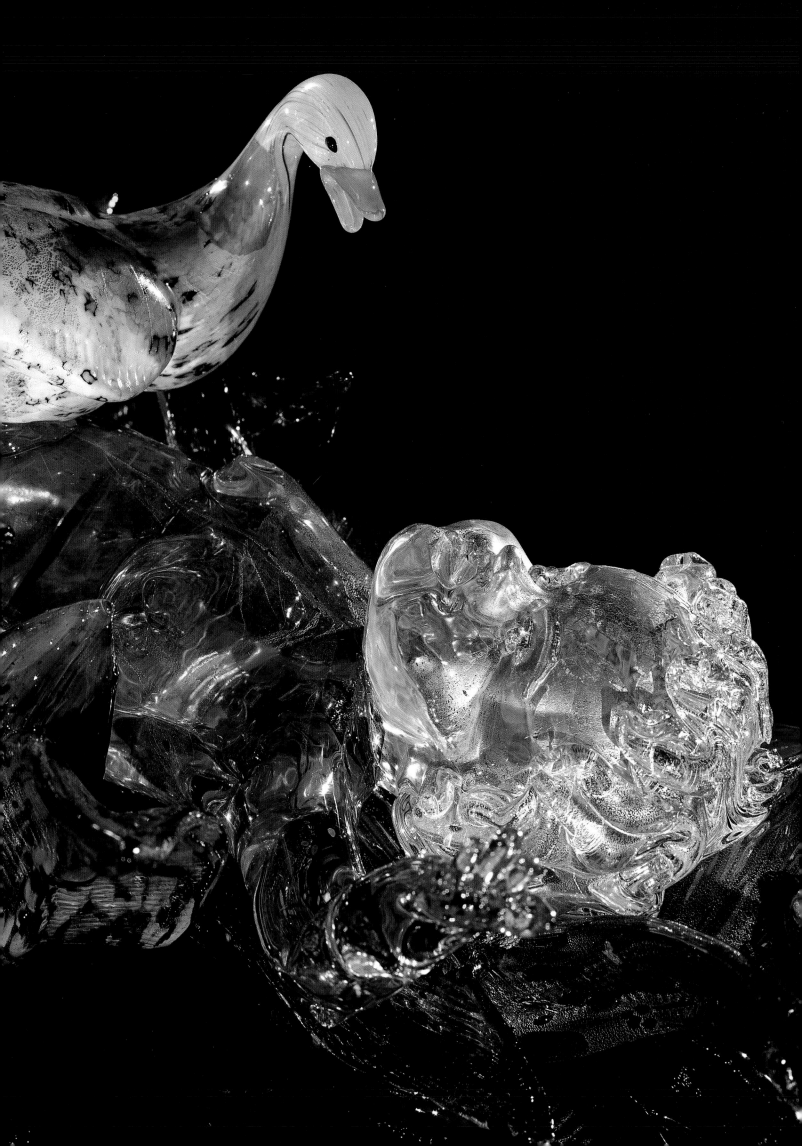

facing: detail, *Gilded Putti in Leaves with Swan*

below: *Gilded Putti in Leaves with Swan*, 1991, w. 24 in., cat. no. 236

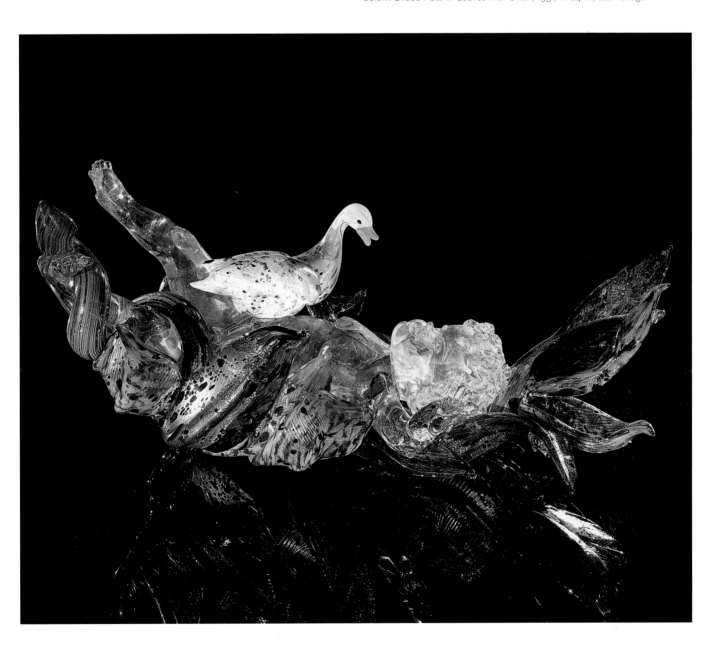

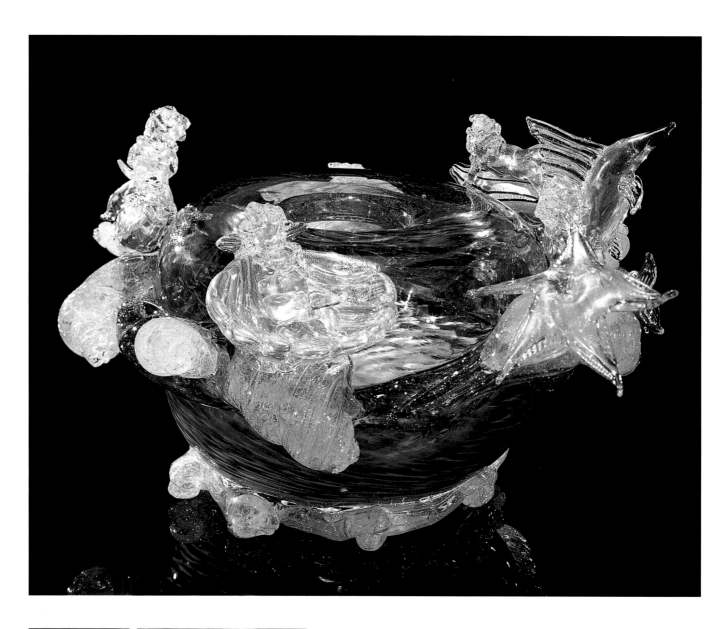

above: *Blue Seascape Venetian with Four Putti*, 1991, w. 21 in., cat. no. 237
left and facing: details, *Blue Seascape Venetian with Four Putti*

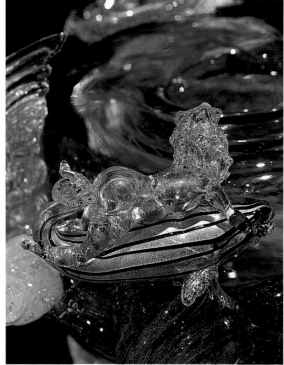

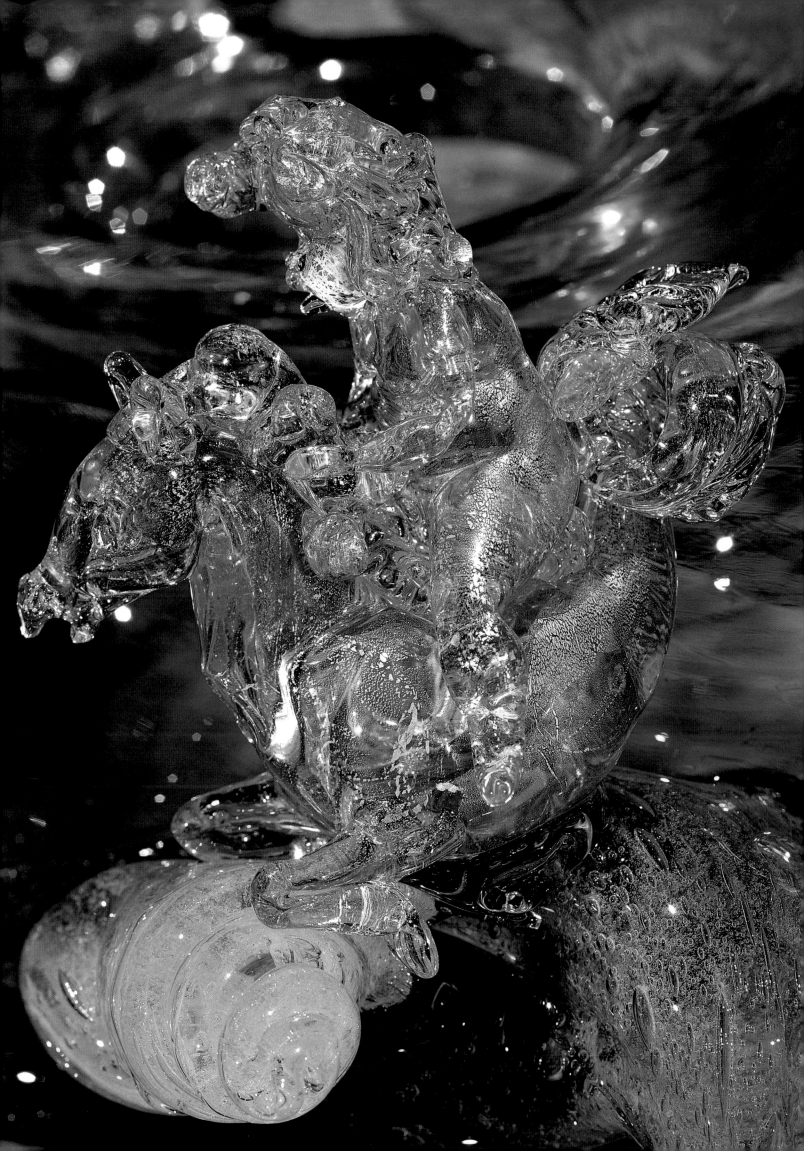

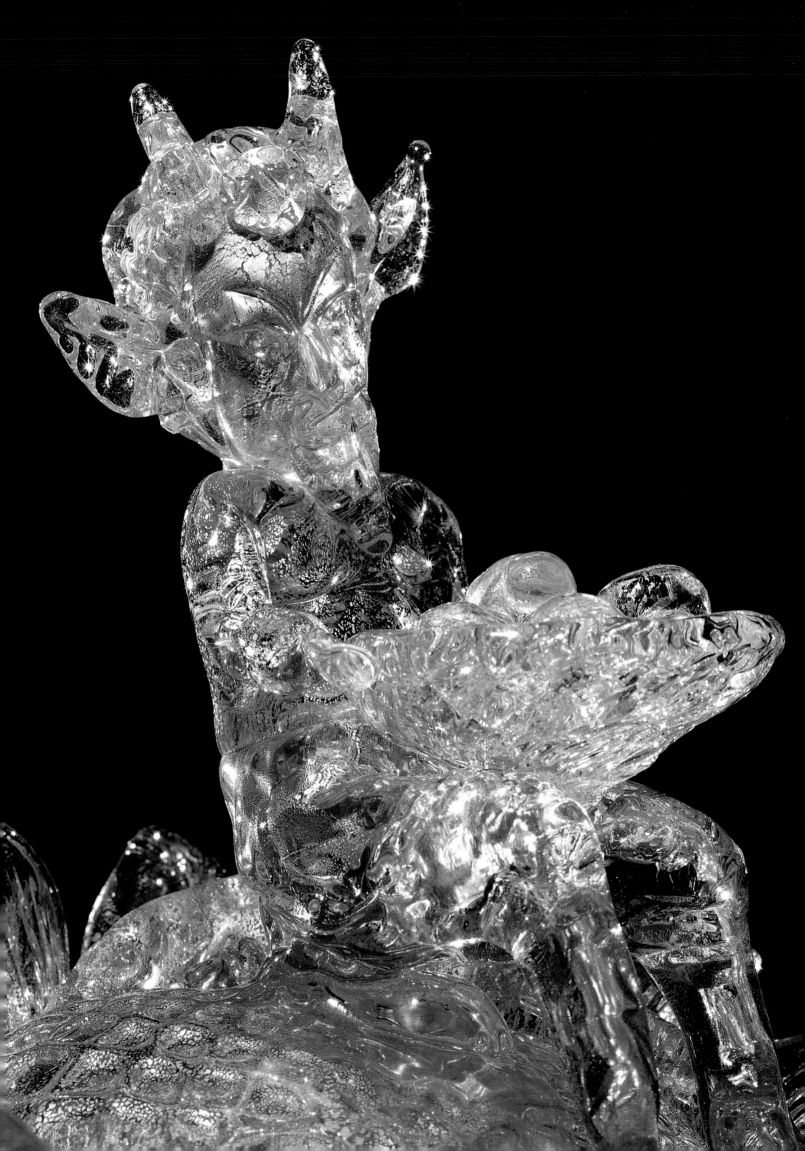

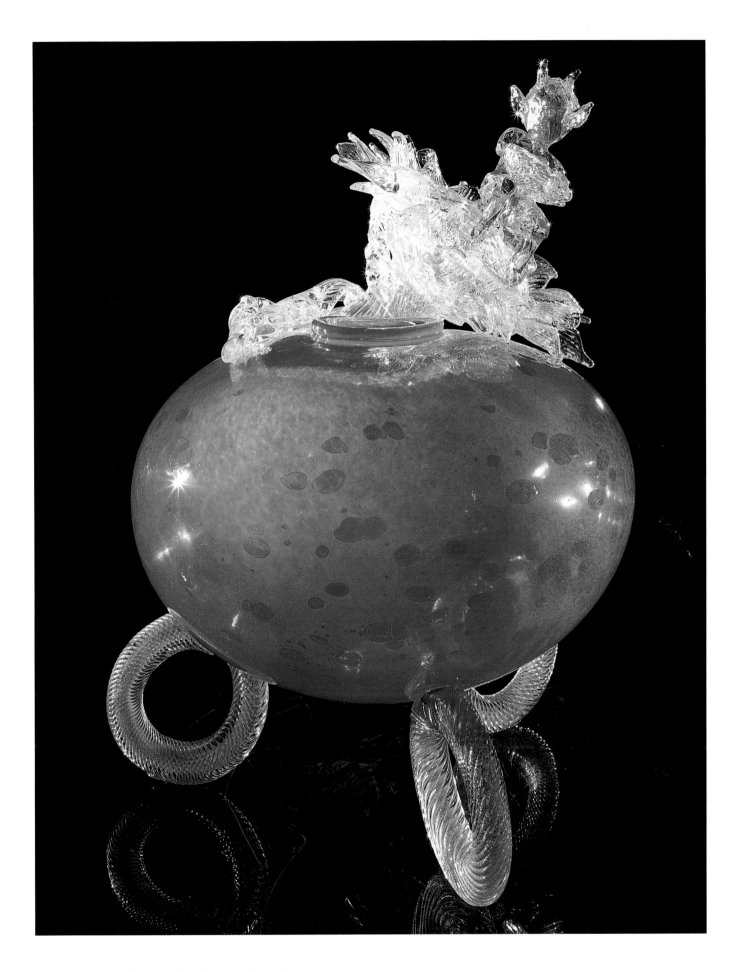

facing: detail, *Spotted Raspberry Putti Venetian with Devil On Sunflower*

above: *Spotted Raspberry Putti Venetian with Devil On Sunflower*, 1994, h. 19 in., cat. no. 245

below: *Gilded Mystic Blue Putti Venetian with Swan and Cherubs*, 1994, h. 19 in., cat. no. 242
facing: *Translucent Blue Putti Venetian with Gilt Leaves and Dragons*, 1994, h. 17 in., cat. no. 248

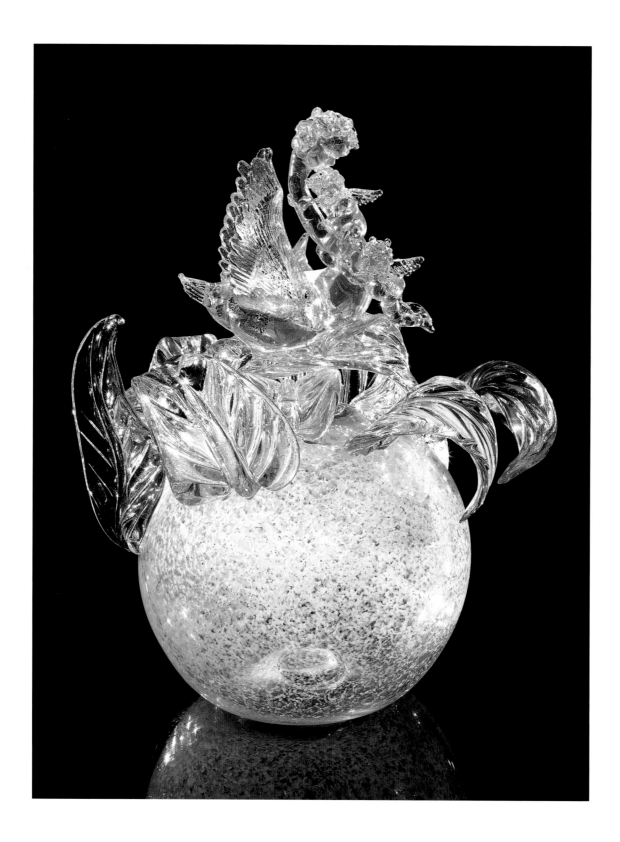

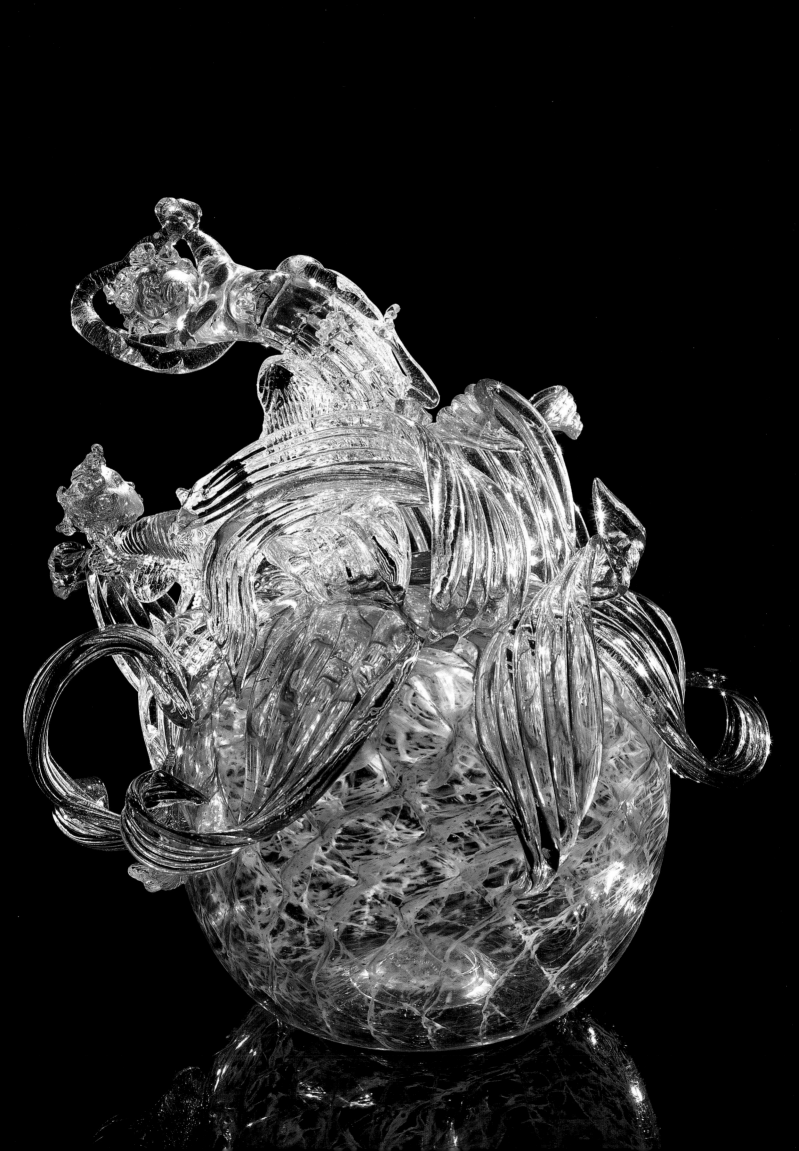

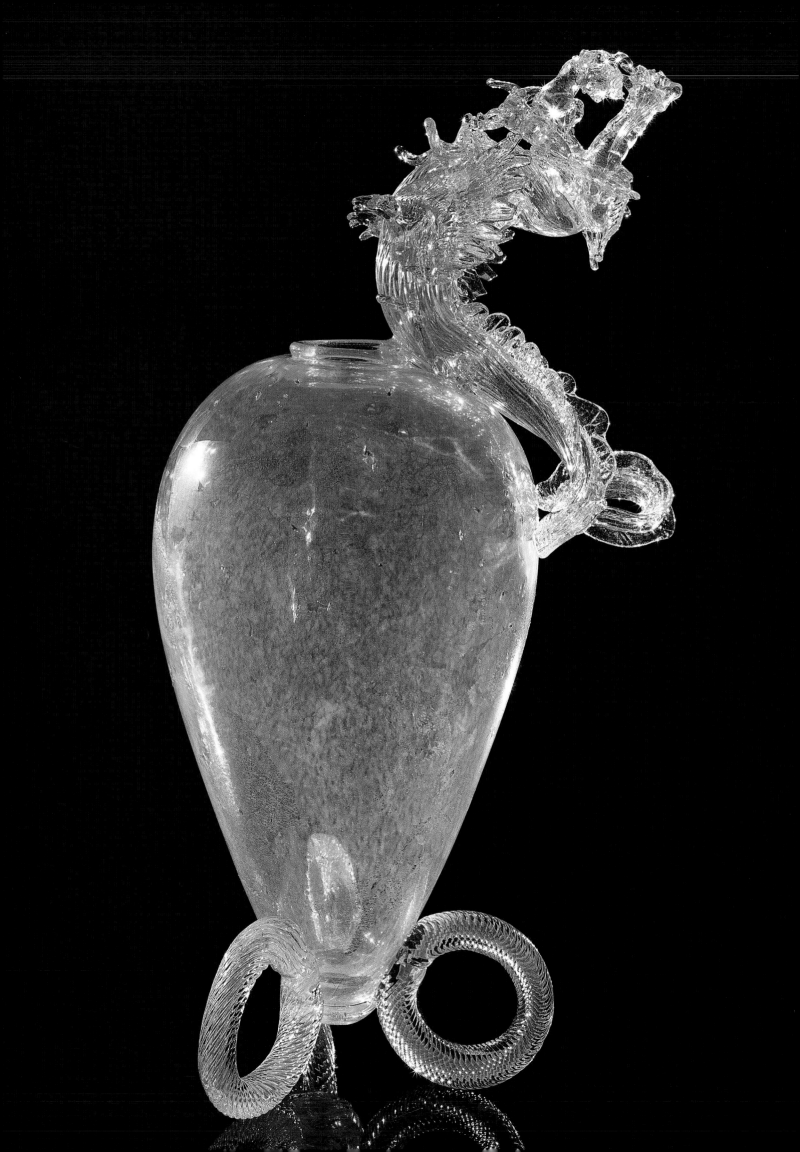

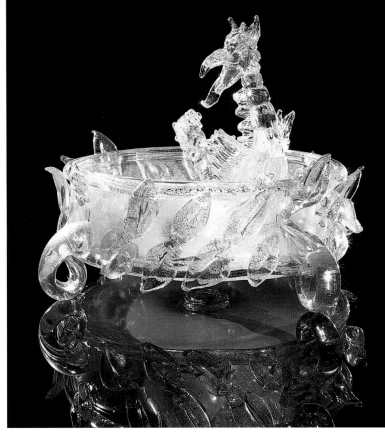

facing: *Golden Putti Venetian with Dragon*, 1994, h. 27 in., cat. no. 246

above: *Gold Over Fountain Green Putti Venetian with Leaves and Dragon*, 1994, w. 18 in., cat. no. 244

left: *Fountain Green Putti Venetian with Gilt Leaves and Centaur*, 1994, h. 18 in., cat. no. 247

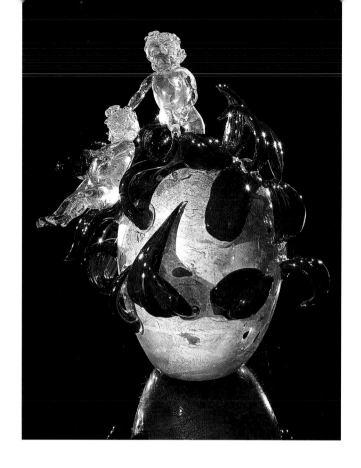

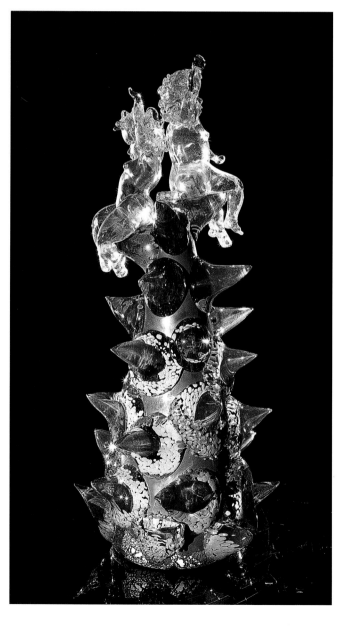

facing, top: *Gold Over Pale Ruby Putti Venetian with Burgundy Leaves,* 1994, h. 19 in., cat. no. 243

facing, bottom: *Silver Over Navy Blue Putti with Spotted Raspberry Prunts,* 1994, h. 13 in., cat. no. 249

below: *Gilt Tangerine Putti Venetian with Handles and Ribbons,* 1994, h. 19 in., cat. no. 253

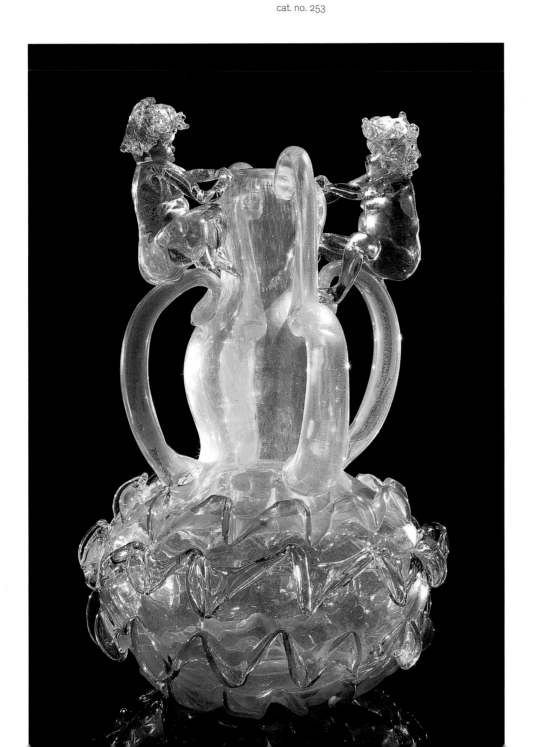

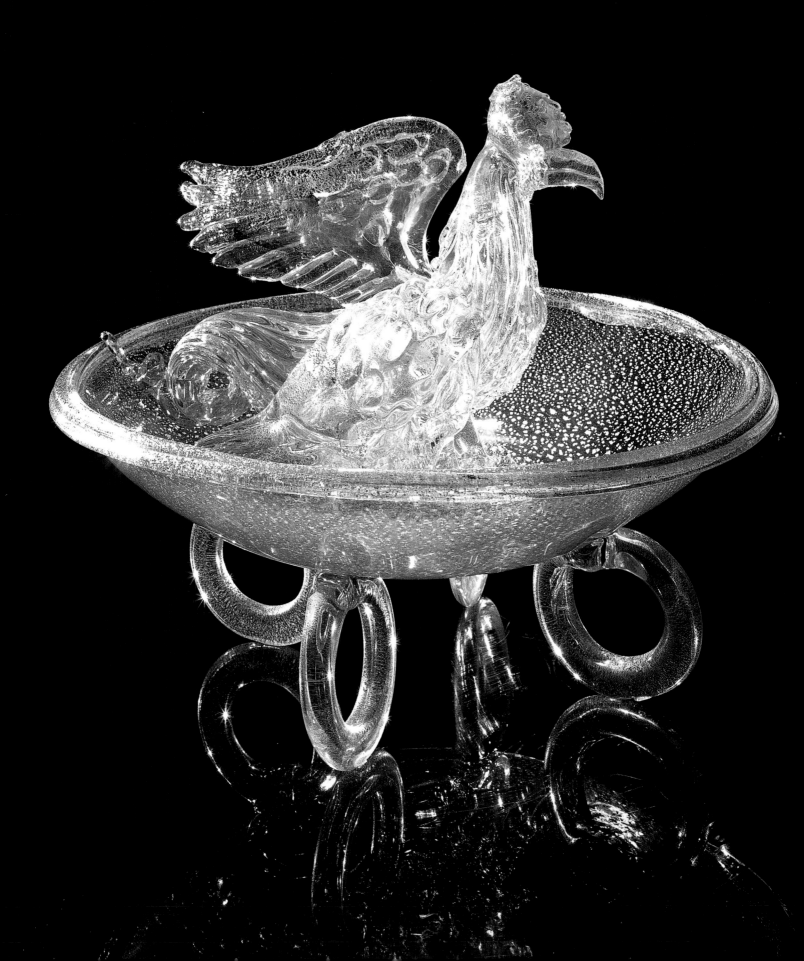

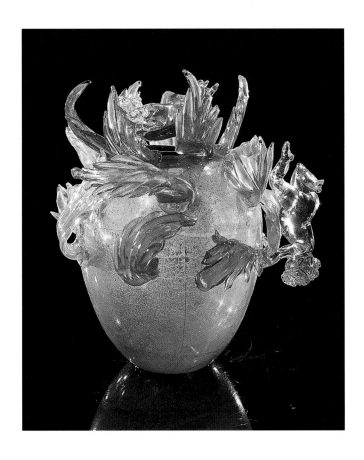

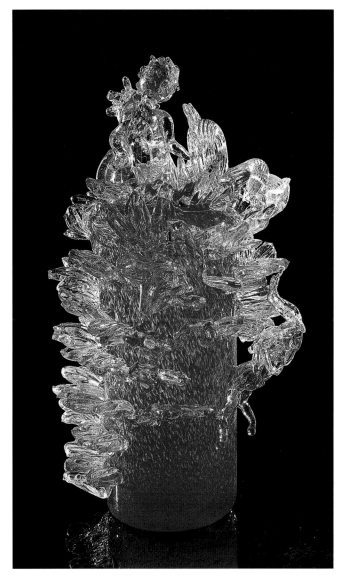

facing: *Spotted Gold Putti Venetian with Eagle*, 1994, w. 19 in., cat. no. 251

above: *Gold Over Bright Orange Putti Venetian with Leaves*, 1994,

h. 15 in., cat. no. 250

right: *Ruby Red Putti Venetian with Gilt Ram and Twin-headed Dragon*,

1994, h. 20 in., cat. no. 252

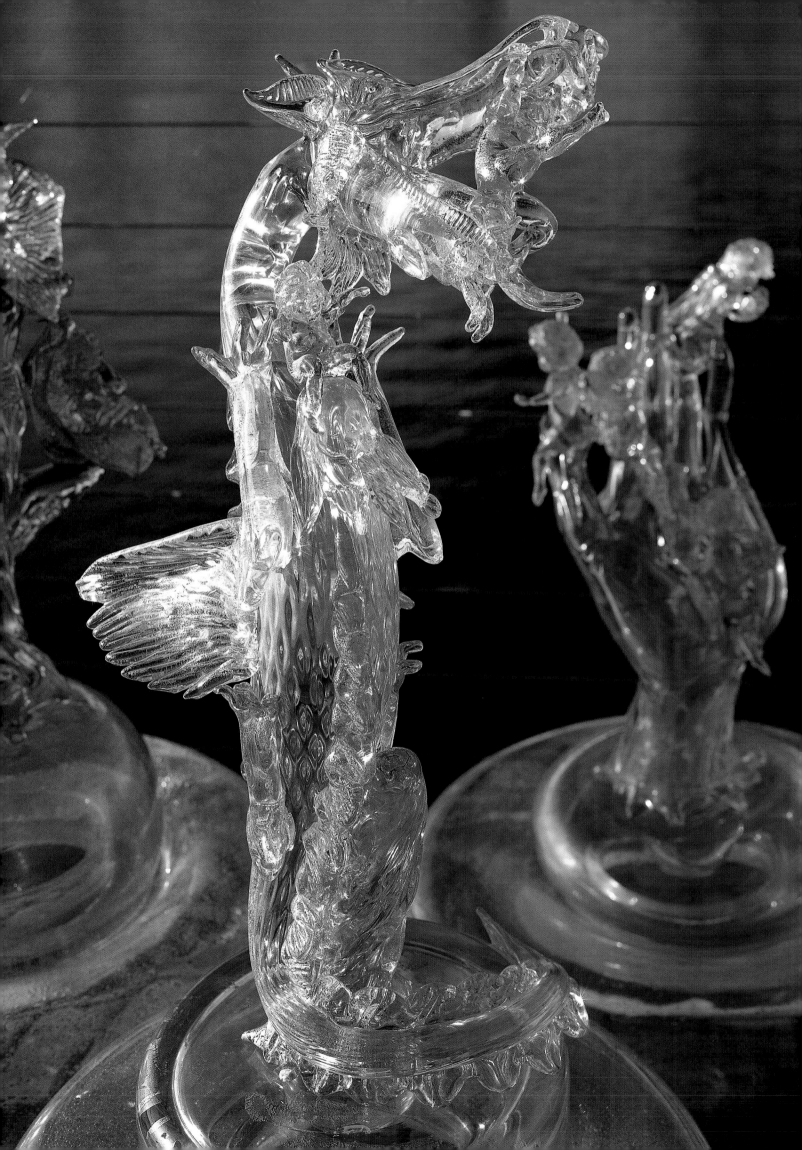

facing: Stoppers, cat. nos. 308, 309, 310

below: *Stopper (Putti and the Dragon),* 1994–97, h. 43 in., cat. no. 309

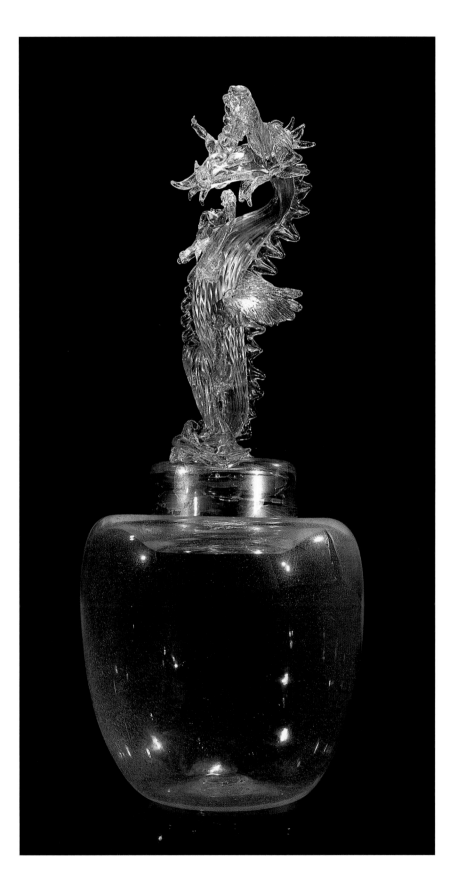

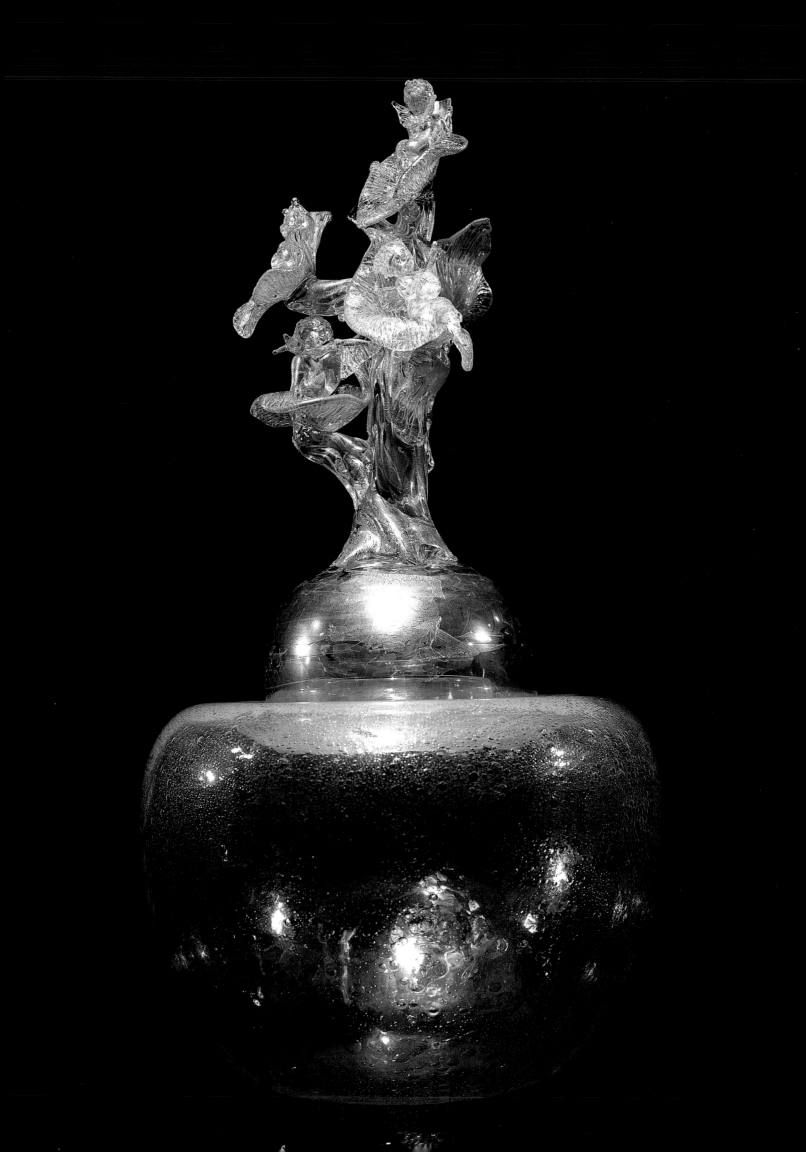

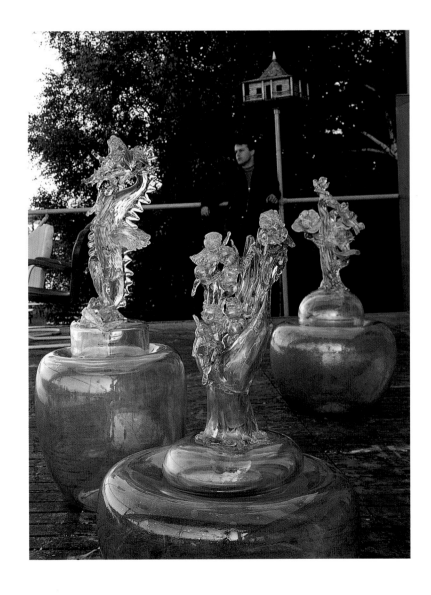

facing: *Stopper (Putti and the Tree)*, 1994–97, h. 40 in.,
cat. no. 308

right: Stoppers, cat. nos. 308, 309, 310

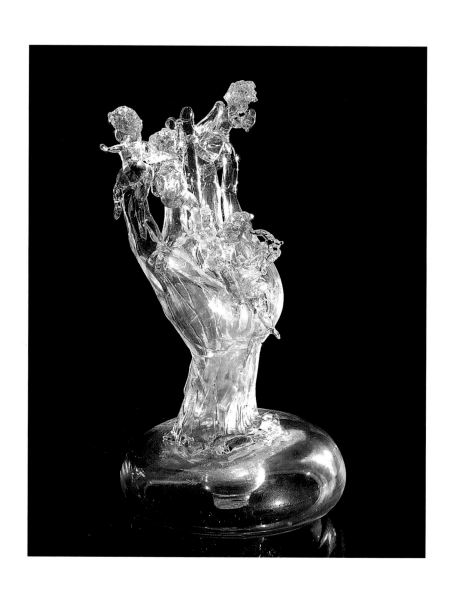

above and facing: *Stopper (Putti and the Hand)*, 1994–97, h. 33 in., cat. no. 310

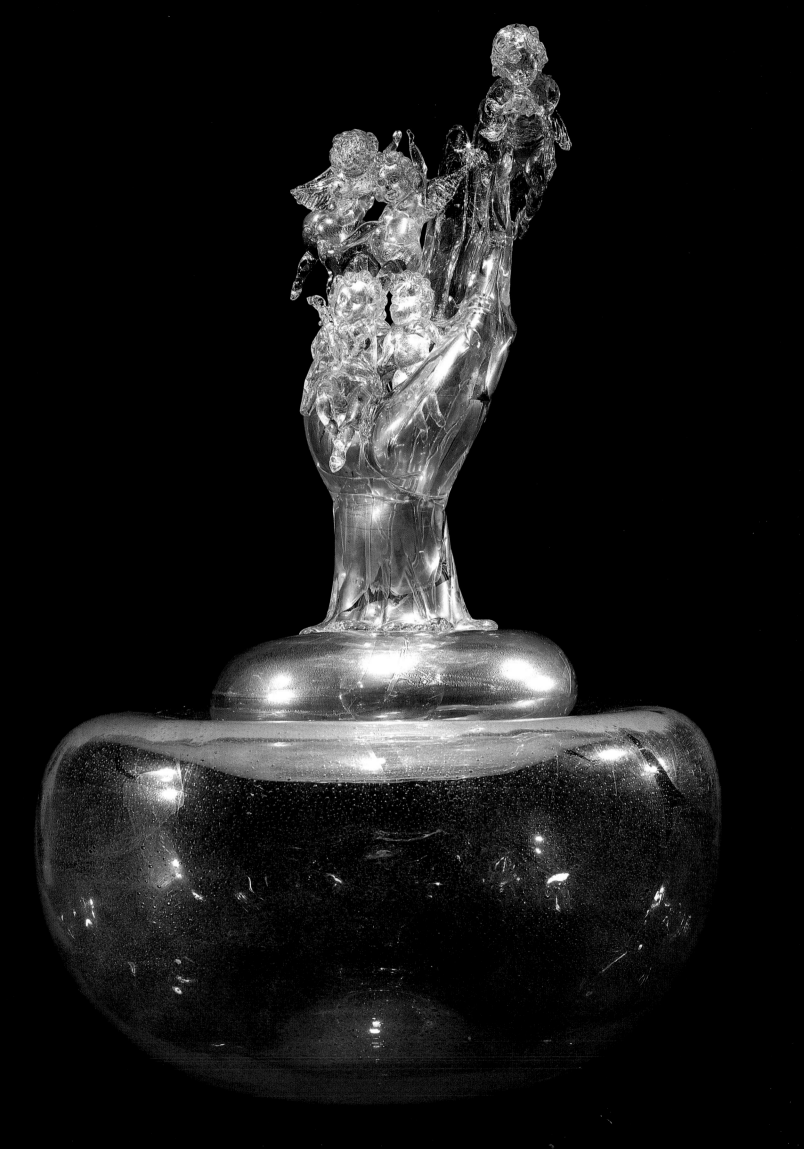

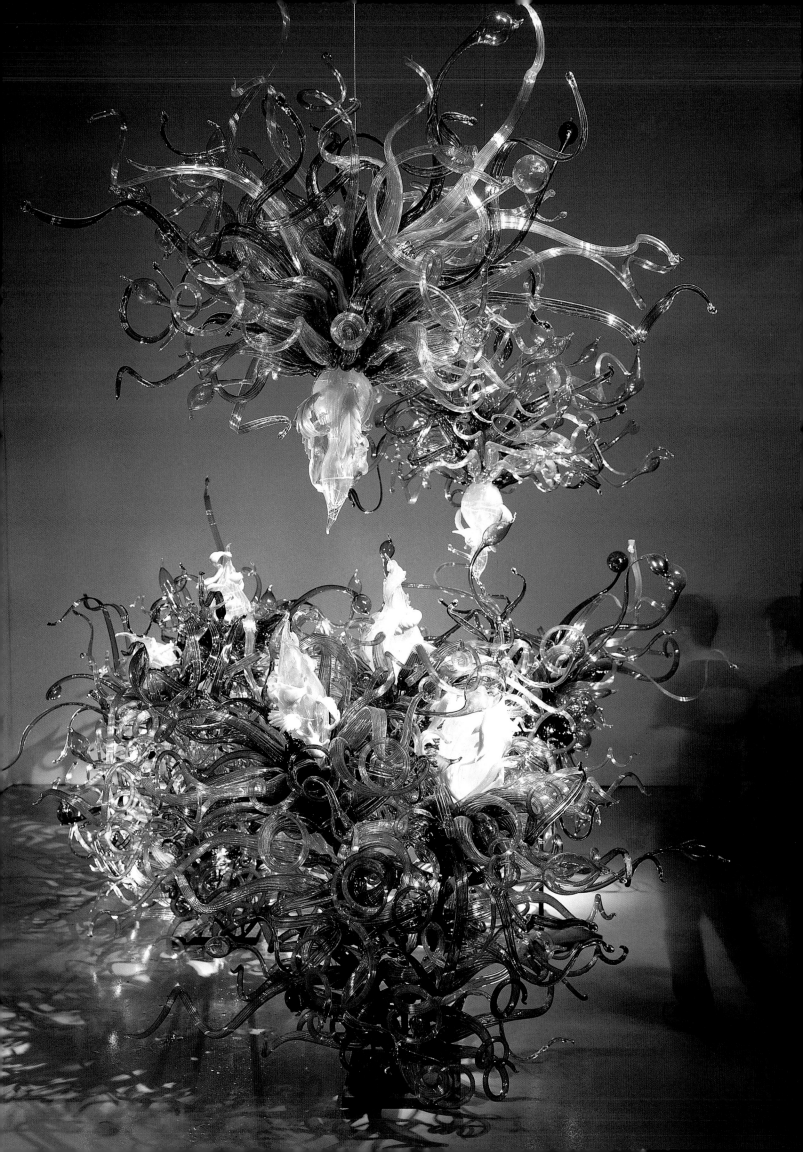

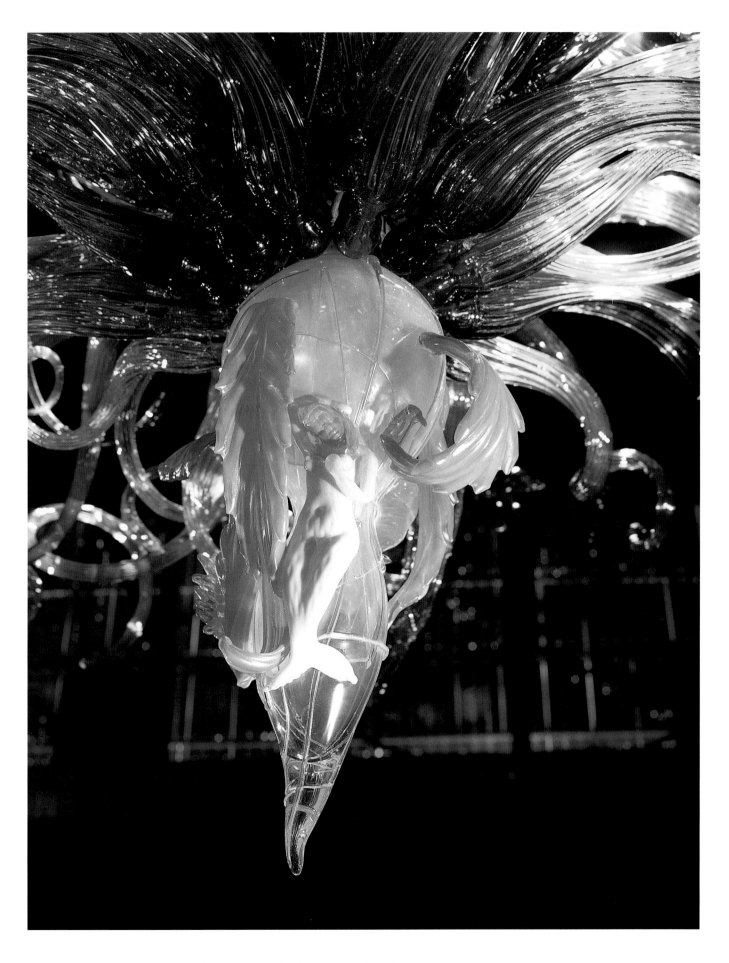

above: *Laguna Murano Chandelier,* 1996–97, dimensions variable, cat. no. 311

facing and pages 110–11: details, *Laguna Murano Chandelier*

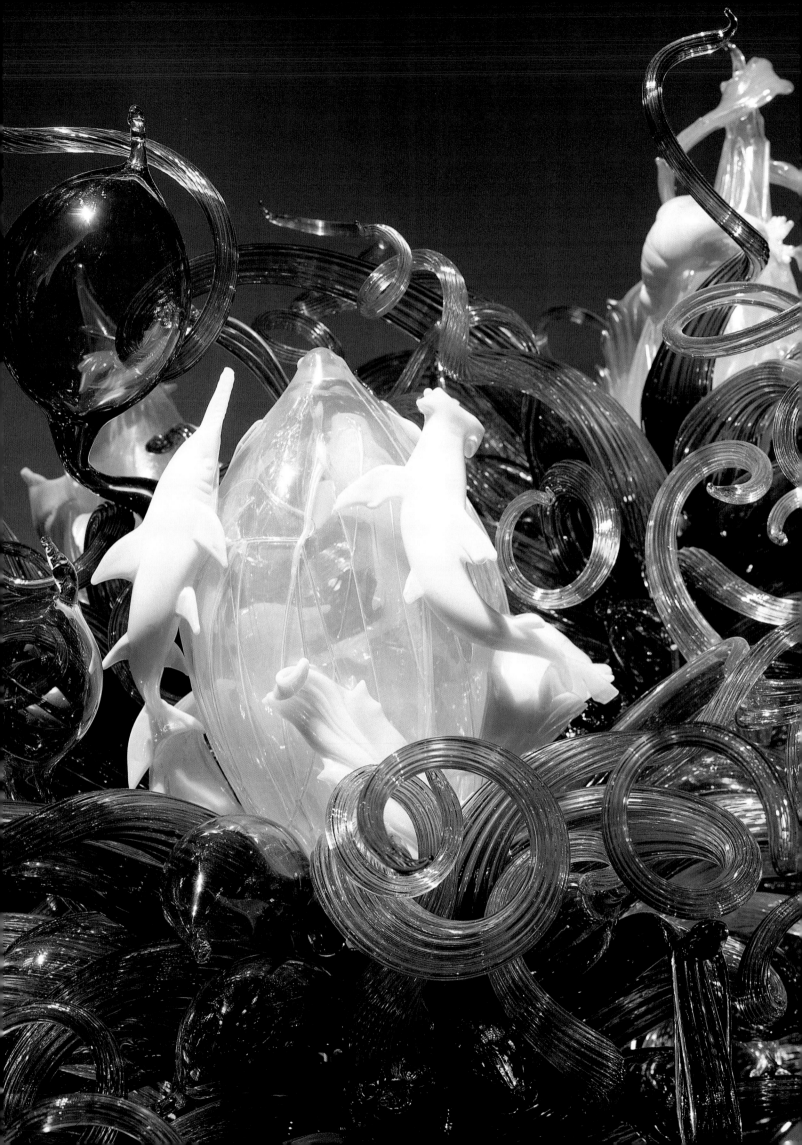

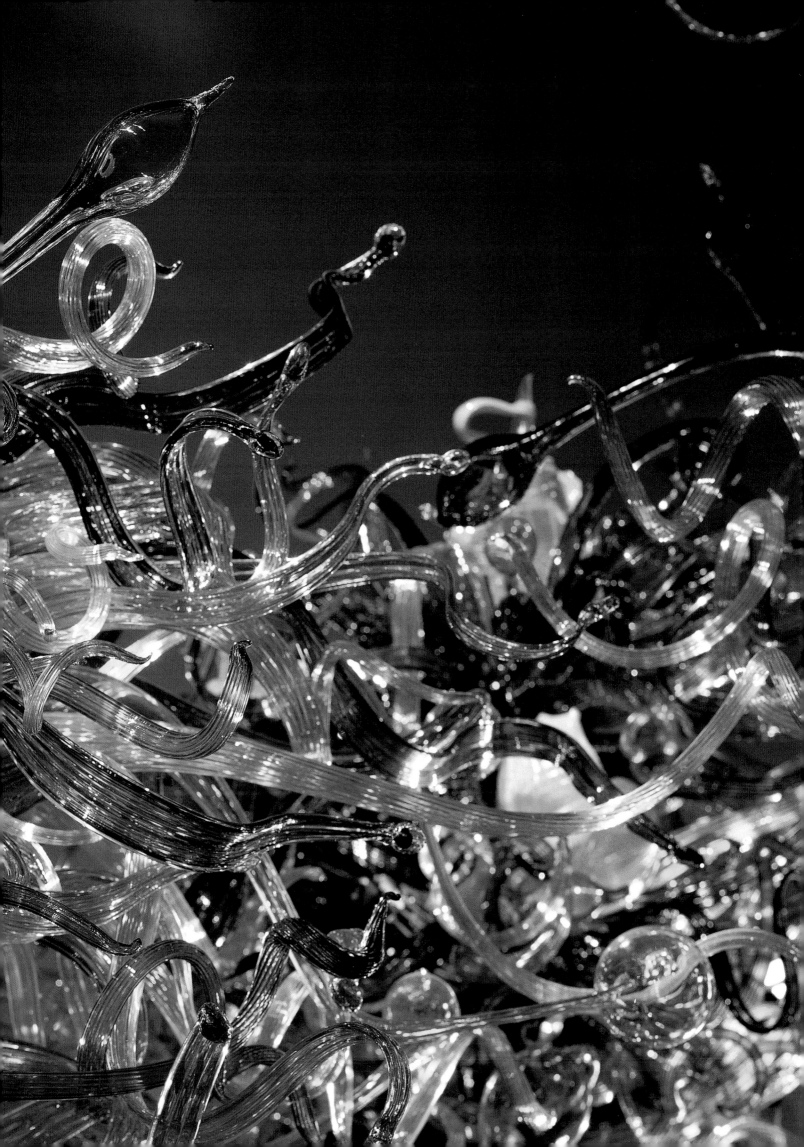

right: *Niijima Drawing #52,* 1989,
graphite and watercolor on paper,
22 × 30 in., cat. no. 343
below left: *Basket Drawing,* 1983, mixed
media on paper, 30 × 22 in., cat. no. 338
below right: *Macchia Drawing #14,* 1982,
charcoal, watercolor, and graphite on
paper, 30 × 22 in., cat. no. 312
facing: *Basket Drawing,* n.d., mixed
media on paper, 30 × 22 in., cat. no. 339

left: *Venetian Drawing*, 1990, pastel and charcoal on paper, 30 × 22 in., cat. no. 349
below: *Pink Putti Drawing*, 1989, pastel and charcoal on paper, 30 × 22 in., cat. no. 335
facing: *Ebeltoft Drawing*, 1991, mixed media on paper, 45 × 30 in., cat. no. 323

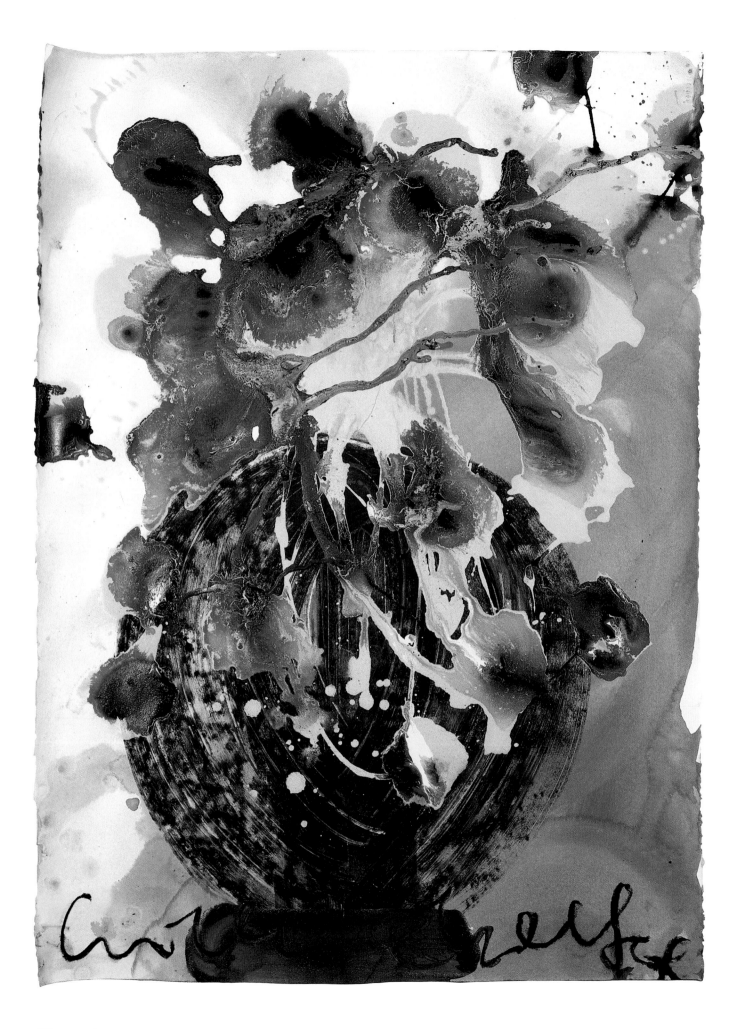

116

facing: *Ebeltoft Drawing*, 1991, mixed media on paper,
30 × 22 in., cat. no. 320
below: *Ebeltoft Drawing*, 1991, mixed media on paper,
45 × 30 in., cat. no. 322
pages 118–19: *Ebeltoft Drawing*, 1991, mixed media on
paper, 50 × 70 in., cat. no. 316

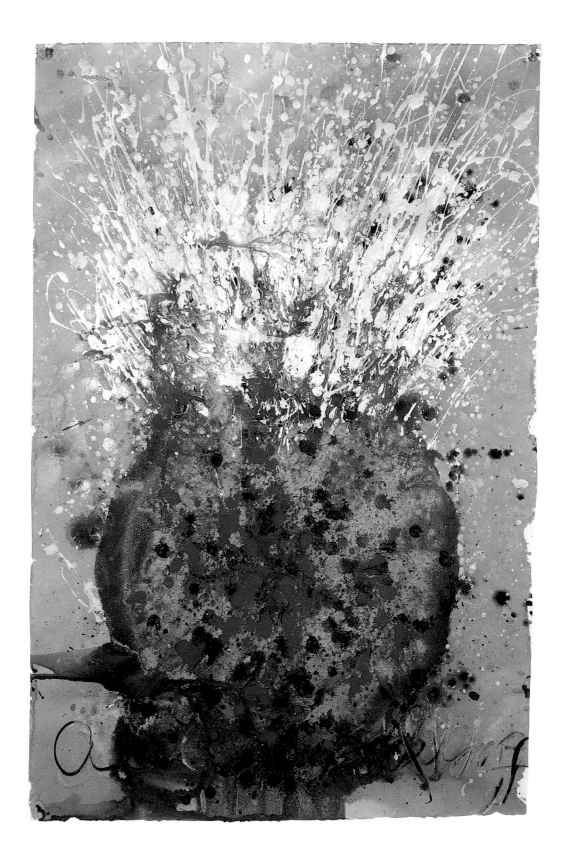

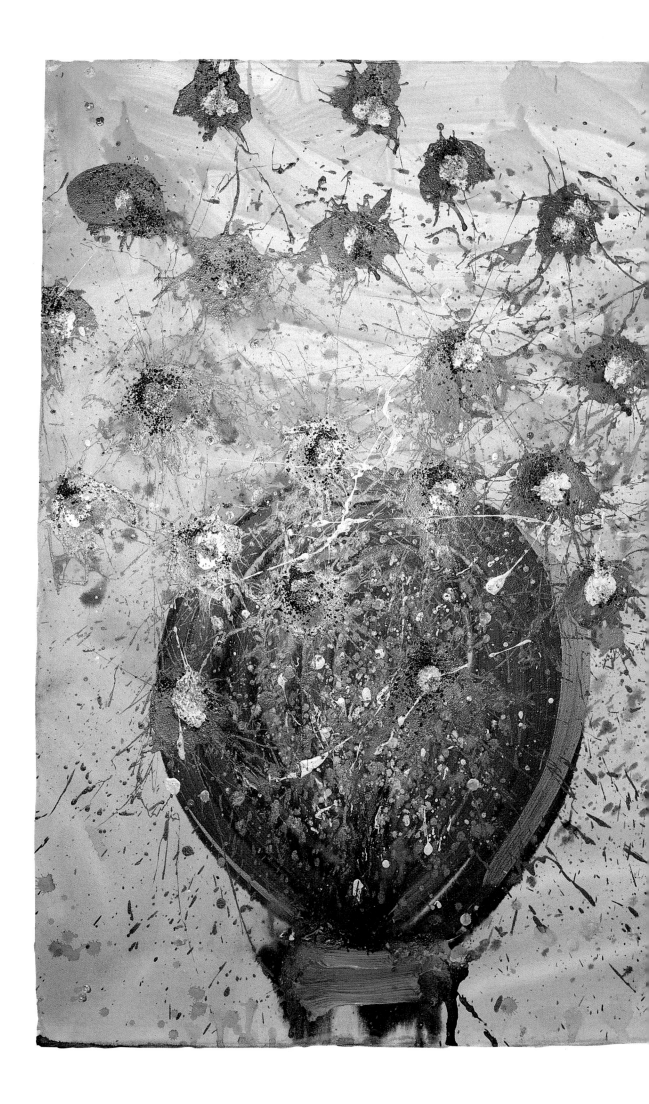

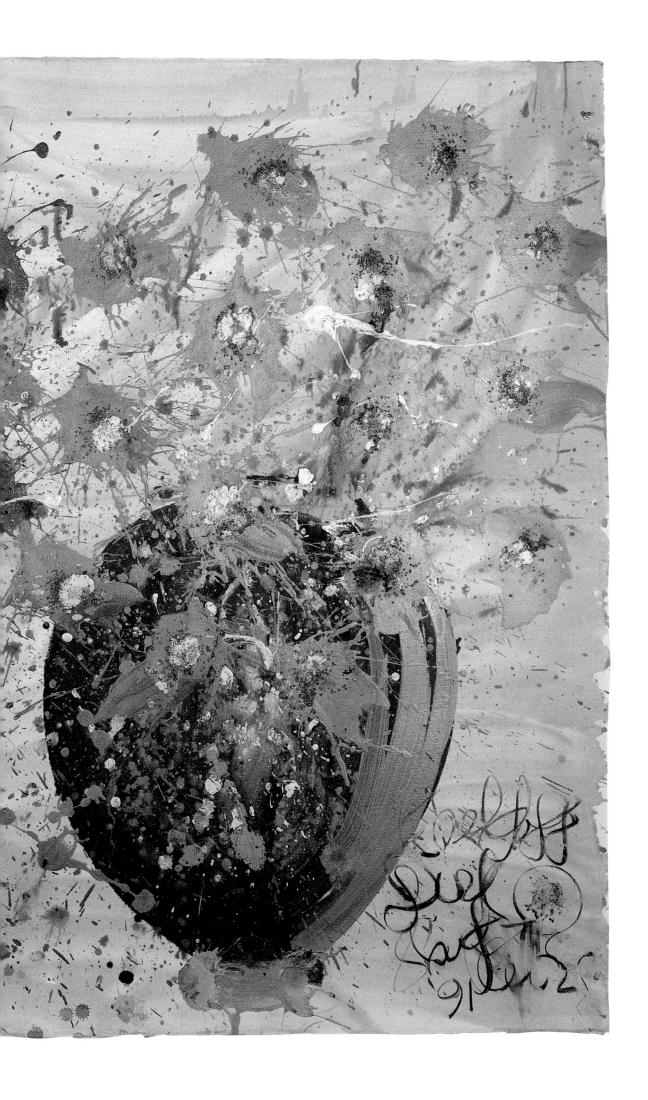

above: *Seoul Venetian Drawing*, 1990, acrylic and ink on paper, 65 × 52 in., cat. no. 346

facing: *Seoul Venetian Drawing #2*, 1990, charcoal, acrylic, and watercolor on paper, 65 × 52 in., cat. no. 347

Ebeltoft Drawing, 1991, mixed media on paper, 45 × 30 in., cat. no. 321

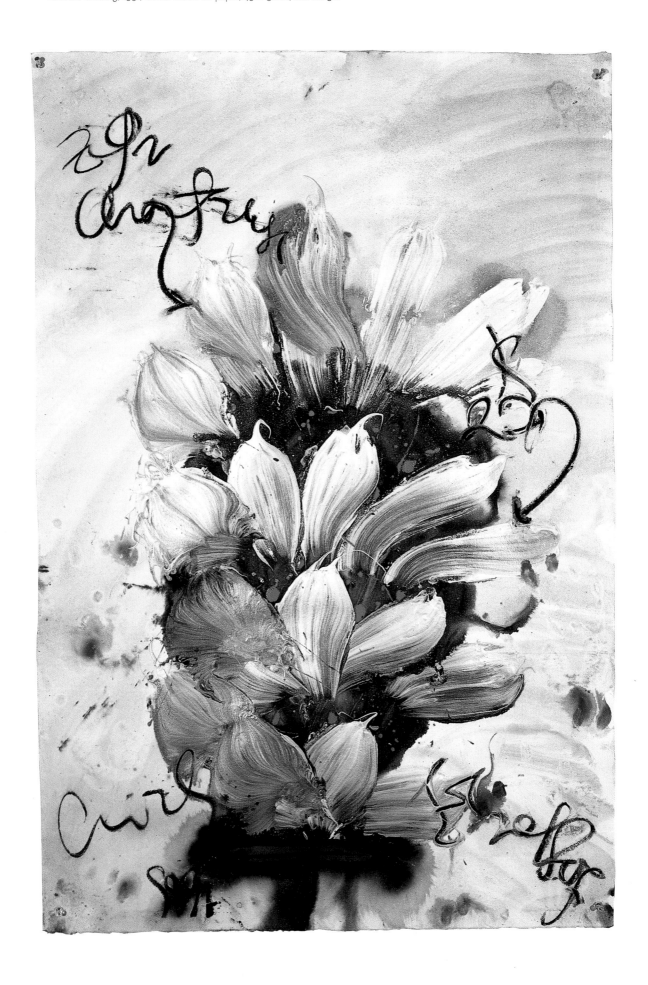

Dimensions are in inches; height precedes width precedes depth. All works are in glass, unless otherwise indicated.

Irish Cylinders

1. (page 38)
Irish Cylinder #1, 1975
9½ × 7½

2. (page 36)
Irish Cylinder #2, 1975
10 × 7

3. (page 39)
Irish Cylinder #3, 1975
9 × 7¼

4. (page 22)
Irish Cylinder #4, 1975
8½ × 7

5. (page 41)
Irish Cylinder #5, 1975
11½ × 7½

6. (page 31)
Irish Cylinder #6, 1975
6½ × 4

7. (page 31)
Irish Cylinder #7, 1975
8½ × 4

8. (page 31)
Irish Cylinder #8, 1975
7½ × 5

9. (page 41)
Irish Cylinder #9, 1975
10½ × 6

10. (page 38)
Irish Cylinder #10, 1975
8½ × 5½

11. (page 32)
Irish Cylinder #11, 1975
9½ × 7½

12. (page 35)
Irish Cylinder #12, 1975
12½ × 5½

13. (pages 17, 33)
Irish Cylinder #13, 1975
9½ × 5½

14. (page 36)
Irish Cylinder #14, 1975
9 × 5

15. (page 41)
Irish Cylinder #15, 1975
12½ × 6½

16. (page 35)
Irish Cylinder #16, 1975
9½ × 4½

17. (page 32)
Irish Cylinder #17, 1975
7 × 3

18. (page 35)
Irish Cylinder #18, 1975
10 × 5

19. (page 35)
Irish Cylinder #19, 1975
11½ × 5½

20. (page 39)
Irish Cylinder #20, 1975
12½ × 6

21. (page 41)
Irish Cylinder #21, 1975
10 × 8

22. (page 40)
Irish Cylinder #22, 1975
8 × 7

23. (page 40)
Irish Cylinder #23, 1975
7½ × 6½

24. (page 40)
Irish Cylinder #24, 1975
9 × 7

25. (page 39)
Irish Cylinder #25, 1975
10 × 7½

26. (page 32)
Irish Cylinder #26, 1975
9 × 5

27. (page 38)
Irish Cylinder #27, 1975
9½ × 6½

28. (page 41)
Irish Cylinder #28, 1975
11½ × 9

29. (page 33)
Irish Cylinder #29, 1975
7 × 3

30. (pages 33, 37)
Irish Cylinder #30, 1975
5½ × 4

31. (pages 33, 37)
Irish Cylinder #31, 1975
9 × 5

32. (page 41)
Irish Cylinder #32, 1975
11 × 5½

33. (page 31)
Irish Cylinder #33, 1975
11 × 4½

34. (page 38)
Irish Cylinder #34, 1975
10 × 5½

35. (pages 17, 33)
Irish Cylinder #35, 1975
9 × 4½

36. (page 39)
Irish Cylinder #36, 1975
10 × 6

37. (page 37)
Irish Cylinder #37, 1975
9½ × 6½

38. (page 20)
Irish Cylinder #38, 1975
10 × 8

39. (page 39)
Irish Cylinder #39, 1975
9 × 9

40. (page 36)
Irish Cylinder #40, 1975
8 × 6

41. (page 34)
Irish Cylinder #41, 1975
10½ × 8

42. (page 32)
Irish Cylinder #42, 1975
9½ × 6 ½

43. (page 34)
Irish Cylinder #43, 1975
10 × 6

44. (pages 17, 36)
Irish Cylinder #44, 1975
10½ × 6½

Macchia

45. (page 46)
Veronese Green Macchia with Blue Etain Jimmies, 1981
8 × 9 × 9

46. (page 47)
Wisteria Violet Macchia with Plumbago Lip Wrap, 1982
6 × 12 × 8

47. (page 52)
Delta Yellow Macchia with Cassel Lip Wrap, 1981
10 × 10 × 10

48.
Red and Green Dappled Daffodil Macchia with Orion Blue Lip Wrap, 1981
6 × 7 × 6

49.
Cadmium Yellow Macchia with Oxblood and Cobalt Patterns, 1982
4 × 6 × 6

50.
Alabaster Macchia with Multicolored Jimmies, 1981
6 × 5 × 5

51. (page 44)
Lumierè Green Macchia with Lapis Blue Lip Wrap, 1981
5 × 5 × 5

52.
Almond Pink Macchia with Aero and Oxblood Jimmies, 1982
5 × 10 × 8

53.
Aureolin Macchia with Pech Black Lip Wrap, 1982
8 × 12 × 11

54. (page 51)
Larkspur Blue Macchia with Persimmon Lip Wrap, 1981
8 × 12 × 10

55.
Roseleaf and Italian Ochre Macchia, 1982
8 × 8 × 7

56. (page 54)
Cobalt Violet and Poplar White Macchia, 1982
7 × 14 × 7

57. (page 48)
Araby Red Macchia with Ultramarine Lip Wrap, 1983
4 × 9 × 7

58. (page 49)
Birch Macchia with Raw Umber Lip Wrap, 1981
7 × 9 × 7

59.
Caldera Orange Macchia Pair with Black Lip Wraps, 1983
10 × 22 × 22

60.
Yellow Green Macchia with Cerulean Lip Wrap, 1983
15 × 14 × 13

61. (page 55)
Chrysanthemum Yellow Macchia with Windsor Violet Lip Wrap, 1982
10 × 13 × 17

62. (page 45)
Cobalt Turquoise Macchia with Terra Rosa Lip Wraps, 1983
12 × 20 × 17

63. (page 42)
Marigold Macchia Set with Kashmir Green Lip Wrap, 1982
14 × 27 × 20

64.
Davy's Gray Macchia with Crimson Lip Wrap, 1981
7 × 13 × 5

65.
Quince Yellow Macchia with Argon Blue Lip Wrap, 1981
6 × 9 × 7

66. (page 43)
Aureolin Yellow Macchia with Armenian Blue Lip Wrap, 1981
5 × 7 × 7

67.
Naples Yellow Macchia with Desert-colored Jimmies, 1981
7 × 11 × 10

68.
Hazel Macchia with Carbon Lip Wrap, 1981
7 × 15 × 14

69.
Emerald Ridged and Oxblood Macchia, 1981
8 × 9 × 9

70.
Italian Ochre Macchia with Apricot Lip Wrap, 1981
6 × 8 × 8

71.
Realgar Macchia with Cypress and Laurel Patterning, 1981
8 × 11 × 7

72.
Saffron Macchia with Umber Lip Wrap, 1981
5 × 9 × 7

145.
Etang Green Piccolo Venetian with Dark Ribbons, 1994
15 × 7 × 7

146. (page 56)
Nymph Pink Piccolo Venetian with Pink and Green Ribbons, 1994
11 × 7 × 7

147. (page 59)
Cerulean Blue Piccolo Venetian with Red Prunts, 1994
11 × 7 × 7

148.
Chartreuse Green Piccolo Venetian with Three Leaves, 1994
15 × 7 × 6

149.
Citron Yellow Piccolo Venetian with Magenta Leaves and Handles, 1994
8 × 7 × 8

150.
Pink Piccolo Venetian with Silver Blue Leaves and Silver Pink Coils, 1994
12 × 6 × 7

151.
Spotted Orange Piccolo Venetian with Green Leaves and Coil, 1994
12 × 5 × 5

152.
Orange Piccolo Venetian with Pink Leaves, 1994
11 × 7 × 7

153.
Black Piccolo Venetian with Green Leaf and Golden Coils, 1994
13 × 5 × 7

154.
Sienna Brown Piccolo Venetian with Magenta Leaves, 1994
9 × 7 × 8

155.
Golden Brown Piccolo Venetian with Green Leaves, 1994
4 × 10 × 10

156. (page 59)
Crackled Mauve Piccolo Venetian with Mauve Handles, 1994
9 × 6 × 6

157.
Gray Blue Piccolo Venetian with Orange Coils, 1994
14 × 7 × 7

158.
Billiard Piccolo Venetian with Mulberry Leaves, 1994
10 × 8 × 8

159.
Deep Emerald Green Piccolo Venetian, 1994
10 × 9 × 5

160. (page 58)
Gold Over Porcelain Blue Piccolo Venetian with Handles, 1994
8 × 10 × 10

161. (page 64)
Marbled Sky Blue Piccolo Venetian with Cobalt Blue Handles, 1994
10 × 9 × 5

162.
Gold Over Pink Piccolo Venetian with Rosette and Handles, 1994
10 × 6 × 6

163.
Golden Pearl Piccolo Venetian with Blue Leaf and Coil, 1994
13 × 5 × 5

164.
Rose Piccolo Venetian with Ruby Handles and Gilt Leaves, 1994
10 × 7 × 5

165.
Gold Over Violet Piccolo Venetian with Marbled Orange Leaves, 1994
10 × 7 × 5

166. (page 56)
Gold Over Purple Piccolo Venetian with Clear Spotted Leaves, 1994
10 × 8 × 5

167.
Clear Red Piccolo Venetian with Handles, Leaves and Tigerlilies, 1994
13 × 7 × 7

168.
Gold Over Amber Piccolo Venetian with Coil and Green Leaves, 1994
12 × 6 × 5

169.
Spotted Black Onyx Piccolo Venetian with Lily and Coil, 1994
15 × 5 × 5

170.
Clear Lilac Rose Piccolo Venetian with Spotted Green Prunts, 1994
11 × 8 × 7

171.
Reduced Wintergreen Piccolo Venetian with Abundant Leaves, 1994
11 × 8 × 8

172.
Marbled Yellow Piccolo Venetian with Green Leaf and Coil, 1994
14 × 7 × 7

173. (page 61)
Fluorite Violet Piccolo Venetian with Gilt Mint Green Leaves, 1994
12 × 6 × 6

174.
Gold Over Zephyr Green Piccolo Venetian with Spotted Wings, 1994
16 × 8 × 10

175. (page 56)
Gold Over Swiss Rose Piccolo Venetian with Green Leaves, 1994
12 × 9 × 8

176.
Reduced Salmon Piccolo Venetian with Abundant Leaves, 1994
13 × 9 × 8

177.
Silver Over Starlight Blue Piccolo Venetian with Clear Prunts, 1994
10 × 6 × 6

178.
Yellow Gem Piccolo Venetian with Gilt Ribbons, 1994
8 × 6 × 6

179.
Spotted Sterling Blue Piccolo Venetian with Clear Ribbons, 1994
9 × 7 × 7

180.
Crushed Strawberry Piccolo Venetian with Spiked Clear Prunts, 1994
10 × 10 × 10

181.
Gold Over Carnelian Red Piccolo Venetian with Leaves, 1994
10 × 8 × 8

182.
Gold Over Sunset Red Piccolo Venetian with Clear Prunts, 1994
10 × 9 × 9

183.
Brilliant Amber Piccolo Venetian with Abundant Clear Leaves, 1994
10 × 7 × 7

184.
Green and Blue Spotted Clear Piccolo Venetian with Prunts, 1994
12 × 7 × 6

185. (page 59)
Silver Over Pastel Blue Piccolo Venetian with Clear Prunts, 1994
10 × 8 × 8

186.
Silver Over Ruby Piccolo Venetian with Marbled Green Prunts, 1994
6 × 7 × 8

187.
Brilliant Yellow Piccolo Venetian with Light Sky Blue Leaves, 1995
8 × 5 × 5

188.
Marbled Red-Orange Piccolo Venetian with Handles and Leaves, 1995
10 × 9 × 5

189.
Mottled Red-Orange Piccolo Venetian with Bright Green Coils, 1995
10 × 7 × 6

190.
Clear Pale Green Piccolo Venetian with Abundant Leaves, 1995
10 × 7 × 7

191.
Clear Pale Lavender Piccolo Venetian with Handles and Leaves, 1995
10 × 9 × 7

192.
Silver Over Peacock Blue Piccolo Venetian with Coil and Leaf, 1995
11 × 4 × 5

193.
Chamoline Yellow Piccolo Venetian with Blue Flowers and Coils, 1995
11 × 6 × 4

194.
Clear Piccolo Venetian with Pink Leaves, Flowers, and Handles, 1995
11 × 6 × 7

195.
Red Rose Piccolo Venetian with Abundant Green Leaves, 1995
10 × 7 × 7

196.
Ultramarine Piccolo Venetian with Russet and Green Fronds
14 × 8 × 10

197.
Pale Pink Piccolo Venetian with Larkspur Blue Leaves, 1995
12 × 9 × 9

198.
Light Cerulean Blue Piccolo Venetian with Coils and Green Leaves, 1995
9 × 6 × 7

199. (page 58)
Clear Red Piccolo Venetian with Opal Blue Leaves and Handles, 1995
9 × 9 × 5

200.
Sulphine Yellow Piccolo Venetian with Leaves and Handles, 1995
11 × 9 × 6

201.
Celadon Green Piccolo Venetian with Pink Handles and Leaves, 1995
10 × 9 × 5

202.
Mottled Red-Orange Piccolo Venetian with Abundant Coils, 1995
11 × 7 × 6

203.
Reduced Brilliant Blue Piccolo Venetian with Spotted Leaves, 1995
8 × 7 × 6

204. (page 66)
Coral Blush Pink Piccolo Venetian with Handles and Leaves, 1995
10 × 7 × 6

205.
Clear Pale Pink Piccolo Venetian with Ribbons and Leaves, 1995
9 × 7 × 7

206. (page 67)
Clear Pale Green and Rose Piccolo Venetian with Ribbons and Leaves, 1995
10 × 9 × 8

207.
Clear Primrose Green Piccolo Venetian with Ribbons, 1995
8 × 5 × 5

208.
Clear Larkspur Blue Piccolo Venetian with Ribbons, 1995
5 × 8 × 8

209.
Emeraude Green Piccolo Venetian with Handles and Leaves, 1995
7 × 7 × 6

210. (page 67)
Clear Pallid Violet Piccolo Venetian with Abundant Leaves, 1995
10 × 10 × 7

211. (page 61)
Marble Green Venetian with Green Lip Wrap, 1997
10 × 9 × 8

212.
Blackish Violet Piccolo Venetian with Golden Handles and Leaves, 1995
8 × 7 × 7

213.
Cadmium Lemon Piccolo Venetian with Black Coils and Lilies, 1995
10 × 6 × 6

214.
Cerulean Blue Piccolo Venetian with Coils and Yellow Flowers, 1995
10 × 6 × 5

215.
Chartreuse and Navy Piccolo Venetian with Orange Coil, 1995
12 × 7 × 6

216. (page 56)
Sandalwood Piccolo Venetian with Spotted Green Leaves, 1995
11 × 8 × 5

217.
Teal Piccolo Venetian with Poppy Red Coil and Flowers, 1995
10 × 5 × 5

218.
Spotted Orange Piccolo Venetian with Reduced Green Leaves, 1995
10 × 7 × 5

219.
Spotted Red Piccolo Venetian with Reduced Deep Purple Leaves, 1995
10 × 6 × 6

220.
Violet Piccolo Venetian with Rose Coil and Red Flowers, 1995
11 × 6 × 5

221.
Gold Over Yellow Piccolo Venetian with Reduced Plum Leaves, 1995
8 × 9 × 6

222.
Marbled Burgundy Piccolo Venetian with Reduced Green Leaves, 1995
9 × 6 × 6

223.
Turquoise Piccolo Venetian with Serpentine Coils, 1995
9 × 8 × 7

224.
Opaline Green Piccolo Venetian with Spotted Red Leaves, 1995
10 × 8 × 5

225.
Sienna Piccolo Venetian with Reduced Leaves and Green Handles, 1995
10 × 8 × 5

226.
Gold Over Blue Piccolo Venetian with Spotted Green Leaves, 1995
11 × 5 × 6

227.
Neon Yellow Piccolo Venetian with Black Coils and Leaves, 1995
11 × 7 × 5

228.
Billiard Green Piccolo Venetian with Yellow Lilies and Blue Coils, 1995
11 × 5 × 5

229.
Ruby Red Piccolo Venetian with Reduced Green Leaves, 1995
11 × 6 × 6

230. (page 70)
Clear Venetian with Crimson Lake Birds, 1989
17 × 14 × 12

231. (page 80)
Cadmium Yellow Venetian with Red Lilies, 1989
19 × 14 × 16

232. (page 74)
Rose and Cadmium Yellow Venetian with Black Swirls, 1989
24 × 12 × 11

233. (page 75)
Gold Over Cobalt Venetian #49, 1989
24 × 12 × 10

234. (page 16)
Olive Green Venetian with Blue Coils, 1989
22 × 13 × 11

235.
Gold Over Rose Venetian with Crimson Feather, 1989
21 × 10 × 9

236. (pages 88, 89)
Gilded Putti in Leaves with Swan, 1991
11 × 24 × 12

237. (pages 90, 91)
Blue Seascape Venetian with Four Putti, 1991
12 × 21 × 21

238. (page 86)
Black Venetian with Golden Ochre Leaf, 1990
43 × 12 × 11

239.
Platinum and Black Venetian with Horns, 1991
16 × 13 × 15

240.
Black Venetian with Cobalt Blue Petals, 1991
16 × 17 × 16

241. (page 85)
Gold Over Green Venetian with Yellow Flowers, 1990
24 × 16 × 16

242. (pages 17, 94)
Gilded Mystic Blue Putto Venetian with Swan and Cherubs, 1994
19 × 15 × 15

243. (pages 16, 98)
Gold Over Pale Ruby Putti Venetian with Burgundy Leaves, 1994
19 × 16 × 13

244. (pages 27, 97)
Gold Over Fountain Green Putti Venetian with Leaves and Dragon, 1994
13 × 18 × 18

245. (pages 17, 92, 93)
Spotted Raspberry Putti Venetian with Devil On Sunflower, 1994
19 × 16 × 14

246. (page 96)
Golden Putti Venetian with Dragon, 1994
27 × 15 × 10

247. (page 97)
Fountain Green Putti Venetian with Gilt Leaves and Centaur, 1994
18 × 16 × 17

248. (page 95)
Translucent Blue Putto Venetian with Gilt Leaves and Dragons, 1994
17 × 16 × 14

249. (page 98)
Silver Over Navy Blue Putti with Spotted Raspberry Prunts, 1994
13 × 10 × 10

250. (page 101)
Gold Over Bright Orange Putti Venetian with Leaves, 1994
15 × 15 × 15

251. (page 100)
Spotted Gold Putti Venetian with Eagle, 1994
16 × 19 × 19

252. (page 101)
Ruby Red Putti Venetian with Gilt Ram and Twin-headed Dragon, 1994
20 × 12 × 12

253. (page 99)
Gilt Tangerine Putti Venetian with Handles and Ribbons, 1994
19 × 13 × 13

254.
Cobalt Blue Venetian with Crimson Spires, 1997
9 × 5 × 5

255.
Tulip Yellow Piccolo Venetian with Teal Streaks, 1997
9½ x 7 x 6

256.
Spitfire Red Piccolo Venetian with Cobalt Orchids, 1997
10 x 9 x 8

257.
Spotted Teal Piccolo Venetian with Green and Gold Orchids, 1997
9½ x 8 x 7

258.
Mandarin Orange Piccolo Venetian with Teal and Violet Coils, 1997
14 x 6 x 5

259. (page 60)
Damascan Violet Piccolo Venetian with Clear Fronds, 1997
13 x 5 x 6

260.
Prussian Blue Piccolo Venetian with Gold Overlay, 1997
10 x 6½ x 3½

261.
Honeysuckle Piccolo Venetian with Cyan Spires, 1997
13½ x 7½ x 7

262.
Gold Ochre Piccolo Venetian with Climbing Lilies, 1997
11 x 6 x 4½

263.
Zinnia Red Piccolo Venetian with Bottle Green Fronds, 1997
13 x 5½ x 5

264.
Burgundy Red Piccolo Venetian with Gold and Black Flares, 1997
14½ x 6 x 6½

265.
Flaxen Piccolo Venetian with Moss Green Leaves, 1997
13 x 5½ x 6½

266.
Dark Violet Piccolo Venetian with Green Marbled Leaves, 1997
9 x 6 x 6

267.
Spotted Sepia Piccolo Venetian with Gold and Sepia Coils, 1997
11 x 6 x 5

268.
Emerald and Gold Spotted Piccolo Venetian with Orange Leaves, 1997
10 x 8 x 6

269.
Olive Spotted Piccolo Venetian with Antique Rose Flares, 1997
12 x 9½ x 5

270.
Antique Garnet Piccolo Venetian with Gold Prunts, 1997
9 x 7 x 6

271.
Transparent Chartreuse Piccolo Venetian with Coils, 1997
10 x 7 x 6

272.
Imp Green Piccolo Venetian with Gold Leaf, 1997
9 x 7 x 6

273.
Strawberry Marbled Piccolo Venetian with Emerald Prunts, 1997
13½ x 6½ x 6½

274.
Mosaic Teal Spotted Piccolo with Tangerine Flames, 1997
18 x 5 x 7

275.
Sunbeam Yellow Piccolo Venetian with Leaves, 1997
9 x 7 x 5

276.
Cadmium Green Venetian with Red Orange Lip Wrap, 1997
9 x 8 x 7

277.
Rose Cloud Piccolo Venetian with Sepia Spotted Leaves, 1997
14 x 6 x 7

278.
Clear Yellow Venetian with Burgundy Prunts, 1997
11 x 9 x 7

279.
Spired Yellow Venetian with Black Lip Wrap, 1997
9 x 7 x 6

280.
Gilded Violet Venetian with Crimson Spires, 1997
7 × 5 × 5

281.
Willow Green Venetian, 1997
11 x 9 x 4

282.
Pale Yellow Venetian with Crimson Blossoms, 1997
8 x 9 x 7

283.
Cadmium Yellow Venetian with Amber Blossoms, 1997
9 x 12 x 9

284.
Yellow Sand Venetian with Clear Prunts, 1997
6 x 6 x 6

285.
Ancient Rose Piccolo Venetian with Urn Handles, 1997
10 x 6 x 6

286.
Cypress Green Piccolo Venetian with Burgundy Leaves, 1997
12½ x 7½ x 6

287.
Tea Green and Gold Piccolo Venetian with Tangerine Handles, 1997
10 x 5 x 5

288.
March Green Spotted Piccolo Venetian with Burnt Umber Coil, 1997
12 x 7 x 5½

289.
Arabian Orange Piccolo Venetian with Serpent Green Trendils, 1997
14 x 7 x 7

290.
Speckled Melon Piccolo Venetian with Tangerine Prunts, 1997
8 x 7 x 7

291.
Caspian Blue Piccolo Venetian with Frosty Prunts, 1997
9½ x 7 x 7½

292.
Daphne Blue Piccolo Venetian with Teal and Lemon Twists, 1997
8 x 9 x 7

293.
Persimmon Piccolo Venetian with Orange Swizzles, 1997
8½ x 7 x 8

294.
Athens Blue Piccolo Venetian with Gilded Rose Leaves, 1997
12 x 6 x 6

295.
Chinese Gold Piccolo Venetian with Teal and Rose Fronds, 1997
11½ x 7 x 5

296. (page 61)
Imperial Jade Piccolo Venetian with Kelly Green, 1997
10 x 9 x 7

297. (page 66)
Sistine Blue Piccolo Venetian with Golden Seals, 1997
9 x 7 x 7

298. (page 66)
Arctic White Piccolo Venetian with Ice Leaves, 1997
8½ x 7 x 8

299. (page 67)
Bronze Olive Piccolo Venetian with Clear Spines, 1997
11 x 5 x 6

300.
Amethyst Piccolo Venetian with Gold and Silver Leaf, 1997
5½ x 5 x 5

301. (page 68)
Clear with Copper Piccolo Venetian with Amber Coils, 1997
12 x 7 x 7

302. (page 62)
Canal Green Piccolo Venetian with Gold Leaf and Rose Prunts, 1997
7 x 6 x 6

303. (page 64)
Spotted White Piccolo Venetian with Burnt Umber Handles, 1997
12 x 8 x 5

304. (page 64)
Iris Gold Piccolo Venetian with Teal Spires, 1997
11 x 8 x 5

305. (page 65)
Creme and Coralbell Piccolo Venetian with Tiers, 1997
11 x 6 x 4

306. (page 63)
Moss Green Spotted Piccolo Venetian with Clear Spheres, 1997
8 x 8 x 9

307. (page 62)
Aquamarine Piccolo Venetian with Iris Blooms, 1997
9 x 7 x 7

308. (pages 102, 104, 105)
Stopper (Putti and the Tree), 1994–97
40 x 21½

309. (pages 27, 102, 103, 105)
Stopper (Putti and the Dragon), 1994–97
43 x 19½

310. (pages 102, 105, 106, 107)
Stopper (Putti and the Hand), 1994–97
33 x 22

311. (pages 2, 108, 109, 110–11)
Laguna Murano Chandelier, 1996–97
dimensions variable

Works on Paper

312. (page 112)
Macchia Drawing #14, 1982
charcoal, watercolor, and graphite on paper
30 x 22

313.
Macchia Drawing #7, 1983
mixed media on paper
30 x 22

314.
Macchia Drawing #31, 1989
graphite, charcoal, and watercolor on paper
30 x 22

315.
Ebeltoft Drawing, 1991
mixed media on paper
50 x 70

316. (pages 117–18)
Ebeltoft Drawing, 1991
mixed media on paper
50 x 70

317.
Ebeltoft Drawing, 1991
mixed media on paper
30 x 22

318.
Ebeltoft Drawing, 1991
mixed media on paper
30 x 22

319.
Ebeltoft Drawing, 1991
mixed media on paper
30 x 22

320. (page 116)
Ebeltoft Drawing, 1991
mixed media on paper
30 x 22

321. (page 122)
Ebeltoft Drawing, 1991
mixed media on paper
45 x 30

322. (page 117)
Ebeltoft Drawing, 1991
mixed media on paper
45 x 30

323. (page 114)
Ebeltoft Drawing, 1991
mixed media on paper
45 x 30

324.
Ebeltoft Drawing, 1991
mixed media on paper
45 x 30

325.
Ebeltoft Drawing, 1991
mixed media on paper
45 x 30

326.
Ebeltoft Drawing, 1991
mixed media on paper
45 x 30

327.
Ebeltoft Drawing, 1991
mixed media on paper
30 x 22

328.
Ebeltoft Drawing, 1991
mixed media on paper
30 x 22

329.
Ebeltoft Drawing, 1991
mixed media on paper
45 x 30

330.
Ebeltoft Drawing, 1991
mixed media on paper
30 x 22

331.
Ebeltoft Drawing, 1991
mixed media on paper
30 x 22

332.
Ebeltoft Drawing, 1991
mixed media on paper
30 x 22

333.
Ebeltoft Drawing, 1991
mixed media on paper
30 x 22

334.
Ebeltoft Drawing, 1991
mixed media on paper
30 x 22

335. (page 115)
Pink Putti Drawing, 1989
pastel and charcoal on paper
30 x 22

336.
Basket Drawing, 1983
watercolor, graphite, ink, colored pencil, and coffee on paper
30 x 22

337.
Basket Drawing, 1984
watercolor, graphite, ink, and colored pencil on paper
30 x 22

338. (page 112)
Basket Drawing, 1983
mixed media on paper
30 x 22

339. (page 113)
Basket Drawing, 1983
mixed media on paper
30 x 22

340.
Ebeltoft Drawing, 1991
mixed media on paper
30 x 22

341.
Niijima Drawing, 1989
watercolor, charcoal, color pencil, and graphite on paper
30 x 22

342.
Niijima Drawing #31, 1989
colored pencil, graphite, and watercolor on paper
22 x 30

343. (page 112)
Niijima Drawing #52, 1989
graphite and watercolor on paper
22 x 30

344.
Venetian Drawing (NY Lino Blow), 1992
mixed media on paper
30 x 22

345.
Seaform/Basket Drawing, 1983
mixed media on paper
30 x 22

346. (page 120)
Seoul Venetian Drawing, 1990
acrylic and ink on paper
65 x 52

347. (page 121)
Seoul Venetian Drawing #2, 1990
charcoal, acrylic, and watercolor on paper
65 x 52

348.
Hawaii Drawing, 1992
mixed media on paper
41½ x 29½

349. (page 114)
Venetian Drawing, 1990
pastel and charcoal on paper
30 x 22

350.
Seaform Drawing, 1984
mixed media on paper
30 x 22

Designed by Ed Marquand

Produced by Marquand Books, Inc., Seattle

Printed by C & C Offset Printing Co., Ltd., Hong Kong

Type set in Quadraat and Akzidenz Grotesk, with heads in DINNeuzeit Grotesk

Photography credits:

Philip Amdal, pp. 12, 16 (top), 71 (top); Eduardo Calderón, p. 86 (right); Shaun Chappell, pp. 2, 60, 61 (top right, bottom right), 62, 63, 64 (top left, top right), 65, 66 (right, bottom left), 67 (bottom right), 68, 108, 109, 110–11; George Erml, pp. 20, 33, 34, 35, 37, 38 (bottom right), 40, 41 (top right, bottom); Claire Garoutte, front and back covers, pp. 17 (bottom), 56, 57, 58, 59, 61 (top left, bottom left), 64 (bottom), 66 (bottom right), 67 (bottom left); 69, 72, 73, 76, 88, 89, 90, 91, 92, 93, 94, 95, 96, 97, 98, 99, 100, 101, 115, 116, 117, 118–19; Terry Rishel, pp. 8, 42, 43, 44, 45, 46, 47, 48, 49, 50, 51, 52, 53, 54, 55; Morgan Rockhill, pp. 70 (top), 74; Roger Schreiber, pp. 38 (top, bottom left), 39 (bottom left, bottom second left), 41 (top left), 79, 80, 82, 83, 84, 85 (top), 86 (left); Mike Seidl, pp. 17 (top left, top right), 22 (top), 31, 32, 36, 39 (top, bottom second right, bottom right), 81 (top), 85 (bottom), 112 (bottom right).